THE CURIOUS LIFE OF NEVADA'S
LaVere Redfield

THE CURIOUS LIFE OF NEVADA'S

LaVere Redfield

THE SILVER DOLLAR KING

JACK HARPSTER

THE
History
PRESS

Published by The History Press
Charleston, SC 29403
www.historypress.net

Front cover: The famous "Biggest Little City" arch on Virginia Street is seen in the 1960s, when LaVere Redfield frequented many of the casinos seen along the street. Harolds Club on the left and Harrah's on the right were both Redfield haunts. *Courtesy University of Nevada, Reno Special Collections.*

First published 2014

Manufactured in the United States

ISBN 978.1.62619.704.6

Library of Congress Control Number: 2014952384

Contents

Acknowledgements

Many individuals and organizations deserve high praise for contributing generously to this work. First in line have to be the reporters, photographers and editors of the *Reno Evening Gazette* and Reno's *Nevada State Journal*, both of which date back to the third quarter of the nineteenth century, and the newspaper into which they were combined in 1983, the *Reno Gazette-Journal*. Of the many stories and important events in the life of LaVere Redfield that are chronicled in the book, a great many of them were reported on and fleshed out in one of these three distinguished newspapers. I owe them a debt of gratitude for the hundreds of stories they published about LaVere Redfield and his fascinating life and times and for their historic photos you'll find sprinkled throughout the story.

A big thanks also goes to Mrs. Jilda Warner Hoffman, the only ancestor No of the Redfield family who was willing to share stories of this large extended family's unique personalities. The older photographs of LaVere and Nell Redfield also come courtesy of Mrs. Hoffman.

Nearly two dozen Reno old-timers graciously sat for interviews and shared their stories about Redfield. You'll find these folks listed in the bibliography, and I thank them all for their time and their great stories.

All the people at the Nevada Historical Society in Reno and the Special Collections Department at the University of Nevada, Reno Mathewson-IGT Knowledge Center were very helpful to me, as they always are. Both organizations are always a pleasure to work with.

ACKNOWLEDGEMENTS

Special thanks go out, too, to the *Nevada Silver & Blue* staff from the University of Nevada, Reno Development and Alumni Relations department; Dace Taube, Regional History Collection librarian at the Doheny Memorial Library at the University of Southern California; Reno attorney Richard Hill; wedding chapel owner and longtime Nevada lobbyist George Flint; and Reno writer, raconteur and man-about-town Karl Breckenridge.

Prologue

The short, trim man with the graying crew cut would not normally have attracted any attention as he walked briskly south on Forest Street through the southwest residential neighborhoods of Reno, Nevada. He was fewer than four short blocks from his Mount Rose Street house, an imposing stone mansion that sat atop the highest knoll in his neighborhood.

The walk from the city's downtown casino corridor, where he enjoyed playing roulette, was only about a mile and a half, and he had never seen any reason to waste gasoline driving the short distance downtown and back. Counting pennies was an important fixation in his life despite his enviable wealth. Even when the weather was colder than it was on this early January 15, 1948 afternoon, he would still leave his truck at home and make the trip on foot or perhaps by bus in inclement weather. LaVere Redfield was a man bound tightly by his routines and idiosyncrasies. Many of his friends and neighbors, and even total strangers who knew him only by reputation, thought many of his habits were unusual, if not downright odd. But at fifty-one years old, and wildly successful by any measure despite his eccentricities, Redfield was not about to change the way he did things just to please other people.

Forest was a well-kept residential street of small wood-frame houses and brick cottages. It could even have been described as the quintessential postwar, middle-class Reno neighborhood. A narrow greenbelt between the sidewalks and streets was lined with poplar trees, now completely denuded of their autumn leaves, and the grass lawns fronting the well-kept homes

were brown and crisp. The last six months had witnessed one of the worst droughts in the city's history. The normally dependable winter clouds had squeezed out only one-third of an inch of precipitation during that time, so even some of the slumbering evergreens—the hollies, boxwoods and junipers—that lined the concrete ribbon driveways were losing their vibrant emerald color.

It was 1:50 in the afternoon. Redfield had enjoyed a good run of luck at the roulette wheel at Harolds Club, one of his favorite downtown hangouts, and his $2,300 winnings were tucked into a paper bag clutched tightly in his hand. Few people would entrust so much cash to a paper bag, but Redfield often did so. His suspicions had been aroused by a man who had been following him for the past few blocks, however. He would later describe the man to police as about thirty-five years old, of medium height and weight, with a dark complexion. Redfield picked up his pace again as he crossed the intersection at Mary Street, only a few blocks from his home, but the stranger overtook him. The man announced that he had a gun in his pocket and demanded of Redfield, "Give me the $2,300." Despite his small size and mild manner, LaVere Redfield was not a pushover in any sense of the word. It occurred to him that the man must have been following him all the way from the downtown casino. The stranger repeated his demand, but Redfield stood his ground, tightly gripping the fragile brown paper sack.

If ever there was a man who had difficulty parting with a dollar under any circumstances, it was LaVere Redfield. Those who knew him well—and there were few such people outside of his large extended family—could have told the would-be robber that he had set a difficult task for himself. But unaware of whom he was dealing with, the robber swung a brick he held clutched in his hand and hit Redfield on the side of the head with a resounding crack. Again the mugger demanded the money, and again Redfield resisted. Twelve to fifteen times, according to Redfield's later estimate, the stranger hit him on the head with the brick, but each swing only tightened Redfield's grip on the paper bag and steeled his resolve not to surrender his money to the thug. Eventually, frightened by the commotion he was creating on the quiet street, the stranger gave up and ran away.

Redfield had proven to be tough, but he paid a high price for his courage and stubbornness. He lay on the pavement with a fractured skull and a concussion, the paper sack holding his $2,300 winnings still clutched tightly in his hand. A passerby called the police, and an ambulance was dispatched to the scene and hurriedly carried the injured man to Washoe General Hospital. The following morning's newspaper reported that hospital

personnel said Redfield "was in serious condition…[but] he is believed to have a good chance of recovery."

A week later, while Redfield was still recuperating in the hospital, he was told he had lost a lawsuit he had filed earlier against Washoe County for excessive taxation on his massive Mount Rose and Carson Range mountain property. To top it off, somebody had stolen the fender skirts off a new Packard automobile he had just purchased and left parked in his driveway. It had truly been a bad week for the man. Redfield remained in the hospital for a number of weeks. A young neighbor boy who looked up to Redfield because of his extraordinary business success recalled that Redfield wore a hard, protective skullcap on his head for months after the incident.

The botched robbery and assault would turn out to be a seminal event in the life of one of Nevada's most prominent and eccentric characters. For the first decade LaVere Redfield and his wife, Nell, had lived in Reno, they had met many people and formed some comfortable friendships. They entertained frequently in the large stone mansion they called home, and they enjoyed their life in the small city on the banks of the Truckee River. But the botched robbery and assault changed all that, according to his wife. Nell Redfield made the only public utterance on the subject many years later in a newspaper interview when she said, with a sad shake of her head, her voice trailing off into silence, "We entertained a lot. People would talk about LaVere being a miser…" Pamela Galloway, the reporter who conducted the interview, explained: "She [Mrs. Redfield] indicated that the entertaining ended…after Redfield was 'hit over the head.' She did not elaborate." Following the death of LaVere in 1974, Mrs. Redfield also told one of the estate attorneys that the mugging had likely caused her husband's hoarding tendencies. The attorney said, "Today Mrs. Redfield told me that before that event, the basement was clean. After that, he started going to auctions and buying about everything in sight."

As LaVere Redfield's life unfolds in the following chapters, and his eccentricities and odd habits begin to define him, perhaps his behavior can at least partially be explained by the violence he suffered on that chilly winter day in 1948. Unfortunately for the Redfields, this event would be just the first of five attempts over the next two decades to separate them from their considerable fortune by force. In fact, a burglary just four years later at their Reno home—the largest burglary in U.S. history at that time—would make international news and subject the ultra-private couple to media scrutiny that would haunt them for the rest of their lives.

As for the 1948 mugging and attempted robbery, it proved once again that justice can be fleeting. On March 30, two and a half months after

his encounter with the brick-wielding stranger, Redfield was at the Bank Club casino in downtown Reno when he thought he saw a familiar face at a gaming table. It was his attacker! Redfield quickly alerted police, and the man was arrested. He was thirty-two-year-old William Charles Hundrieser, who lived at the downtown Nevada Hotel and, like Redfield, frequented the downtown clubs and casinos. Unable to post bail, Hundrieser was bound over for trial.

Two weeks later, at his first hearing, a thoroughly baffled Hundrieser provided proof that he had been in Culver City, California, on the day Redfield was assaulted. He was actually an employee at the Bank Club and had been on duty when Redfield spotted him. On order of the district attorney's office, all charges against Hundrieser were dropped. Thus, in the end, LaVere Redfield would not get justice for the vicious attack against him.

Acclaimed author John Berendt, Pulitzer Prize finalist for his nonfiction book *Midnight in the Garden of Good and Evil*, specializes in books about quirky people like LaVere Redfield. He wrote: "Eccentrics have a certain charm, and their lifestyles require a certain amount of daring. They live outside the norm and therefore run the risk of ridicule or even ostracism. I consider them artists, and their masterpieces are their own lives."

This book is the story of the life—the masterpiece, John Berendt might say—of LaVere Redfield, to the extent it is possible to accurately record the story of any man's life when he left little or no personal or professional records behind. Although the story that unfolds in the following chapters often reads like fiction, it is all true.

It all began in a small Utah town in the closing years of the nineteenth century.

1
The New Zion

LaVere Redfield (no middle name) was born on October 29, 1897, in Ogden, Utah, less than two years after Utah had gained statehood. Both his parents had impressive bloodlines. His mother, Sarah Eleanor Browning Redfield, was an Ogden native, and her maternal line included *No?* Jonathan Browning, a blacksmith and gunsmith whose family would found the famed Browning Arms Company in Utah in 1928. LaVere's father, William Sheldon Redfield, was born in Nauvoo, Hancock County, Illinois, in 1845. His parents had been founding members of Joseph Smith's Mormon Church in New York; but shortly after William's birth they, along with other dissenters, formed a splinter sect called the "Cuterlites" and resettled in Iowa.

Sarah and William Redfield would eventually have seven surviving children; one child died in infancy. Despite Ogden's prosperity in the early twentieth century, the Redfield family did not share in the bounty. The family was, by LaVere Redfield's account, a poor family, living hand to mouth. When William Redfield passed away at only fifty-four shortly after LaVere's birth, the family's financial situation became more dire. Sarah—usually called Elly or Ella—was on her own, with only the proceeds from a small life insurance policy to raise her seven children. The older boys were able to work, and Elly, who was a musically gifted woman, began giving piano instructions in her home to the children in the neighborhood for fifty cents a lesson. Despite all these efforts, many years later, LaVere Redfield said he often went to bed as a youth with gnawing hunger as his companion.

Fred Redfield, LaVere's older brother by sixteen years, was his closest sibling in their adult years. Fred, pictured here as a teenager, and LaVere bore a striking physical resemblance to each other. *Courtesy of Jilda Warner Hoffman.*

The Redfield children grew up under the tutelage of their mother. Although the family had abandoned the Mormon Church, living in Ogden would still have exposed them to the bedrock Mormon fundamentals of the day. God, the Mormon Church believes, does not condone nor is tolerant of idleness and laziness. "They advocate the virtues of the Puritan ethic, including hard work, thrift and deferred gratification," wrote sociologist Alan Aldridge in his book *Religion in the Contemporary World: A Sociological Introduction.* Members are exhorted to be industrious and not to spend their money to have things done that they could and should do for themselves. LaVere once told a newspaper reporter, "That's [his boyhood in Ogden] where my background of thrift came in. There was no garbage can in our house—everything was consumed. I practiced the same thrift then that I do now."

Over the first two decades of the twentieth century, as LaVere's older brothers grew into manhood, they all advanced rapidly in the Ogden business community, most of them establishing their own successful businesses. At some point, two of the brothers moved to Idaho Falls, Idaho, where they opened a second plant of their Superior Honey Company. Meanwhile, LaVere, the youngest, worked at any job he could find in Ogden to earn his own money while he went to high school. He attended the public Ogden

High School where he was a member of the Cadet Battalion, a kind of Reserve Officers' Training Corps (ROTC) organization for high school boys. His nickname was "Vere." Even in those early years, classmates described Redfield as a "retiring" boy.

For the annual yearbook, each student was asked to identify a favorite literary quote, one that held special meaning for him or her. LaVere's quote was telling. It was from British poet John Gay's (1685–1732) book of poems *Fables* and was entitled "The Pack-Horse and the Carrier: To a Young Nobleman": "Learning by study must be won/'Twas ne'er entail'd from son to son." The poem is a warning to a young nobleman that despite his aristocratic heritage, what he makes of himself is entirely up to him. As Gay writes, "By birth the name alone descends/Your honour on yourself depends." We can assume the message was clear to the impressionable LaVere Redfield that a man's fate is entirely in his own hands; he is what he makes of himself. This belief is reflected throughout LaVere's life in the "lone wolf" philosophy by which he lived.

Ogden High School records for 1916 do not show Redfield's name on the graduation program, however, indicating that he may have left school during his senior year.

In late 1917, or early 1918, LaVere Redfield joined more than twenty-four million other men between the ages of eighteen and forty-five in registering for the draft. He indicated that at that time, he was working for his brother Fred at the Superior Honey Company in Ogden. Given his age and his participation in the high school ROTC program, Redfield would have been a likely candidate for conscription. However, he was never called before World War I ended late in 1918.

When he was in his early twenties, LaVere left Ogden and moved to Idaho Falls. Showing his independence, he had eschewed working for any of his brothers in Ogden, and in Idaho Falls, he also made his own way. Rather than working in the family's honey plant, he got a dirty, backbreaking job digging potatoes. These choices certainly reflected the philosophy of independence that his favorite poet, John Gay, had espoused, indicating that young LaVere paid more than just lip service to the poet's advice. LaVere's mother, Elly, perhaps recalling her own difficult life, had advised him not to marry until he had saved enough money to afford a wife. Any advice that encouraged thrift always appealed to the young man's sensibilities, and he worked hard and followed his mother's counsel, saving his earnings.

After a few years, Redfield moved to Burley, Idaho, a small town about 150 miles southwest of Idaho Falls on the Snake River. He took a position as a

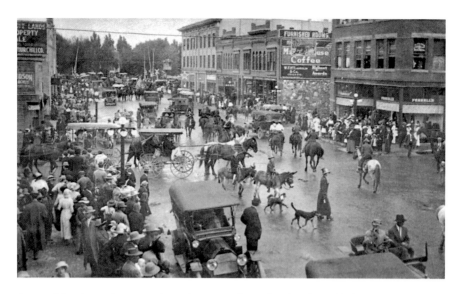

Automobiles, horse-drawn carriages, horses, mules and pedestrians mingle on crowded Broadway Street in downtown Idaho Falls, Idaho, in the second decade of the twentieth century, about the time LaVere Redfield relocated there from Ogden, Utah. *Courtesy of the Idaho Falls Post Register.*

clerk in what his wife, Nell, described as a small department store. The work was easier than digging potatoes, and the pay was better. Plus, he was able to continue saving most of his earnings. At some point, according to Nell, he advanced into a management position at the store. Nell, a young widow at the time, worked for him. The two began dating, and LaVere continued saving his money so he could afford to marry his new girlfriend.

Nell Jones—also referred to in Mormon Church records as "Nellie Rae Jones"—was born on August 16, 1894, in Malad City, Idaho. In 1922, LaVere and Nell were married in Burley. Redfield had been saving his money for nearly five years, and he felt they deserved a honeymoon. They decided to go to Southern California.

The early 1920s was known as "the jazz age." It was the era of the flapper, bathtub gin and exciting new technologies like automobiles, moving pictures and radio. It was also the advent of the great prosperity that followed the ending of World War I. No other city in the West seemed to offer as much promise for the future as Los Angeles. For the first few days of their honeymoon, the young Redfield couple took in all the sights. Then LaVere experienced a life-changing moment. "One day in Los Angeles, when my wife and I were window shopping, we came upon a very busy

[stock] brokerage office," he related to Nevada's most celebrated writer, Robert Laxalt, in a 1952 interview. "The feverish excitement I saw disturbed me more than I could say. The next day saw me there again…It was there I decided to take a chance, to risk my few hundred dollars in hard-earned savings," he continued. "It seemed like such a gamble then, but in reality I had so little to lose."

Many years later, Redfield related this story to a young friend, John Metzker, adding a few more colorful details. As he and Nell had walked by the brokerage office, Redfield recalled, all the windows were open, and there was a great deal of commotion inside. "I went inside and all these guys are yelling and shouting and waving papers…it was an oil stock exchange," Redfield told Metzker. He went back alone the next day and spent the entire day in the frenzied environment, taking notes and watching all the excitement. The following day, he went back again and purchased some stock in one of the oil well syndicates. It's likely this was his first purchase in a syndicate being promoted and sold by famous Roaring Twenties flimflam man C.C. Julian.

Shortly afterward, LaVere and Nell returned to Burley, and he began following the stock tables in the nearby Twin Falls newspaper and reading books on investing from the local library. He began buying and selling stocks at a calculated pace, concentrating primarily on industrial stocks in the beginning. Then he gradually branched off into oil and mining stocks, which were more speculative but also more profitable when his picks were on the money, which they usually were. "His earnings skyrocketed at a dizzying pace, until 10 years later [1932] at the age of thirty-five he was a millionaire," Robert Laxalt wrote.

How LaVere Redfield managed to financially survive the Wall Street crash of 1929 is not known. But as Robert Laxalt's statement indicates, somehow he must have done so. During the initial period of Redfield's investing, the Dow Jones Industrial Average increased in value fivefold, and many speculative stocks were double or triple that figure. The Los Angeles Stock Exchange offered the same opportunities for astute investors. Redfield was always a contrarian in every aspect of his life, and he viewed investing through the same prism and was not unduly damaged by the crash. As a matter of fact, as the decade of the 1930s and the Great Depression ground inexorably on, it would prove to be a blessing—not a curse—for LaVere Redfield.

2
The Year of the Golden Harvest

In 1929, LaVere and Nell Redfield moved to Los Angeles. Redfield had been mesmerized by the opportunities he saw during their honeymoon visit seven years earlier, and the investments he had made since then had ballooned in value. Once the October 1929 stock market crash had occurred—what effects it had on Redfield's portfolio we cannot know—he was ready to roll the dice again.

Because of his lifelong penchant for keeping his financial matters close to the vest, it is difficult to say exactly how LaVere Redfield built his fortune. We do know he started investing in the stock market in 1922, first in oil syndicates and then very quickly adding mining and industrial blue chip stocks. Past that brief knowledge little is known about Redfield's Los Angeles investing years. But public records do reveal one specific investment, one of his first, and like almost everything LaVere Redfield touched, it's a fascinating story. Here's how it happened.

When LaVere and Nell made their honeymoon visit to Los Angeles in 1922, the biggest story playing out in the newspapers was the historic oil boom occurring throughout Southern California. The discovery of rich new oil fields in Huntington Beach, Long Beach and Santa Fe Springs over the preceding few years had captured the public's fancy and created a buying frenzy in the stocks of oil companies like Standard Oil, Union Oil and dozens of lesser-known firms. And then there were the wildcatters. These were men with no large organizations behind them and no multimillion dollar exploration budgets with which to drill for the liquid

gold. These were men who had only one thing going for them: their dream of fabulous riches.

The oil boom in Southern California had been preceded by a land boom. People from across the nation had been wooed to this land of sunshine, sandy beaches and unlimited opportunity by a chamber of commerce gone wild with promises. The result was that most of the property that sat atop these newly discovered oil fields had already been subdivided and gobbled up as individual housing lots. Where the big oil companies had previously purchased oil fields in their totality, in Southern California there were hundreds, perhaps even thousands, of ordinary folks who now had access to the oil beneath their small parcels of land. It was impossible for the big oil companies to purchase the entire oil field under these circumstances, and it opened opportunities for individual wildcatters to buy or lease a few adjoining residential lots and join the big boys in the oil hunt.

One law was important to the success of any oil venture: the "rule of capture." This governing rule in the oil exploration business is a uniquely American law. While many other countries consider any subsurface wealth to be owned by the government, in the United States, individual landowners are usually granted the mineral rights under their property. But pools of oil may extend under the property of thousands of neighboring landowners, so the rule of capture holds that the oil belongs to the person or company that pumps it from the ground.

While the Redfields were honeymooning in Southern California in 1922, it would have been impossible not to get caught up in this hype. Thousands of ordinary citizens dreamed that their trim little wood-framed stucco houses and white-picket-fenced yards could be sitting atop a fortune. Most didn't want to sell; that would mean giving up their chance to get rich. And most certainly couldn't afford to drill for oil themselves. Enter the oil companies and the wildcatters. They would lease the land from the owner, front the money for the drilling operation and share the proceeds with the landowner when and if—a great big IF—they struck a gusher. All this resulted in a terrain where oil derricks crowded tightly together. Historian Jules Tygiel, in his book about the 1920s oil boom in Los Angeles, *The Great Los Angeles Swindle: Oil, Stocks and Scandal During the Roaring Twenties*, states it was normal practice to drill one well for every five acres of oil land. But in the Santa Fe Springs oil field in 1923, he said, "one eighty-acre plot...hosted forty-six derricks, an average of one well to every 1.74 acres. Six months later the more congested half of that tract held sixty wells."

Into this milieu had come C.C. (Courtney Chauncey) Julian, a failed Canadian entrepreneur turned oil wildcatter. Julian arrived in 1922, the same year the Redfields were honeymooning in Los Angeles. But by 1934, barely a dozen years later, LaVere Redfield would be on his way to fabulous wealth while C.C. Julian would die by his own hand as a fugitive in a seedy Shanghai hotel, dead broke and remembered only for pulling off one of the Roaring Twenties' most celebrated stock swindles.

Julian, like Redfield, had sensed opportunity from the moment he arrived in town. He visited the three newly discovered oil fields and decided that Santa Fe Springs offered the greatest potential for the smallest investment. In the past, the community had been explored for oil three times, with no success; but on October 30, 1921, Union Oil struck a gusher at a depth of 3,763 feet on leased land. The Santa Fe oil field became national news overnight.

C.C. Julian jumped right into the fray. Because he had little money, he selected a few sites on the outskirts of the activity, about a mile distant from Union Oil's wells, and began trying to sign leases. Eventually, Julian subleased a five-acre parcel from the small Globe Petroleum Company. Later Julian would sublease Globe's remaining land, but first, he had to find the money to pay for the initial lease because he was flat broke. He went on a three-day fundraising marathon. By tapping many of the same people who had invested in his past failed schemes, he raised the money to pay Globe Petroleum for the five-acre lease. But his work had only begun. Now he needed to raise money for the drilling operation, which was even costlier; and it was here that C.C. Julian showed his true marketing genius.

"[He] began fishing for investors in a series of colorful advertisements in the *Los Angeles Times* and other newspapers," Jules Tygiel wrote in a *Los Angeles Times* article summarizing the story from his book. "Julian portrayed himself as the champion of the independent oilman and the small investor, battling against big oil and the corporate moguls." His marketing strategy struck a nerve with small investors, and money for the drilling operation came gushing in from people anxious to buy unit shares in the syndicate and get rich quick along with him. One of his early investors was twenty-four-year-old store clerk LaVere Redfield from Burley, Idaho, who was visiting the city on his honeymoon.

Over the next couple years, Julian's first four wells produced healthy gushers. He quickly became, according to historian Tygiel, "the prince of oil promoters." Those who bought early were rewarded for their vision. Their initial $100-per-unit purchase price for the syndicates on wells 1 and 2 had

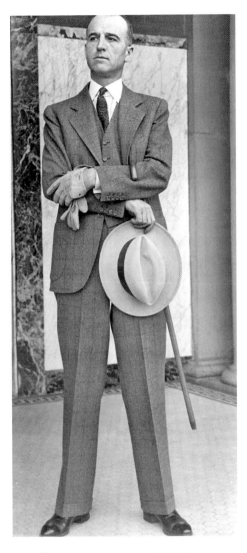

Canadian entrepreneur turned oil wildcatter
C.C. Julian, whose Julian Pete oil scandal
rivaled the Teapot Dome scandal during the
Roaring Twenties. Julian committed suicide in
1934. *Courtesy of University of Southern California,
on behalf of USC Special Collections.*

risen to $225 by early 1923, plus dividends, and before the year was out, they would soar to $290. Redfield would eventually invest in at least five of Julian's Santa Fe Springs oil well syndicates: wells 1, 2, 3, 11 and 12. The per-unit asking prices on each well quickly went on a roller coaster ride as Julian manipulated the prices downward in hopes of repurchasing the units cheaply for resale while new oil discoveries made at a deeper levels jacked the prices back up. But C.C. Julian was just getting started. In 1923, energized by his early successes, he formed the Julian Petroleum Company— nicknamed "Julian Pete" by his adoring investors—and in less than two months he had sold $5 million worth of stock in his new oil refinery. Over the next few years, C.C. Julian became the toast of Los Angeles: a huge mansion, a fleet of luxury cars, Hollywood pals, beautiful female companions and lavish parties.

In 1927, it all began to unravel when the Los Angeles Stock Exchange halted trading in Julian Petroleum due to a litany of financial shenanigans, and Julian Pete collapsed in a flurry of lurid headlines. C.C. Julian went down hard, taking with him a number of banks and brokerage houses, many influential Hollywood investors, a handful of politicians and thousands of small investors.

Julian decided it might be a good time to seek opportunities elsewhere, and he hastily left town for Canada. But in 1930, the rarely bashful entrepreneur reappeared in Southern California at the head of his new company, C.C. Julian Oil and Royalties Company. By now, he had severed all his ties to Julian Pete, but he did still control the syndicates for many of his original oil wells. Wells 1, 2 and 3 had sat dormant since 1924, but he refitted and reactivated them. Within a few weeks, all three wells were once more producing oil, and LaVere Redfield and other unit holders again began receiving dividends.

It wouldn't be long before Julian was up to his old tricks, however, and unit holders were furious about it. A group of them hauled Julian into court and had him removed as the trustee for the three wells that were still hard at work pumping oil. He appealed; but on November 3, 1933, Julian was denied a new trial. Appointed to act as new trustees for the 4,500 unit holders of the three wells were three men, including thirty-six-year-old investor LaVere Redfield.

Summing up C.C. Julian's decade-long Southern California caper, the *Los Angeles Times* wrote, "The Julian wreckage was mostly plain thievery, even though juries let the...plain thieves go, and they were convicted of quite other offenses." When C.C. Julian took a drug overdose in Shanghai in 1934, his great Los Angeles scandal ranked only behind the Teapot Dome Scandal as the Roaring Twenties' most audacious flimflam.

The Redfields chose to live in Long Beach when they moved to Southern California. A suburban community southeast of Los Angeles, it is located within a short drive of Santa Fe Springs. LaVere obtained a stockbroker's license—not too difficult in the day—that he used to facilitate buying and selling for his own portfolio. Other than his participation with C.C. Julian, little is known about other securities Redfield may have bought and sold. He probably participated in both long and short sales, as he was an astute market watcher and had an unusually delicate feel for where a particular stock might be heading. One admirer referred to Redfield as a walking ticker tape for his in-depth knowledge of the stocks he followed. He also likely traded on both the Los Angeles Stock Exchange, one of dozens of regional exchanges that traded primarily in local stocks like Julian Pete, and in New York Stock Exchange issues.

We do know that among the stocks he profited from during the Depression was that of San Francisco–based Gladding, McBean, a company born during the gold rush era that manufactured clay sewer pipes, firebricks,

roof tiles and ornamental garden pottery. Rumor circulating in Reno for many years after Redfield's arrival also held that he had speculated—and profited nicely—in National Distillers Products Corporation that hit it big when Prohibition was repealed in 1933, with brands like Old Crow, Sunny Brook, Old Grand Dad and Old Taylor bourbons. It's unlikely, however, that Redfield would have bought into any of the initial stock offerings that blossomed during the 1920s: "Like other suckers, I invested but never on the original issue—only after the prices had been beaten down on the open market," he once told a newspaper reporter.

The early 1930s were not normal times, but the most successful market speculators—Redfield was certainly among them—realized that opportunities abounded in the stock market. By mid-1932, the year by which Redfield had earned his first million dollars, the Dow had bottomed out, concluding a shattering 89 percent decline from its 1929 peak. It was the lowest point the stock market had witnessed since the nineteenth century. LaVere Redfield, on the other hand, must have been quite satisfied, not at the misfortunes of his fellow citizens, but at his own good fortune. He had obtained a bank loan—he rarely borrowed money—to load up on out-of-favor stocks at historically low prices. That year his earnings reached their highest peak to that point. "I made more money during the Depression than in times of prosperity," Redfield once remarked. He referred to 1932 as "the year of the golden harvest."

Redfield was not entirely alone in his fabulous investing success during the Roaring Twenties and the Great Depression that followed. There were others, although few in number, who were also master speculators and built fortunes out of the rubble: Bernard Baruch, Billy Durant, Joseph Kennedy, Arthur Cutten and Jesse Lauriston Livermore were a few of the most successful speculators. While most of these men were, or became, well known, Redfield flew under the radar. As he quietly amassed a fortune, brokers on South Spring Street in Los Angeles snickered at him behind his back, referring to him as "the junk man" for the unloved stocks he purchased. According to one man in Reno who knew Redfield, local stockbrokers also called him the "Lone Wolf of Spring Street." Despite the less than flattering labels, Redfield knew what he was doing. One writer, after Redfield's death, said, "His mind had a computer-like speed and accuracy. He was a genius at figures."

The ten-year investing period from 1922 to 1932 was the most volatile in U.S. history. Many people made fortunes during the 1920s, only to lose all of it in the 1930s. Precious few investors flourished in both decades, as LaVere Redfield did. But despite his success, by 1935, Redfield was getting

nervous about his residency in California. The state, like most of its citizens, was suffering through terrible financial hardships, and the need to find new sources of revenue overwhelmed every other concern. Discussions began in Sacramento about the possibility of increasing the state income tax for the wealthy. This tough new tax law was known the 3.47 Act, whereby securities and cash would be taxed at a then onerous 3.47 percent. LaVere Redfield, a fierce opponent of income taxes of any sort, began thinking of pulling up stakes and seeking a safe tax haven for himself, his wife and his money.

At exactly the same time Redfield was considering his future, neighboring Nevada was looking for ways it could lure new money to its borders. Simultaneously, one of the leading businessmen in Reno, the state's largest city, was also fomenting a civic plan to attract men exactly like LaVere Redfield into its fold. It would only be a matter of time before all these forces coalesced.

3
A Financial Cyclone Cellar

In the early 1930s, Nevada was the least populous state in the nation, and its ninety-one thousand residents had yet to enter the Great Depression. Despite that good fortune, there were few among its lawmakers who did not believe that it was only a matter of time before their state joined the other forty-seven in the severe economic morass that had swept the nation. Perhaps, they believed, if they could be proactive, they could keep the economic calamity at bay a little longer. Thus it was that on March 21, 1931—the first day of spring—the Nevada state legislature was meeting in the state capital in Carson City. Lawmakers had just completed their final session that very afternoon, and perhaps at least a few of them intuited that this winter legislative session had been a historic one for their state. They had passed two laws and forwarded them on to Governor Fred Balzer for his approval, and it would only take the governor three days to sign into law the solons' two measures.

The first measure was a more liberal divorce law. Prior to the new law, anyone seeking to untie the marital knot had to establish residency in one county of the state for three months. The new law erased the need to stay put in one place and shortened the residency requirement to only six weeks. It also decreed that divorce cases would be private, and property settlements sealed. These measures would prove to be a boon for Reno, the state's largest city, already touted as the "Divorce Capital of the Nation," and they would thwart the plans of Idaho and Arkansas, which had recently passed three-month residency requirements for divorces.

But it was the second law passed in 1931 that would have the longest-lasting impact on the state: the nation's first legalization of casino gambling. This included games like faro, monte, roulette, keno, fan-tan, twenty-one, black jack, seven-and-a-half, big Injun, klondyke, craps, stud poker, draw poker "or any banking or percentage game played with cards, dice or any mechanical device or machine." Each game would require a licensing fee, and the new law prescribed how the fees would be carved up among the cities, counties and state and that minors under the age of twenty-one would not be allowed to play or even frequent the gambling parlors and resorts. Ranching and mining had fueled Nevada's early economy, and gambling was a common pastime in every mining camp in the state. Recognizing that reality, the state had legalized gambling from 1879 until 1909; but that had ended when the prim and proper citizens of the state finally had their say in 1909, and all forms of gambling were declared illegal the following year. That law stood—although it was brazenly ignored by a large segment of the independent-minded citizenry—until the 1931 casino gambling law overturned it.

Nevada's bold move was big news across the entire country, but nowhere was it more heavily covered—and censured—than by the newspapers in neighboring California. "Nevada's Two False Steps," the *Los Angeles Times* headlined in an editorial describing Nevada's two new laws. "The sovereign state of Nevada has set its seal of approval on what have been listed as two of the chief sources of weakness in American society today, too easy divorce and the passion for gambling." Further along in the editorial, the *Times* finally arrived at the crux of its objection to its neighbor's conduct: "California, however, [is] next-door neighbor to this new Mecca for undesirables...[and] some of the disagreeables are sure to slop over. And we shall have to mop up part of the mess."

By the middle of the 1930s, Nevada had continued to weather the Great Depression better than most states. The two 1931 laws had helped, but Nevada's federal highway expenditures and President Roosevelt's New Deal public works program dollars, the highest in the nation on a per-capita basis, had also kept state coffers reasonably healthy. Despite these bright spots, state leaders were still anxious over the possibility of Nevada's economy failing. The result was a promotional campaign, inaugurated by Governor Richard Kirman, calling attention to Nevada as "One Sound State." *Time* magazine itemized Nevada's chief attractions, as outlined in the marketing campaign: "A balanced budget. No Corporation tax. No income tax. No inheritance tax. No tax on gifts. No tax on intangibles. The greatest per

capita wealth ($5,985)." The magazine article described the effort of the One Sound State campaign as setting out to "promote Nevada as a sort of financial cyclone cellar."

Concurrently, a leading Reno businessman had also launched a regional campaign to attract new money to northern Nevada. Norman Biltz was born in Bridgeport, Connecticut, in 1902. A great salesman and idea man par excellence, Biltz had already made and lost a fortune in California before settling on real estate as a career. In 1927, he met wealthy California landowner Robert Sherman and became his key man in selling a large tract of lakefront land on Lake Tahoe. Biltz moved to Reno and continued his real estate sales activities in both Nevada and California. By the time of the Great Depression, he was worth between $8 and $10 million but labeled himself as only "a two-bit capitalist." Explaining his extensive network of contacts, he added, "If I need to, I can raise real dough, fast, from real capitalists."

Hitchhiking on the state's One Sound State bandwagon, Biltz turned his confidence and enthusiasm into a program to attract multimillionaires to move to northern Nevada. "We purchased a list of millionaires over the nation that were supposedly worth $20,000,000 or more," Biltz said in his university oral history interview, *Memoirs of "Duke of Nevada."* Each of the men and women on the list received a colorful magazine entitled *Nevada, the Last Frontier*, from Biltz and his associates. The magazine was filled with informative articles extolling the virtues of the Silver State, its tax haven status and its economic opportunities. Engaging photographs of men and women—mostly beautiful young women—enjoying all the amenities the state had to offer, enhanced the narrative. Each magazine was mailed to its wealthy recipient in a leather binder with his or her name emblazoned in gold on the cover, and each mailing was followed up by a personal phone call.

These two promotional campaigns eventually caught the eyes of a number of disgruntled millionaires, and many of them made the move to Nevada. Some purchased ranches outside the cities, others bought land on the Nevada side of Lake Tahoe and some moved to Reno. One of these men was Long Beach, California resident LaVere Redfield. Among the others who relocated were such luminaries as transportation magnate E.L. Cord; Standard Brands' Max C. Fleischmann; Singer Sewing Machine's Arthur J. Bourne; England's fourth Earl of Cowley; singer/actor Bing Crosby; stockbroker Dean Witter; American racecar driver, speedboat racer and aviation pioneer Caleb Bragg; and Luckenbach Steamship Company's Lewis Luckenbach. *Time* magazine wrote that by 1937, Nevada could claim "about 500 prosperous 'immigrants' to its tax-free Utopia," but the more

commonly accepted number of multimillionaires attracted to relocate was closer to fifty or sixty. By any measure, the campaign was a huge success for Nevada and, of course, for Norman Biltz.

In his promotional literature, Biltz had described one of the peculiarities of the Silver State, writing, "And since Nevada has so few people, everyone tends to know everybody, and things are done differently than in the states with big populations." This should have been a warning to LaVere Redfield that Nevada would be a tough climate in which to seek obscurity, which was exactly what he had hoped to achieve.

Being a stock market speculator, as opposed to being simply an investor, takes a different type of individual. The speculator must be fearless, have complete confidence in his ideas and, foremost, be a gambler. LaVere Redfield was all of those things, and it was likely his penchant for high-stakes gambling was another factor in drawing him to Reno. Had he simply wanted to be left alone to live in obscurity, as he often claimed, he could have chosen to relocate to a rural ranch in the middle of Nevada's wide-open spaces like Bing Crosby had done. But despite his secretive nature, Redfield chose to live in Reno, the gambling capital of the United States at the time, and over the next four decades of his life in Nevada, Redfield would become one of the city's largest and most notable gamblers.

"Life is a gamble," Redfield once said, explaining one of the reasons he invested as he did and gambled as he did. "Most people…play always with their cards close to their chests, and they never risk their little stack of security when the game opens. This is the difference between the true gambler and the player who drops out early in life, the player who can't realize that to make money, he must bet money."

Like Redfield, most of the wealthy folks who chose to relocate to the One Sound State were not disappointed, nor were officials of the state that had devised the plan to attract them. By 1936, in the heart of the Great Depression, the State of Nevada had a budget surplus. Former Nevada state archivist Guy Rocha wrote, "By 1939 the state surplus was so large that the property tax rate which had been raised by the 1937 legislature was cut by 20 percent." Citing a 1939 quote from the *San Francisco Chronicle*, Rocha wrote, "It [the Nevada legislature] handed out a dividend to taxpayers by cutting taxes one-fifth. These people just do not belong in the United States." The *Chronicle*'s sour grapes attitude is certainly understandable when one considers that many of the millionaires lured to Nevada had come from the Golden State.

4

Miners, Sheepmen, Cowboys and Bewildered Women

He was Reno's eccentric multi-millionaire, a mystery man who lived as a recluse in his stone castle, a shrewd bargainer, a land owner who jealously guarded his territory…dressed in an inconspicuous and near-shabby fashion in worn trousers…his chief diversion was gambling…The Internal Revenue Service got him on income tax evasion…[and] he also figured in a bizarre robbery…with the defendant a French divorcée who was identified as [his] mistress.

Although the man described above may sound like a character from a B-list movie or a lurid paperback novel, the colorful fellow was actually one of Reno, Nevada's most prominent citizens during the forty years he lived there. Highly respected Reno newspaper reporter, columnist and editor Ty Cobb penned the above description of LaVere Redfield, and his succinct portrait of Redfield is the picture most Nevadans who remember the man or his legend have come to accept as historical truth.

But Redfield was much more than most people imagined. Like many men who are very private and keep to themselves, he was often misunderstood. Yet despite all the confusion and contradictions about this enigmatic man, the truth is more fascinating than the myths and the folklore that still surrounds him now, four decades after his death.

When he arrived in Reno in 1935, LaVere Redfield was thirty-seven years old. It's doubtful that even in his wildest dreams as a boy he could have imagined a life that would have found him a multimillionaire at such a young

LaVere Redfield, always an animal lover, with his terrier Brownie, waters the lawn at his home on Mount Rose Street in 1940. *Courtesy of Jilda Warner Hoffman.*

age. What he did know for sure was that he owed no man for his success; what he had done, he had done entirely on his own.

Physically, Redfield was a small man. He had narrow shoulders and a small, spare frame. One person who spent a lot of time with him said he was only about five feet, four inches tall; others who knew him verified he was short but thought he may have been a couple inches taller. LaVere's grandniece Jilda Warner Hoffman confirms that, saying he was about five feet, six inches. Bill Leonesio, who knew Redfield for years, added, "He only weighed about 120 pounds soaking wet." He was slightly built and always trim. One writer, describing him at fifty-five years old, said he looked twenty years younger than his true age due to his excellent physical condition. Another acquaintance remarked, "He ate very little…He was very fastidious about his diet. He had a waistline that Mike Tyson would envy." A forester Redfield knew through his mountain land acquisitions said, "We'd either go…to his house, or to my house, and have a glass of red wine. As far as I know, that was his only form of dissipation. He abhorred cigaret [*sic*] smoking and the drinking of hard liquor."

Redfield's face was often described as chiseled or sharp featured. Some who knew him described him as dapper. His hair was originally dark brown,

turning to gray-brown by the time most people in Reno came to know him in the 1940s and 1950s. He wore it in a brush cut, with the top straight up rather than combed over. Given his penchant for thrift, he always did his own haircutting.

Redfield was mild mannered and soft-spoken. One Reno newspaper editor who knew him wrote, "[Although] he came from a very poor family...he was very well spoken, his diction perfect and he never used slang." The editor continued:

> *A common public image of Redfield was of a flinty, dour, taciturn man, interested solely in money—and with a razor-sharp, ruthless eye for a good deal. In fact, he was quite the opposite. He seems to have been a kindly, good-natured man with little use for arrogant demeanor and flashy airs.*
>
> ...[To those in the many banks where he did business] *he was universally regarded as being extremely affable and bank employees from tellers to board chairmen liked him. One woman who dealt frequently with him over the years denied that he was surly. "He was anything but that. He was very pleasant. Anyone who waited on him felt the same way...With all his money, he was never arrogant, as many people with money are."*

John Drendel, a Reno attorney who knew Redfield in the 1950s and 1960s, described him as "warm and very courteous...and well-mannered; a very bright guy."

During Redfield's lifetime, people who did not know him personally would hang many labels on him: reclusive, cheap, eccentric, frugal, cantankerous, mysterious, odd, secretive, inscrutable and rude, to mention only a few. Those who knew him, however, said most of those labels were inaccurate.

The rumors that he was reclusive and secretive were untrue, as local lore and legend often tend to be. Redfield was definitely not reclusive. Even after his 1948 mugging, he spent a great deal of time out among people in Reno, but his disheveled appearance, grungy old clothes and battered pickup truck disguised him to the point that most people, even close neighbors, mistook him for a hired hand. His normal wardrobe while out in public was a pair of blue jeans or overalls, a plaid or, on occasion, white dress shirt and boots. In colder weather, he wore a heavy sheepskin coat. In that fashion, he was able to associate with people of his choosing and avoid those who might want to take advantage of his great wealth or view him as a curiosity. This might have made him cautious or peculiar, but it did not make him reclusive. An anonymous Reno friend offered: "I think he basically lived the way he did so

as not to attract those who might want to steal [his money]. I don't think he was really close with anyone."

Richard Dokken, who worked at the reference desk at the downtown Washoe County Library that Redfield frequented, agreed. "I think he was genuinely interested in people—but just shy by nature," Dokken said. "He never impressed me as being anything but friendly—not outgoing, but certainly friendly if anyone talked to him."

Redfield wasn't particularly secretive either. Once he began making news in Reno, newspaper reporters and magazine writers flocked to interview him. Generally, he cooperated in a quiet, courteous manner; however, there were areas that were off-limits. First, no photos; Redfield hated to have his picture taken. Rollan Melton, the editor of the *Reno Evening Gazette* said, "We tried for years to capture good pictures of the Reno multi-millionaire eccentric, LaVere Redfield, but he eluded us at the gaming tables, at his lumberyard [that he operated in west Reno] and during his downtown visits." Finally, Melton said, Redfield phoned him and offered to come to his newspaper office for a visit. "But you must promise not to photograph me if I come in," Redfield insisted. Melton agreed. When Redfield arrived, Melton said, "He gave me the old Greta Garbo spiel, 'I want to be left alone.' We ceased stalking him, except when he was in the news, which was often." At one point in his life, Redfield's adamant refusal to allow his picture to be taken would be carried to the extreme when, following a home burglary at his Reno stone mansion, he ignored a court-ordered subpoena in order to avoid photographers.

Another sore point with Redfield was his wealth. He did not consider it anyone's business how much money he was worth, how he made his money or how he spent it. Some things, he believed, were private. Even his wife, Nell, was not privy to most of the couple's financial matters. Yet the land he would amass in Nevada was public record, and it would be open to scrutiny. To avoid that, Redfield bought property in the name of relatives, while maintaining power of attorney over it. He was always reticent to discuss why he purchased this parcel of land or that lot on the corner or what he paid for any of them.

An unnamed utility company manager who worked with Redfield on many of his land purchases said Redfield was a shrewd businessman. "He was a nice guy to talk to," the utility man explained, "but when you talked money, he put on a new hat." When Nevada writer Robert Laxalt was asked by the Sunday newspaper supplement *American Weekly* to write a story about Redfield, LaVere agreed to talk with him. When the article was finished, Laxalt sent it to the magazine's story editor in New York, accompanied by

a letter. In the letter, Laxalt wrote, "He did me a terrific favor and slipped me into the house after FBI agents had left. The result—I got a terrific philosophy drawing the difference between a man and a millionaire." Although he seldom spoke of his wealth, Redfield trusted Robert Laxalt enough to allow the writer to shallowly probe into the topic for his article, graciously providing a few answers that shed a little light into Redfield's psyche as far as his money was concerned. About his realization in the mid-1930s that he had become a wealthy man, he said, "At first, it frightened me. I had a premonition of things to come, of a change in my way of life, a change made necessary by sudden and tremendous wealth." Redfield continued with uncharacteristic frankness: "But then, I realized…that I had been foolishly frightened by [it]…[I understood] the fact [that] money didn't have to change my life. I was in command of the money…It was so simple that I laughed."

So although LaVere Redfield might have been a private man, he was not reclusive, secretive or particularly mysterious. But it is easy to understand how those widely held rumors might have started and why they spread over the years and became part of the folklore surrounding the man. It had all begun at that 1948 robbery and mugging he had suffered and had been exacerbated by frequent home burglaries that he and Nell underwent. These incidents had a profound affect on the Redfields, as they would have had on any couple. Both LaVere and Nell began to withdraw. The frequent dinner parties, teas and women's gatherings became things of the past, except with his large extended family. They began to keep to themselves, and although LaVere was still out and about quite often, he continued to cling to the tattered dress of a workman so he would not be easily recognized. So if the couple lapsed into privacy, it was from caution and fear, not from any aversion they may have had to being around other people or from any anti-social tendencies.

The one condition ascribed to Redfield that nobody could argue with was his frugality. He took that just about as far as a person could take it. "I'm thrifty," Redfield once said, "but not stingy." And his thrift was—and still is—legendary in Reno. "If I can save a nickel on an item," he said, "I buy it by the case, saving one or two dollars. If I hadn't done that all my life, I'd be just like so many people today—one step ahead of the bill collector." His friend and admirer, brothel owner Joe Conforte, echoed Redfield's words: "He was a multi-millionaire. He just had a fixation that if he could walk from Mt. Rose Street, where he lived, to Wells Avenue and buy a dozen oranges and save ten cents, he'd do it. That's the kind of guy he was."

One of the most often repeated stories about Redfield's thrift involved the old red 1947 Dodge pickup truck he drove around town. His house sat high atop a hill in southwest Reno. A long unpaved driveway led down the hill from the parking pad beside the house to the street below. There were two garages at street level, burrowed into the side of the hill, but Redfield eschewed parking there. He would park his truck at the top of the driveway, pointed downhill. Whenever he took the truck out, he would release the hand brake, allowing the truck to gather speed down the driveway. At the last second he would "pop the clutch," starting the engine. His reasoning—or so the legend goes—was that this method saved gas and preserved the battery for longer use. But despite Redfield's admission that this odd practice saved money, his grandniece Jilda Warner Hoffman said he did it primarily because the old truck was difficult to start in the normal fashion. But, she said, her great-uncle loved the story about his parsimony, so he embraced the rumor about saving money with the jump-start. It has become an accepted part of the lore surrounding the man.

Redfield also owned cars, mostly expensive models like Cadillacs, Lincolns and Packards, but he rarely drove any of them. His wife, Nell, would drive one on the rare occasions when she left home, but mostly they sat unused in the two garages at the bottom of the hill. Off and on during his lifetime Redfield would also collect antique or classic automobiles, but he rarely drove them, either. When venturing downtown to do some banking or gambling, or to attend a free movie, Redfield would normally walk or take a bus. When he did drive, he would park the truck on a residential street just outside the downtown area and walk the rest of the way to avoid the parking meters. Cadging a ride on somebody else's gasoline was his primary mode of transportation, followed by walking or riding the bus. Driving his truck was always a last resort.

Bill Leonesio was a high school senior when he first met Redfield. Leonesio normally picked up his dad next to the Riverside Hotel at 5:15 p.m. after work. One afternoon when he stopped for his father, they spotted Redfield standing nearby at the Judd's Jitney Service stop. Judd's aged Volkswagen buses ferried people around town. Leonesio's father, who was a friend of Redfield's, offered to give him a ride home, and he accepted. Young Leonesio drove what appeared to be the most direct route: down Virginia Street, right at Mount Rose Street and a few blocks to Redfield's stone mansion. "When he was getting out of the car," Leonesio remembered, "he said to me, 'You know, you're not going to make it in the business world.'" Puzzled, Leonesio asked why. "You don't pay attention to

things," Redfield scolded. "If you had come down Virginia Street, turned on California Avenue, then kept going down Forest Street, it's two-tenths of a mile shorter to my house." A teaspoon of gasoline saved was a penny earned in the mind of the frugal millionaire

One of Redfield's Reno stockbrokers, Howdie Umber, related a story about how far the man would go for a bargain. Once, Redfield invited Umber into his basement and showed him all the foodstuffs stored there. There was a little of everything, Umber recalled, but he was especially amazed at the fantastic array of cheeses Redfield had. The Safeway store at the corner of Virginia and Mount Rose Street, just a few short blocks from Redfield's stone mansion, had run an ad in the newspaper on their cheese selection. However, the numbers in the price had been transposed, and instead of seventy-three cents a pound, the cheese was being advertised at thirty-seven cents a pound. The next morning when the store opened, Redfield was the first person inside. "Where's the cheese?" he inquired. "I want to buy all of it." Although the cashier argued, the store eventually honored the price, and laden with Gouda, Danish blue, Parmesan, Gruyère and cheddar, Redfield returned home a happy man.

Many of the stories about Redfield's frugality involved food purchases. He did most of the shopping for the household and actually enjoyed beating down grocery clerks on a price or finding great bargains in the aisles of the neighborhood grocery stores. Before the days of chain supermarkets, locally owned Sewells Market was a favorite food shopping spot for many Renoites. As a young man, Reno businessman John Metzker knew Redfield well enough to chide him gently about his idiosyncrasies. Herb Sewell, co-owner of the food stores and a friend of Metzker, had told him how Redfield would come in and buy their entire stock of canned goods from which the labels had accidentally been torn off. Redfield would pay ten cents a can for the damaged goods. One day, Metzker asked Redfield about the practice, curious why someone would want unidentified canned food. "Oh, yes…a wonderful bargain," Metzker said Redfield told him, quite proud of his little scheme. "But that's not all. When you're fixing dinner you don't know what it's going to be. It could be peas or it could be pears." LaVere's grandniece Jilda Warner Hoffman took many meals at the house with the Redfields as a young girl and teenager. She verified the story and added, "We had to choose three cans, then eat whatever was in them. This was always great fun for LaVere."

Persistent folklore also held that Redfield insisted on the adherence of strict thrift within his home. It was said that LaVere's wife, Nell, did all their

This is the most widely recognized photo of sixty-four-year-old, camera-shy, multimillionaire LaVere Redfield, taken in 1961 as he awaited a transfer to Terminal Island Federal Penitentiary for income tax evasion. *Nevada Historical Society.*

laundry by hand, as he would not buy a washer or dryer. Another story held that he insisted that the house be lit by candlelight to save electricity. Redfield's friend Bill Leonesio said both of those stories were absurd. Leonesio had even advised Nell Redfield once when she purchased a new washer for the home. Hoffman explained that there were a lot of beeswax candles scattered throughout the house, but that was because they were supplied free of charge to all Redfield family members by the family-owned Superior Honey Company. Many people, however, still insist the stories were true.

Whether each individual story—and there are many—of Redfield's tight-fisted control over the household budget is authentic, there can be no doubt that LaVere kept Nell on a strict budget. That was the man's nature, and he seldom strayed from it. Many of the stories bandied about regarding Redfield's miserliness are not that extraordinary when carefully considered. Thrifty? You bet he was. Frugal? To the core of his being. But if one accepts the dictionary definition of a miser—which Redfield was often called—as a person who lives in wretched circumstances in order to save and hoard money and is a stingy, avaricious person, LaVere Redfield simply did not measure up. Despite how closely he watched his pennies, Redfield was not avaricious or stingy. Although he was not known to donate formally to charity, he was generous to family and friends and to those who assisted him. Reno resident Vic Anderson, who knew Redfield only slightly, told of going to Redfield's Riverside Lumber Company in the

1950s to buy some redwood lumber. Redfield greeted Anderson like he had known him for years and told him, "Everything is on the house," Anderson related. "So it just depended on whether he liked you or not."

Redfield's friend Bill Leonesio echoed those words, saying, "If he liked you, he'd give you the shirt off his back." He said Redfield also did a lot of good deeds for friends and even for complete strangers, but always anonymously. It was a side of the shy millionaire that few outside his family, close friends or business acquaintances were aware of. Another story of his generosity involved small gifts he would give to bank employees who assisted him. "On one occasion," one writer recalled, "he learned that a local drugstore was selling out their candy at huge reductions." Redfield loaded a taxi with boxes of candy and took them all around town to bank employees who had befriended him.

Redfield owned an entire city block of land in Reno between Wells and Wheeler Avenues and Crampton and Burns Streets, just a few blocks north of Vassar. Because of its size and location, the parcel was desired by a number of people, but Redfield refused to sell. Yet he secretly gave his permission to have it turned into a skating pond for children during the winter and into a baseball field in the summer. In a similar incident in the late 1940s, he allowed local Boy Scouts to build a camp on some of his forestry land.

Warren Lerude is a professor emeritus at the Reynolds School of Journalism at the University of Nevada, Reno, but for many years, he worked in the editorial departments of Reno's newspapers, eventually serving as publisher of the two newspapers after they merged. As a young city editor at the *Reno Evening Gazette*, he had an interesting encounter with LaVere Redfield. The paper was on deadline, and everybody in the newsroom was frantically busy when a small, slim man in workman's clothes walked in and took a seat at the desk of the absent society editor. Lerude walked over to the stranger and asked if he could help him, and the man introduced himself as LaVere Redfield. Lerude certainly recognized the name, but he had never met Redfield before. He invited him into his office. Redfield, not one for small talk with strangers, got right to the point. He said he had read a story in the *Evening Gazette* that one of Nevada's small ex-mining towns was going broke. The town was either Austin or Eureka; Lerude couldn't recall which one when recounting the story nearly fifty years later. Redfield told him he wanted to donate a few thousand dollars to the small town's treasury. However, in typical Redfield fashion, he did not want any publicity about it, so he asked if the *Evening Gazette* would make the donation in its name. Lerude said the newspaper's attorney checked into it, but it was impossible

for the newspaper to participate, which he related to Redfield. Disappointed, Redfield apparently gave up on the idea but asked Lerude to please not write about it. This was the kind of charity LaVere Redfield believed in.

Finally, in the early 1970s, he donated $25,000 worth of lumber to the Washoe County School Board and the University of Nevada for some school remodeling that was being undertaken. There were a number of other occasions of Redfield helping out those in need over the years and, undoubtedly, many more that were not publicized. He preferred to do his giving quietly and without fanfare. It's true that Redfield's charity may have been small considering his net worth, but claims that he was selfish, miserly and self-absorbed simply were not true.

The Reno of 1935, where LaVere and Nell Redfield made their home, had changed somewhat from the Reno of four years earlier when the state had legalized casino gambling and liberalized the divorce laws. And it had changed even more dramatically from the small city of 1910 when casinos operated as speakeasies because legalized gambling had been outlawed the prior year.

Despite all the changes, the small city on the Truckee River still clung tenaciously to its western roots, and it would have seemed very small and insular to the Redfields after the sophistication and hustle and bustle of Los Angeles. Famed Reno author Walter Van Tilburg Clark summed it up neatly when he said that in Nevada terms, Reno was a "big city," but in relation to the nation's urban centers, it was still "a small town."

A historian describing Reno in the late 1930s wrote:

> *From a distance we can picture this Reno as a Babylon of miners, dudes, sheepmen, prospectors, lawyers, cowboys, bewildered women, bartenders, roulette wheels, dressed-for-Sunday Indians...the University, the ministers, the priests, the hot springs baths* [and] *the regulated Stockade with its regulated whores—put them all together and run the bubbling Truckee River down the midst of them and...we have this Reno.*

According to Reno casino historian Dwayne Kling in his book *The Rise of the Biggest Little City: An Encyclopedic History of Reno Gaming, 1931–1981*, there were twenty-eight operating casino licenses in Reno when the Redfields arrived. These ran the gamut from small one-game operations to bars and taverns with a couple of slots to glitzy nightclubs. A new generation of casino operators had also come on the scene, men who put honesty ahead of earnings, at least for the most part. The earliest of these men who would play

an important role in LaVere Redfield's life were Harold Jr. and Raymond Smith and their father, Harold "Pappy" Smith, who opened Harolds Club downtown at 236 North Virginia Street in February 1935. Prior to Harolds Club, Center Street (east of Virginia Street) and Commercial Row, which connected the two, was the hotbed for most of the downtown clubs and casinos. The Smiths started a new trend when they opened on Virginia Street. Harolds Club would become a favorite hangout for Redfield, who would take his knack for picking winners from the stock exchange floor to the gaming floor.

But Reno, Nevada, and the surrounding area, from the mid-1930s to the prewar 1940s, was more than just casinos, nightclubs, dude ranches and wedding parlors. It was also home to twenty-one thousand men, women and children. One of President Franklin Roosevelt's WPA programs was the Federal Writers' Project. It was designed to put unemployed writers back into the workplace during the Depression. One of its most enduring projects was the "American Guide Series," a library of forty-eight guidebooks, one for each state in the Union. These books provide a broad and colorful look at each of the states and its leading cities in the time period the Redfields were making their new home in Reno. Of the city and its many divergent faces, the authors wrote:

> Seen from the air at night the town looks like a Christmas tree with its strings of white lights interspersed with twinkling red, blue and green. [There is] a view of the charming tree-shaded Truckee [River], the large houses on landscaped grounds above the river, the comfortable Victorian cottages north of the routes, and the gracious university campus on the heights. Even the main street, Virginia…its sprawling iron arch proclaiming Reno as the "Biggest Little City in the World"…becomes a thoroughfare of well-appointed shops offering goods of distinction and quality…Elsewhere practically every street is lined with cottonwoods, poplars, and other trees that resist traffic fumes.

The Redfields enjoyed their new community. For the first year or so, LaVere was able to maintain his privacy, to his delight. But he was not a man who could escape the spotlight for long. His activities, always on a grand scale, whether by design or by happenstance, would eventually bring attention to the couple. It all started with a seemingly innocuous event: they purchased a home.

5
The Sierra Vista Castle

The Reno home LaVere and Nell Redfield purchased in 1936 had an interesting history, as did the neighborhood where it was located. From its birth in 1868, Reno had remained girdled within a narrow belt on both sides of the Truckee River, with cattle and sheep ranches and small farms dominating the countryside. But by the early days of the twentieth century, the city's increasing population began to force residential development outward from the river corridor, primarily in the area known as the South Side, much of it called the Old Southwest today. An ad for the firm Reno Development Company in the April 14, 1907 edition of the *Nevada State Journal* discussed big plans that were underway for the South Side:

> ### TAKE A LOOK FOR YOURSELF
> *More improvements are being made in Reno today than in any other time in the city's history. The building of homes and improving of residential sub-divisions are confined almost entirely in the beautiful south side district. Chief among the new tracts is the Sierra Vista…Take a look for yourself at the grading work on the new boulevard, Plumas Street, where the Moana Springs street car line will be in operation within sixty days.*

The Reno Development Company was owned by some of the state's wealthiest and most influential citizens, including U.S. senators Francis G. Newlands and George S. Nixon and cattle baron T.B. Rickey. The firm had purchased three large ranches just south of the city boundary with

the intention of "induc[ing] people to buy suburban homes and to greatly increase the population of this city and vicinity." The purchase of the Gibson, De Reamer and seventy-acre Litch Ranches for over $200,000 indicated the company's faith in the future of its growing little city. The Sierra Vista Tract, which would occupy a big chunk of the Litch Ranch property, was to be the company's crown jewel. The tract was bordered by South Virginia Road on the east, Plumas Street on the west, Monte Rosa (now Mount Rose) Street on the south and near today's Mary Street on the north. It would soon be joined by other new residential developments and by many small businesses that sprang up to serve the needs of all the new South Side residents.

Sales in Sierra Vista were brisk for a number of years. Large residential lots were offered for sale at $250, corner lots for $350 and a five-acre parcel for up to $1,000. Modern bungalow and cottage homes began to dot the landscape. The South Side area was maturing. Reno author Walter Van Tilburg Clark described the area as it was in the 1920s and 1930s in his 1945 novel, *The City of Trembling Leaves*:

> *The Mt. Rose Quarter…Here there are many new trees, no taller than a man, always trembling so they nearly dance, and most of the grown trees are marching files of poplars, in love with wind and heaven. Here, no matter how many houses rear up…you remain more aware of the sweeping domes of earth which hold them down, and no matter how long you stay in one of the houses, you will still be more aware of Mt. Rose aloft upon the west, than of anything in the house.*
>
> *…It may be significant, for instance, that part way out Plumas Street, which is the main thoroughfare of the Mt. Rose quarter, there is still a farm, with a brook in its gully, cows on its steep slopes, and a sign on a tree saying EGGS FOR SALE.*

It may have been that bucolic rural environment with its panoramic view of the Sierra Nevada's Mount Rose that first attracted a family from Brooklyn to the Sierra Vista tract. Early in the 1920s William Hill, like thousands of men before him, arrived in Reno to establish his residency to obtain a Nevada divorce. He instantly took a liking to the small town on the banks of the sparkling Truckee River. Believing his parents would also like Reno, William cabled them back in New York and invited them to come West for a visit. Soon his father, August, a self-made millionaire, arrived in Reno, and he, too, was taken by the charms of the "city of trembling leaves." He decided to stay. His wife, Elizah, less enamored of

the West, retained her permanent residency in New York, but she would visit Reno a few times a year.

By the mid-1920s, August and William had established Hill & Sons as a residential real estate development and construction company, and they began buying parcels of land in the Sierra Vista Tract. In 1926 and '27 alone, they purchased forty-three lots in the names of Elizah or William Hill. Most of them, according to the official deeds, appear to have been resales or foreclosures. By 1930, according to a Hill & Sons' newspaper advertisement, the firm had amassed one hundred lots in the tract. The cheapest lot had now risen in price to $395, and Hill & Sons were busily building houses on many of the more desirable lots.

August had been attracted to one particular plot of ground in Sierra Vista. It occupied the largest knoll in the tract, one of those "sweeping domes of earth" Walter Van Tilburg Clark had described. It was sixteen contiguous lots, encompassing two full blocks, located on the south side of Mount Rose Street between Plumas Street and Manhattan (now Watt Street) Avenue. There was a high hill sitting right in the middle of the parcel, sloping down to Plumas on the west, Watt on the east and Mount Rose on the north. It was perfect for the large home August Hill had in mind for himself and William, who had by now remarried. From the top of the hill, where they would build the house, there was an unobstructed view north to downtown, south to Mount Rose rising majestically in the distance and west to cattle grazing lazily in green pastures.

The floor plan of the home would duplicate a large brownstone the family had once owned in Brooklyn, according to August Hill's great-grandson Richard Hill, a Reno attorney. It would be two identical levels, each one 1,814 square feet. Each of the two duplex suites would have four bedrooms and two baths with walk-in showers, as well as identical living rooms, dining rooms, tiled kitchens and fireplaces. August would reside in one level, and William and his wife in the other. There would also be a 1,424-square-foot unfinished basement under the house and two narrow but deep garages burrowed into the side of the hill at street level on Mount Rose Street. A large riser of stone stairs, crowned by a stonework arch at street level, led from the garages up to the house on top of the hill.

It was not the floor plan, however, that would make the home one of the most unique buildings in the state and as fresh and distinctive today as it was more than three-quarters of a century ago when it was completed. It was the building material. The house would be built entirely of native Truckee Meadows river stone.

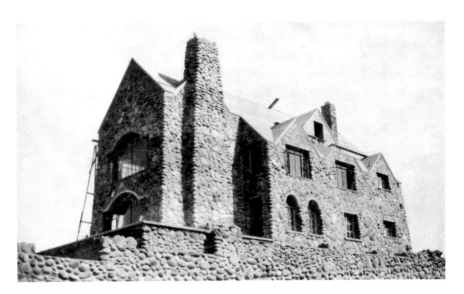

August Hill and his son William Hill began construction on their distinctive river rock home on Mount Rose Street in 1930. Here, in early 1932, it nears completion. *Courtesy of the family of August Hill, original builder.*

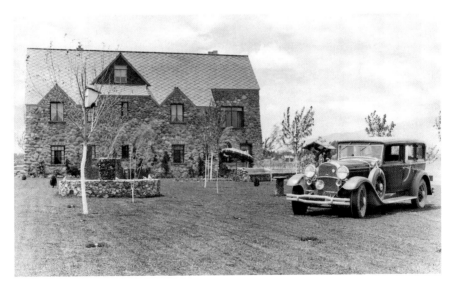

This house has become known locally as the Hill/Redfield mansion. Here, likely in 1932 just before the house was sold to Otto Steinheimer, we see William Hill's 1929 Lincoln. *Courtesy of the family of August Hill, original builder.*

Many of Reno's stone houses began as part of the numerous nineteenth-century ranches that once occupied the area. After the turn of the century, river rock and fieldstone continued to be used because they were so readily available and cheap. However, few stone houses were built after the 1930s. As a construction medium, river rock has both advantages and disadvantages. On the plus side, it was widely available and inexpensive to acquire. It is also an excellent insulation medium and reduces heating and cooling costs. On the other hand, large boulders, rounded over eons by the effect of water tumbling over them, are heavy and difficult to work with. They require a great deal of expert masonry work, and a large quantity of mortar to seal them tightly and hold them in place.

Construction of the Hills' new home began in 1930, and it was completed by mid-1931. However, shortly thereafter, a newspaper classified ad placed by William Hill indicated that the family's plans had changed. The ad stated, "The Sierra Vista Castle…The finest rock estate in Nevada" was for sale or lease. Subsequent ads over the next four months indicated the house was completely furnished and was also being offered for rent. A *Reno Evening Gazette* news story the next month reported that the Hill family was selling all their property and closing their business, likely due to the growing Depression. August Hill headed back to New York, although he would eventually return to Reno. William Hill and his wife moved into the Sierra Vista Castle while he continued to advertise it for sale, lease or rent. He also continued selling off Hill & Sons' remaining inventory of lots and houses.

In 1931 one of Hill's newspaper ads caught the attention of an old Reno family, Mr. and Mrs. Otto Steinheimer, who became the next owners of the home. The family owned and operated Steinheimer Brothers Studebaker, located at 47 West Fourth Street, just west of downtown. But after only three years, the Steinheimers sold the house and moved back to their old neighborhood.

The new owners of the Sierra Vista Castle were Reno newcomers LaVere and Nell Redfield. The couple had no children, and indeed, they never would. The stone house at 370 Mount Rose Street had appealed to LaVere the first time he saw it. "LaVere loved the home and he kept talking about it," Nell said in a newspaper interview years later after LaVere's death. "One day he walked in and I could tell by the look on his face that he had bought it. I thought it was too big, and it would be too much work, but LaVere didn't think so. He admired it."

LaVere purchased the house and eleven contiguous lots along Mount Rose Street in November 1936 from the Steinheimers, for which he paid

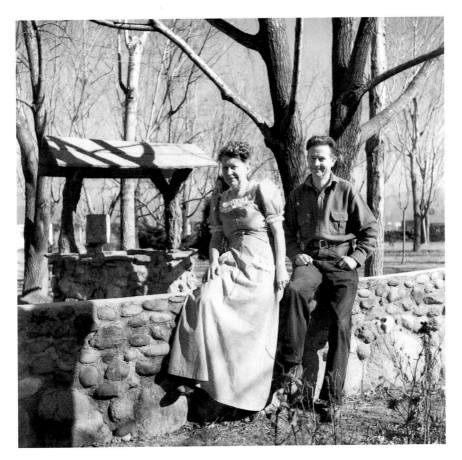

Nell and LaVere Redfield sit by the wishing well at their home at 370 Mount Rose Street in the early 1940s. They purchased the home and seventeen contiguous lots in 1936. *Courtesy of Jilda Warner Hoffman.*

\ or 19?

Author can't math.

$20,000, according to his wife. Six months later, he purchased an adjoining seven lots on the street from August and Elizah Hill, ending up with seventeen contiguous lots that totaled more than a third of a mile of frontage along Mount Rose Street, running from Plumas Street east all the way past today's Watt Street.

The house has since become known as the Hill/Redfield mansion. A description of the house is provided in its nomination papers for a spot on the National Register of Historic Places, although it has never gained that distinction:

The grand river rock residence is the largest and most prominent of several dozen river rock houses in Reno. This indigenous river rock type culminates in the five level, Period Revival…residence, with its design elements derived from the English Cottage style…[including] a prominent, steeply pitched roof; a sharply pointed gable facing front; scant roof overhang; and the use of a "natural" construction material which integrates the house with the surrounding terrain.

Money was of no concern to the Redfields when it came to furnishing the large house. LaVere likely realized that buying quality furniture was best (and cheapest) in the long run, but he would still have sought out the very lowest prices he could find for top-quality goods. They bought much of it in California and had it shipped to Reno, but LaVere continued to seek out fine furniture pieces and art locally, usually at estate auctions. He purchased a large carved wooden chest for his office but discovered after it was delivered that it wouldn't fit. Nell said the beautiful chest was an example of "LaVere's good taste." As to the quality of their furniture selections, and Nell's immaculate housekeeping, Pamela Galloway of the *Reno Evening Gazette*, who wrote a 1975 article about Nell Redfield and the house, said, "Dining room, bedroom, and living room sets purchased in the 1930s by the Redfields [still] appear in perfect condition and fill the rooms."

A persistent Redfield myth in the Reno community has to do with a small stone house at 375 Mount Rose Street, directly across the street from the Hill/Redfield mansion. The house is identical in its use of large, round river boulders as the primary construction medium, and it appears to have been built in the same 1930/1931 time frame as its much larger neighbor, which probably led to the local rumors. The folklore holds that the small house was owned by Redfield and was used to lodge a caretaker for his property. There is also purported to be an underground tunnel leading from the mansion across the street to the small house, where Redfield was believed to have stashed his valuables or kept a mistress.

However, neither story is true. There were never any deeds in the names of the Hills, the Steinheimers or the Redfields recorded on the small property. Additionally, local real estate experts say there is absolutely no truth to the secret tunnel story. The thrifty Redfield would never have hired a caretaker for his property, as he did most of his own gardening and landscape work. In fact, he was often in trouble with city officials for failing to clean up and maintain the empty lots on both sides of the mansion and its grounds. So there was no caretaker, and there is no tunnel, despite the folklore.

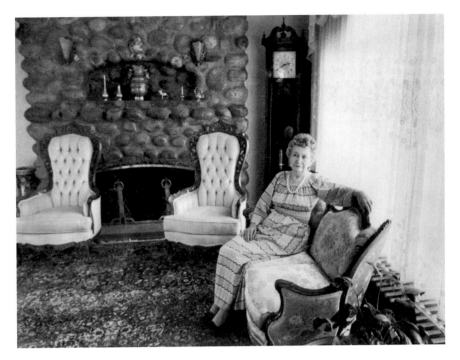

Nell Redfield relaxes in the living room of her home during a 1975 newspaper interview, following the death of her husband, LaVere. This was the first and only time the press had been granted entry to the distinctive stone house. *From the* Reno Gazette-Journal.

The Redfields spent the remaining years of the Great Depression, and through the war years of the early 1940s, enjoying their lives in Sierra Vista and taking in the sights and activities that Reno had to offer during that era. The couple—social and outgoing until LaVere's 1948 mugging and robbery—entertained frequently in the large stone house. Nell also became active in the local society scene, joining the prestigious 20th Century Club. She also opened their doors to her fellow charity workers. "I used to make dolls and cook quite a bit. I was active in the Red Cross during the war," she said. "I must have made hundreds of them [the dolls], monkeys, clowns. There was a lot of rheumatic fever going around, and I would take the dolls into the homes." One of the recipients of Nell's charitable work was seven-year-old Sheri Durkee, a nearby neighbor. The Durkees, who live on Pueblo Street, owned and operated one of only two travel agencies in town, the Durkee Travel Bureau. In 1948, Reno was struck by an epidemic of polio—called infantile paralysis at the time—and both Sheri and her brother Vern contracted the disease. Vern recovered

quickly, but Sheri was in bed for two years. In a personal interview, she recalled fondly that Nell Redfield brought her one of the rag dolls to cheer her up. LaVere, she remembered, collected old rags, shirts and worn out dresses, which Nell used to craft the dolls. The Redfields often stopped in to see how the children were doing, Vern Durkee said. "LaVere and Nell were very compassionate people. They had good hearts."

These were also good years for LaVere's business interests. He continued to actively buy and sell stocks; and he also became very active in the local and regional real estate markets. The Depression and the years following World War II provided plenty of opportunities for those shrewd enough to take advantage of the changing times, and that certainly included LaVere Redfield. Branching out from his initial purchases of land within his own Sierra Vista neighborhood, Redfield would go on to become the largest individual landowner in northern Nevada.

6
Becoming a Land Baron

The Carson Range splits from the main Sierra Nevada mountain range at Carson Pass about eighteen miles south of Lake Tahoe. It then arches northward around the east side of the lake, ending just above the small community of Verdi, Nevada, at the Nevada/California border, a total distance of about fifty-seven miles. Building the Central Pacific Railroad from California to Nevada over these nearly impenetrable mountains was one of the nineteenth century's greatest engineering achievements. When Congress passed the first transcontinental railroad act in 1862 and revised it two years later, it provided the Central Pacific Railroad with huge land grants that would compensate the company for its work. In Nevada, the Central Pacific's land allotment was about five million acres, much of it in rugged, desolate mountain terrain. In the following years, much of this land passed through the hands of Nevada political kingpin George Wingfield and his twelve banks. When the Depression forced Wingfield's banks into receivership, a great deal of this mountain land would be liquidated at tax auctions.

LaVere Redfield made his first nonresidential Nevada land purchase on June 4, 1936, at one of those auctions held to liquidate the remaining assets of Wingfield's United Nevada Bank. Redfield purchased six hundred acres, all within the Tahoe National Forest. On September 28, 1937, he attended an auction for another of Wingfield's banks. This time he purchased twenty-five thousand acres in the Tahoe Forest, stretching from Slide Mountain—just south of its larger and better-known neighbor, Mount Rose—up the eastern slopes of the mountains above Lake Tahoe.

Much of the land had initially come from the Central Pacific Railroad's U.S. government land grant. Redfield was said to have paid as little as one dollar an acre for the land.

Over subsequent years, Redfield would buy more land in the Carson Range, stretching all the way from Slide Mountain to the California border. Most purchases were made at public auctions of foreclosed property or government tax-delinquency sales; occasionally, however, he bought directly from the Southern Pacific Land Company, which then held the old Central Pacific lands. Eventually, Redfield amassed over fifty thousand acres in the mountains and foothills west of Reno.

From his earliest days in Nevada, LaVere Redfield loved to take long walks through the pristine meadows, foothills and mountains on Reno's western flank. He had an affinity for nature, and he was never more comfortable than when watching a mule deer feeding in the distance or hopping over a small meadow stream to visit a newly discovered stand of trees. A Redfield friend, recalling LaVere's mountainside walks, said, "He arose early and retired early, and followed the temperature very closely every morning. He was a great lover of nature."

In the late 1930s and early 1940s, when Redfield began buying his land in the Carson Range's Tahoe National Forest (today part of the Humboldt-Toiyabe National Forest), he would spend hours wandering over his property. Ivan Sack, the Toiyabe Forest supervisor in the 1950s and 1960s, knew Redfield well. In his book *Forester Lost in the Woods*, Sack wrote, "He was very fond of wildlife…especially deer. Mr. Redfield's sentiment towards wildlife is…somewhat typical of other very wealthy people. They seem to have an affection for animals, not only wildlife, but domestic stock." Nell Redfield echoed that sentiment, telling writer Robert Laxalt that her husband had a deep attachment to animals and birds. Once, she related, a baby robin fell from its nest in their backyard. LaVere carried the chick into the kitchen and stayed up all night feeding it with an eyedropper. The next day, he climbed the tree and returned the chick to its nest.

After Redfield purchased his initial Tahoe National Forest land in late 1937, he had granted the Forest Service a fire road easement. Years later, when hunters began using the road, Redfield complained to Ivan Sack about the practice and asked that the road be closed. "One reason that he insisted on closure was to protect the animals, especially deer," Sack wrote. "He wanted me to cooperate with him in creating a wildlife refuge for all of his land east of Lake Tahoe and including intermingled National Forest lands. Looking back, I believe if that had been acceptable to the

Washington office…he might have left that land in his will to the Forest Service," he lamented.

Redfield discovered a few of the Basque sheep camps buried deep in the forest meadows, and he enjoyed hanging around with the uncomplicated men who spent their lives in the wilderness tending their flocks. He was interested enough in these activities that in July 1938 he attended a banquet and program at Reno's Toscano Hotel on wool growing, put on by western Nevada and California sheepmen.

Robert Laxalt summed up this very private man during his happiest times. "For years, he has wandered through the hills and ranches of western Nevada, leaning idly against corral posts, talking to cowhands, or stopping for occasional meals in the remote camp of a sheepherder. To all of them, he was known only as 'Redfield—lives somewhere down around Reno.'"

Redfield was extremely protective of his land. Because he owned so much of it throughout Washoe and Douglas Counties, utility companies were often seeking rights to construct power poles across his property in unimproved areas. One unnamed Redfield acquaintance who worked for the power company said Redfield was afraid of fire in the forest and was also reticent to destroy the untouched feeling of his land. "He felt that anything which was built in a forested area should be built not to detract from the surrounding scenery. He insisted it be as fireproof as possible," the utility man explained in a newspaper story.

A Reno man, Vic Anderson, was also aware of Redfield's fear of fire on his mountain property. In a personal interview, Anderson recalled that in the mid-1960s, he encountered Redfield while driving across the bridge at Thomas Creek near Mount Rose, where Redfield owned a lot of property. "I saw an old fellow with a plaid shirt and jeans. He asked me if I had a match." He said Redfield sat at the bridge all day asking deer hunters who came by if they had a match. "He wanted to know who was on his land and who smoked in case there was a fire." Anderson added that Redfield copied down the license number of every car that entered his property. Another acquaintance noted that Redfield often ordered trespassers off his land. Redfield told the man that it wasn't out of any dislike he had for people but because of the damage they might do to nature. "He told me one time he wanted to see the land stay in its natural state," the man said.

Redfield was not shy or easily frightened about protecting his property, even against armed intruders. He would stand at the window in an upstairs room at his mansion and, from his elevated position and with a good pair of binoculars, keep watch over his land that ran up the side of Mount Rose, a

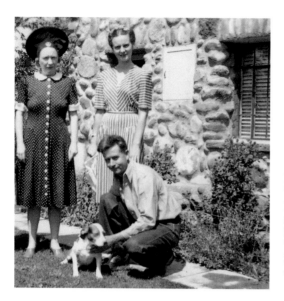

Nell Redfield (left) and Hazel Warner, along with LaVere Redfield and his dog Brownie, at the Redfields' Mount Rose Street home in the early 1940s. The puppy was named after Mrs. Warner, whose nickname was "Brownie." *Courtesy of Jilda Warner Hoffman.*

favorite spot for deer hunters to frequent. When Redfield spied a trespasser, he would jump in his truck, drive the short distance to the property and confront the man. There is no record of any hunters ever taking a shot at him.

Other than hunters, Redfield was generous in allowing people to use his property. Chuck Clifford worked as a cowboy in northern Nevada from the mid-1940s until the early 1950s. In a personal interview, he said every spring he and other ranch hands would drive their herds of cattle down two-lane Virginia Road from Sparks, heading for Washoe Valley, and return them to Sparks in the fall. It was a much shorter cattle drive if they could cut across some of Redfield's foothills property. There was a locked gate where a road dead-ended onto the millionaire's property, and Clifford said Redfield showed the cowboys where the key was hidden, allowing them to take the shortcut to Washoe Valley and back.

Redfield's land-buying methods and habits, during the years he was active in the market, were odd and quirky. For openers, there were often instances when he didn't even record a deed on the property he bought. In the 1950s, for example, Redfield purchased the original University of Nevada farm, a 208-acre parcel on South Virginia Road. As usual, he paid cash for the property, $700,000, but the county assessor said Redfield never recorded the deed. In another instance, he tried to purchase a piece of delinquent tax property only to discover he already owned it but that it was about to be placed at auction for back taxes. Redfield had never recorded a deed on

Hazel Warner, LaVere Redfield's favorite niece, was the mysterious H.B.R. Bushard under whose name Redfield purchased most of his vast land holdings. *Courtesy of Jilda Warner Hoffman.*

the purchase, so the county had not known where to send the tax bill. But Redfield had a mind for details, and he rarely made such mistakes.

Redfield also liked to buy irregular-sized parcels, often with no access. These could be parcels that were twenty feet wide by several hundred feet long, or small pie-shaped parcels completely hemmed in by other private or publicly owned property. But the man knew exactly what he was doing. When the state or the county wanted to widen a road that was contiguous to these odd parcels, when a private individual wanted to add one of them to his property in order to ensure privacy or when a utility company had to pass over or through the land for a right of way, they had to deal with Redfield. He was often able to extract a princely sum for a piece of land in which nobody else had seen any value.

Probably the oddest of Redfield's land buying practices was that up until the mid-1950s, all the property he purchased was deeded in someone else's name, a very risky practice. The name the offbeat millionaire deeded the property in was H.B.R. Bushard, a name that meant nothing to anyone in the assessor's office or the office of the county recorder.

Redfield controlled all the property through a power of attorney granted to him by H.B.R. Bushard.

There was a reason behind Redfield's land buying practice. H.B.R. Bushard was Redfield's favorite niece, and he had a clever arrangement with her. He would pay any realized capital gains taxes for her rather than adding it to his own personal income tax liability, which was at a higher tax rate. Thus, the practice was primarily a tax dodge. He also wanted Mrs. Buchard to inherit the land in case anything should happen to him, but by the time he passed away, he had changed his mind on that part of the plan.

This subterfuge went unnoticed—or at least unquestioned—for almost a dozen years. It was finally publicly exposed in 1947 as a result of his frequent protestations over property taxes for his (or, technically, Mrs. Bushard's) land. Prior to that protest being reported in the newspaper, no northern Nevadans had made the connection between H.B.R. Bushard and LaVere Redfield. If anyone even knew the name Redfield, they only knew him as the friendly but shy fellow who lived in the foreboding stone castle and walked all over town in workman's clothes. But in announcing the aforementioned tax assessment decision, the morning *Nevada State Journal* wrote in amazement, "H.B.R. Bushard, who owns much of the land west of Reno and is suing Washoe County for taxes, is a woman, it was revealed yesterday." The newspaper continued: "L.V. Redfield…is the man who is really doing the suing and has bought up all the Bushard lands…Her [Mrs. Bushard's] name is well known in Washoe county, although as far as can be learned, she has never been seen here. Neither her attorneys nor any of the county officials has any idea what she looks like, and little of anything else about her except that she lives in Pasadena."

So who was this mystery woman? H.B.R. Bushard was Hazel Blanche Redfield Bushard, the daughter of LaVere's brother Fred. A graduate of the University of Southern California and an elementary schoolteacher, she lived in Southern California with her husband, Francis, until their divorce in 1941 or 1942.

Following Hazel's split from her husband, LaVere paid for a trip for her; his wife, Nell; and Hazel's sister Ethel to Brazil to help Hazel recover from her nasty Reno divorce. The trip seems to have worked. While there, Hazel had a whirlwind romance and courtship with Brazilian Paul Warner, who worked in the jungle for a rubber development company. When LaVere got wind of Hazel's impending marriage, he offered her $1 million not to go through with it and to return to the United States, according to Hazel's and Paul's daughter, Jilda Warner Hoffman. When Hazel went ahead with the

marriage—a long and happy one, as it would turn out—LaVere claimed he would renounce her. However, he soon forgave her, and it would be years before he re-deeded all the property in his own name.

Mrs. Bushard's (now Mrs. Warner's) daughter Jilda became one of LaVere's and Nell's most frequent family houseguests. While Jilda; her older sister, Taffy; and their parents lived in Brazil, Hazel Warner and her girls made periodic trips to the states in the late 1940s and throughout the 1950s, and they always included a visit to Reno to see LaVere and Nell. Paul Warner rarely accompanied them, as LaVere never warmed up to Hazel's Brazilian husband. After high school, Jilda attended Stanford University in Palo Alto. While a student there in the 1960s, she often visited the Redfields in Reno when she came to the area to ski. She and LaVere developed a warm friendship. Although Jilda was still a teenager in college, LaVere would take her with him to the Nevada Club, where she would play roulette, using LaVere's system. "I almost always won," she smiled, "but I didn't like it because of all the smoke and everything."

An extremely active and independent-minded young lady, Jilda loved to spend time with her uncle LaVere. She was very fond of Nell, too, but became easily bored in her great-aunt's presence. "She was a very kind, sweet, loving woman," Jilda said in an interview, "but she just sat around all the time and didn't do anything." Jilda noted that by the 1950s, the Redfields lived separately in the big stone house—LaVere lived in the ground floor apartment, and Nell lived in the identical upstairs apartment—and they lived completely distinct lives. They would occasionally dine out together or attend a show as a couple, but they shared no friends and had no common interests.

Throughout his life in Nevada, Redfield was a regular attendee at auctions, whether to purchase land, furniture or any other product or service that could be bought cheaply. He preferred to deal in cash, and he always showed up with wads of money tucked into the pockets of his denims or carried in a small satchel or paper bag like a workman's lunch. Redfield did not trust banks; many people who had lived through the Great Depression and its bank failures felt that way. When the purchase price of an item was high, Redfield would carry enough cash for a down payment, or for earnest money, but he would always pay the remainder in cash at a later date.

Redfield had a number of ploys he would use to improve his chances of success when attending an auction. Walt Mongolo said Redfield rarely missed an auction for delinquent property, held on the steps of the courthouse. "He would stand among the crowd and when a piece of property he wanted came up, Redfield would bid on it," Mongolo

recollected in a newspaper interview. "If another bidder started to move the price up, Redfield would walk over and make him an offer. He'd say, 'I'll give you $100 cash right now if you'll stop bidding.' We finally had to get the district attorney after him—that's illegal," Mongolo laughed.

Another legendary Redfield scheme involved the system of bidding he employed at auctions. Preston Q. Hale told of the time he was attending an auction where Redfield was bidding. It was being held at the Washoe County Courthouse, and a piece of property was on the block for delinquent taxes. Redfield was vying with three other bidders for the property. "The auctioneer would say, 'We've got $17,500. Anybody want to raise it?'" Hale explained. "It looked like it was going to go, but Redfield would raise his hand and say, 'And one dollar.'" One of the other bidders would raise Redfield by making a more normal bid, and Redfield would come back with his customary, "And one dollar." "He did that about 10 times, and he ended up buying it!" Hale said, smiling. Redfield was famous for that ploy—"And one dollar"—and other regulars at the land auctions soon discovered it was futile to bid against him. He would simply keep it up until he wore down other bidders, or they reached their limits. Most bidders soon realized that it was futile to try to outbid the richest man in town.

This bidding tactic of Redfield's was not used solely at land auctions. He would also use it at auctions for goods and merchandise, things offered at less substantial prices. But in those cases, Redfield—always the frugal one—was not about to raise the bid by a whole dollar if he didn't have to. Insurance broker and onetime Nevada Insurance Commissioner Lou Mastos once attended an auction of used office furniture and equipment, and he found himself bidding against Redfield for a particular item. "Fifteen dollars," the auctioneer intoned. "And ten cents," Redfield responded, according to Mastos in a personal interview. "So I went twenty-five cents higher," he recalled. "And ten cents," Redfield droned. After this went for a spell, Redfield approached Mastos: "Son, you really want that piece, don't you?" he asked. When Mastos said he did, Redfield nodded and said, "Then you can have it," and he stopped bidding. It was a game for Redfield, whether he needed the item he was bidding on or not. Hundreds—perhaps thousands—of the items he purchased at these auctions would simply be stored in the huge basement of his stone house or in a rented locker.

He wasn't always so cooperative at the auctions. Jack Douglass, a pioneer Reno amusement machine route operator and later co-owner of the Club Cal Neva on Virginia Street, also recalled running afoul of Redfield at an auction in his book *Tap Dancing on Ice: The Life and Times of a Nevada Gaming*

Pioneer. Douglass owned a small bar, the Montana Bar, on downtown's East Douglas Alley that he leased to another man to operate. In the late 1940s, the operator skipped town, and the IRS seized the contents of the bar for back taxes. An auction was scheduled to sell the merchandise and furnishings, and Douglass attended to buy some of the items, planning to reopen the bar. "LaVere Redfield was there," Douglass said, "and no matter what anybody bid he would go a bit higher…I bid against him on [a case of] toilet paper just to push him higher." But Douglass's scheme backfired. The rule of the auction stated that the entire inventory of the bar was valued at $2,200—the amount of the back taxes owed—and anyone who overbid that amount would get everything. Frustrated by Douglass's toilet paper ploy, Redfield said, "I'll bid $2210 for everything." "And he got it," Douglass lamented.

Finally there was Redfield's habit of carrying a bag of cash with him to pay for the goods and services he purchased. Jean Sale, a dealer at Harolds Club in downtown Reno from the early 1950s until 1972, recalled in a personal interview a story about her husband, Jim, who worked at the United Airlines counter inside the Riverside Hotel. "About 1946 or '47, LaVere Redfield came in and ordered a long flying trip," Sale recollected. "Jim planned his trip…and it was quite expensive…it came to about $4,000," she said. "He [Redfield] always wore a Pendleton wool shirt, Levis and black high-top farmers' boots, laced all the way up." When Redfield returned to pick up his tickets, Jim Sale asked him how he was going to pay for it. "He had a brown paper bag, and…he took the $4,000 from the bag and paid for the trip," Jean Sale said.

One of the most perplexing aspects of Redfield's four-decade-long land buying frenzy was the fact that he seldom sold any of his land. As preoccupied as he was with money, one would expect him to turn his land into cash as the value of it ballooned over the years, but he rarely did. Once, however, he did come close.

Early in 1960, Redfield met Reno attorney John Drendel when the lawyer came in to purchase some building materials at the Riverside Lumber yard that Redfield operated at the time. In a personal interview Drendel said that a week later, Redfield came to his law office to collect $100 for the lumber, and the two men began discussing Redfield's massive mountain holdings. Redfield had always sworn that he would never sell his land as long as he was alive, but at his meeting with Drendel, he said suddenly, "I believe I'll sell every acre of ground I own." Drendel called in his partner, Bud Bradley, and in a short time, a deal was consummated. The only land not included in the agreement was Redfield's Mount Rose Street home and the old University of Nevada farm on South Virginia Road.

The agreement included an option price for all the other land—about fifty thousand acres—and Redfield would receive only the option price. Drendel and Bradley would keep whatever amount they could sell the land for above the option price and, in Bradley's words, "make a buck." The option price was $9 million, and the two attorneys had ninety days to act as agents in the sale. John Drendel recalled Redfield telling him, "You can make a million dollars each on this thing." Unfortunately, however, Drendel said they could never put a deal together. Busy with their own law practice, they arranged for others to put the deal together for them, and it did not work out well. That was the only time Redfield seriously considered selling his massive land portfolio.

7
Not a Snowball's Chance

With so much Sierra Nevada mountain property in his real estate portfolio, it was only a matter of time before Redfield would bump heads with those who had other ideas on how his land should be utilized. It didn't take long for the first idea to surface, a grand plan to create an international ski resort. Once the idea took hold, Redfield's land would become the centerpiece in a number of winter sports schemes over the succeeding years.

In 1937, Norman Biltz was one of the early Nevadans to see the advantages of building a winter ski resort close to Reno and Tahoe. Sun Valley, Idaho, had opened just the year before, and Biltz and his partner, Oscar Alexander, envisioned a similar setup with ski runs, ski jumps, tramways and tows, lodges, bobsledding, ice skating and other related winter activities, to be augmented by similar summertime facilities. So grand was the plan that the United Press news wire christened the project "a new American Gold Coast." The preliminary survey and proposal focused on 22,000 acres of mountain land in the Sierra Nevada range. The U.S. Forest Service had agreed to the plan, but it owned only 15 percent of the targeted land; the other 85 percent was privately owned. The largest private landowner was the Hobart Estate, with 11,500 acres; the second largest was LaVere Redfield (deeded in the name of H.B.R. Bushard) with 2,960 acres. Redfield told Biltz his land was not for sale but that he was willing to lease it.

Unfortunately for Biltz and his partner, however, their plan was too extravagant for the times and for the still-struggling Depression economy.

Norman Biltz, shown here around 1950, engineered the mid-Depression marketing strategy that initially attracted multimillionaires like LaVere Redfield to Reno. In 1937, Biltz solicited Redfield to lease some of his Mount Rose land for a massive winter resort, but the plan faltered due to the Depression. *Special Collections, University of Nevada Reno, Library.*

"We made quite a study of skiing, but never got our efforts off the ground," Biltz said years later in his oral history interview, *Memoirs of "Duke of Nevada."* "We did start to develop a ski resort on Mt. Rose [but] abandoned it because in those days, they weren't finally successful."

Redfield's desire to profit from his mountainside land by leasing it had not disappeared along with Norman Biltz's dream of a winter sports resort.

But when the idea resurfaced a decade later, the investor would not be at all happy with the direction it took.

In November 1947, LaVere Redfield had made one of his regular visits to the Washoe County commissioners' meeting. His purpose was the same as it had been on his many previous visits: he wanted to get his property reappraised and thus lower his taxes. For over an hour, according to a newspaper report, Redfield haggled over $474 he felt was due him for what he considered an excessive land assessment on a piece of his mountain property at Grass Lake, just south of Lake Tahoe. As evidence, he told commissioners his property had been assessed at $30 an acre, while nearby property belonging to the Up Ski Corporation was assessed at only $3 an acre. After Redfield had lost his appeal and departed the commissioners' meeting, the newspaper reported, "The commissioners discussed seriously the idea of condemning some of his [Redfield's] lands in the vicinity of Galena Creek park...[so] the area could be developed to good advantage as a winter sports site." If Redfield believed $30 an acre was too high an assessment, commissioners opined, the county would be more than happy to reclaim it from him at that price.

So Redfield himself had set into motion a skirmish that would lead to a four-year battle between the millionaire landowner and governmental powers-that-be. And there wasn't a snowball's chance that Redfield would go quietly while the government tried to forcibly take his land from him. Although the first shoe had been dropped at that 1947 county commissioners' meeting, it would be nearly two years before the next shoe fell.

Redfield was not against the idea of a ski resort. In fact, just as with the Biltz/Alexander project a decade earlier, he was willing to cooperate if two conditions were met. First, he wanted a share of the gross receipts from the ski resort, which would be operated by a private company; and second, while he was willing to lease his 158-acre parcel, he was not willing to sell it. Despite his wishes, on September 20, 1949, county commissioners instructed the Washoe County district attorney's office to institute a condemnation proceeding against Redfield to obtain the 158-acre parcel for a proposed Slide Mountain ski resort.

Since the Biltz/Alexander plan had fallen flat, the U.S. Forest Service had purchased much of the private land in question, and in 1949, Redfield was one of only three private landowners whose holdings still stood in the way of a 100 percent publicly owned project. The other two landowners, including the Up Ski Corporation, had already agreed to sell their land, so obtaining the Redfield property was key. Parking facilities, a picnic ground,

a public park and a recreation area were to occupy 120 acres of the Redfield land, and a critical access road from the highway to the resort would occupy the other 38 acres. Federal funds were available to pay for constructing the access road but only if it terminated on public property. So there had been an impasse between Redfield and Washoe County that ultimately led to the condemnation order.

Redfield's contention during the ensuing court battles and appeals was that the county had exceeded its constitutional rights in condemning his land since the proposed ski resort would be turned over to a private enterprise to operate. Over the next year, he unsuccessfully waged his small war: district court, lost; appeal for new district court hearing, lost; appeal to Nevada Supreme Court, lost. Finally, it was over, and the Reno Ski Bowl winter resort project was on its way. In the end, Redfield was paid ten dollars an acre for the 158 acres the county took through the eminent domain process.

Even in death, the stubborn old man would stir up controversy around his mountain holdings. Shortly before his death in September 1974, and in his typical fashion of working without an attorney, Redfield signed a fifty-year lease with Swiss businessman James Luescher. Luescher planned to consolidate the Slide Mountain ski area, the Mount Rose ski area in which he held an ownership stake, and some 6,500 acres of Redfield-owned land into one giant winter resort area. Under the terms of the signed agreement, Redfield would receive $5,000 annually plus 10 percent of the project's gross receipts for the use of his land.

When attorneys for the Redfield estate heard about the deal after the millionaire had passed away, they argued that it must be bogus. The seventy-seven-year-old man had suffered a stroke just a month before signing the lease, and attorneys claimed he was incompetent when he put pen to paper, as the terms of the contract were very one-sided against him. Luescher, on the other hand, said Redfield had been sound as a dollar when he signed the agreement. Redfield estate attorney Proctor Hug was lead counsel when the Redfield Estate sued Luescher for exerting undue influence over Redfield. A Washoe County District Court jury agreed with Hug, and the lease was declared null and void, putting an end to Luescher's plans.

Another piece of Redfield's real estate, one that figured prominently in the history of the University of Nevada, Reno would also stir up controversy and would drape more fascinating stories and rumors around the narrow shoulders of the brilliant business entrepreneur.

The University of Nevada is a land-grant university. Among other things, that means the university must focus on the teaching of agriculture in

addition to science, engineering and classical studies. To advance that objective, in 1915, the university made two key land purchases. First it bought an 8-acre tract of land known as the Evans property, located adjacent to the campus. There it establish a dairy farm and poultry houses. Then it also purchased the old 208-acre Wheeler farm on the northwest corner of South Virginia Road at Hash Lane (now South McCarran Boulevard) for an experimental farm, where haying, fruit orchards and livestock experimentation would be carried out. For the next four decades, the two properties fulfilled their missions, although for a sixteen-year period of time, the experimental farm was leased to a private interest. However, by the early 1950s, it had become evident that change was needed at the farm. It was considered inadequate for the growing institution's needs, and it was located too far from the main campus for students to move quickly and freely between the two. Thus began a rocky five-year journey for the university's board of regents.

A federally supported beef-breeding program had been initiated at the farm, and the regents realized it was important for that work to continue. So from the beginning of their discussions in 1951, regents emphasized a two-pronged plan: first, sell the farm—which was on prime commercial property on South Virginia Road—for as much money as possible; and second, ensure that a replacement farm closer to the campus was purchased so the agriculture department's beef-breeding work could continue. From that starting point, the regents discussed, studied and dithered over the idea for the next three years, making little progress.

In June 1954, the board of regents finally decided to act. Its members had entertained a number of unsuccessful bids for the farm, but they finally announced in the newspaper that the farm would be traded to real estate investor Roy Crummer in exchange for a one-thousand-acre farm—the Flick Ranch, made up of the old Mapes and Questa Ranches in southeast Sparks—plus $95,000 cash and a lot of old farm equipment. Regarding the sale, the newspaper reported, "The regents expressed considerable pleasure that they had been able the purchase the Flick Ranch. Board member Roy Hardy of Reno estimated the [Flick] ranch was worth $750,000."

The regents' "considerable pleasure" was short-lived. To the embarrassment of the board of regents and university officials who had merrily jumped on the bandwagon, Governor Charles Russell, who had the last say on the deal, rejected it. Instead of taking the word of the regents on how great a deal they had engineered, he selected a blue-ribbon panel of ranchers, farmers and other experts to do a study of the situation. A month later, the

panel presented its findings, which were a further embarrassment to those involved. Basically, the report said: 1) the Flick Ranch was both unsuitable and too large for the university's needs and was overpriced to boot; 2) the farm equipment being offered was old and useless; and 3) the present university farm on South Virginia Road was worth more than the regents had received for it from Roy Crummer. Red-faced, the regents went back to the drawing board with instructions from Governor Russell to get at least $750,000 for the farm and to get it in cash. They could buy another suitable experimental farm out of the proceeds rather than attempt a cash-and-swap deal, they were told. Over the following year, new bids came in, but none equaled the amount required by the governor. Finally, late in 1955, bids were solicited again, but only one potential buyer showed any interest.

LaVere Redfield had been watching the university farm debacle with some interest since it had begun four years earlier. He had bided his time until he sensed the right moment had arrived. Just before the bidding was closed, he stepped in with a $100,000 certified check and a total bid of $700,000. Anxious regents, unwilling to make another embarrassing blunder by accepting less that the governor had stipulated, declared they would extend the bidding period by two weeks before making a decision, hoping another, higher bid would come in. Longtime university administration employee Alice Terry wrote in her memoir, *Recollections of a Pioneer: Childhood in Northern Nevada, Work at the University of Nevada, Observations of the University Administration 1922–1964*, that although word never leaked to the newspapers, one prominent university administrator later said that the board of regents had become involved in a little hanky-panky. One of the regents ran a large hotel-casino, and he alerted a member of his staff to Redfield's bid with instructions to go a little higher. When that was done, the new high bidder was awarded the sale. Somehow Redfield learned of the insider deal. He visited the university president, Dr. Minard Stout, and told him he had evidence of the scheme and that he was going to sue the university and the board of regents. Dr. Stout gladly kicked the mess back up to Governor Russell's office, and between the governor and the attorney general, they decided it would be wise to accept Redfield's lower bid.

Dr. Stout, in an attempt to put the best possible face on the fiasco, told the newspaper, "We have heard a great deal of talk in the past three years. We have heard a lot of oral offers. Mr. Redfield is the first one to come in and lay the money on the table in a firm bid." In the end, the university did purchase the Flick Ranch to carry on its beef breeding and other experimental agriculture activities. It paid $525,000 for it, a full 30 percent

less than regents had initially agreed it was worth. The entire debacle was not one of Nevada higher education's finer moments.

For the next decade, Redfield held on to his valuable South Virginia Road acreage. In 1958, he made one attempt to sell the property—a rare occurrence for Redfield—for $1 million, but he got no takers. In the same year, he made news again when he ousted three sharecroppers from the farm for failing to pay him his share of the crop sales, and the following year, he was again in the news when his offer to donate twenty acres of the farm to the city for a civic auditorium was rejected. But in 1968, the seventy-one-year-old land baron was involved in another bizarre incident with his university farm property that left Reno wags clucking over their back fences for months.

Not for the first time, Redfield had forgotten, or neglected, to pay his income taxes. He owed the IRS more than $450,000 in back taxes, and a tax lien had been levied against some of his mountain holdings and the 208-acre farm. On November 1, an auction was scheduled at the downtown federal building to sell the farm and retire the debt. Redfield invited his young friend John Metzker to attend the auction with him, Metzker recalled in a personal interview. The following day, the story of the auction and Redfield's antics were front-page news in the morning paper.

As Redfield had walked into the auction, he carried a large, full grocery bag with a couple of packages of oatmeal cookies on top. Metzker asked him why he had brought the food. "I thought I'd better bring a few things to eat…we might get hungry before this thing is over," Redfield told him. Metzker remembered there were about fifteen people in attendance as the auction began. Redfield immediately started heckling the IRS people who were running the show. "Can't you speed things up? You've got folks here who can't sit around all day," Metzker recalled Redfield shouting out. He continued badgering the IRS people and bantering with the small crowd of attendees throughout the proceedings. Finally, all the submitted bids were sealed, turned in and opened. The winning bid was $450,000, submitted by a partnership of three local dentists and a deputy sheriff.

As soon as it was announced, Redfield jumped from his seat and said he wanted to claim his exemption, a short period of time in which the property owner can pay the lien and retain ownership of the property. Exasperated, the auctioneer said Redfield had to produce the cash if he wanted to claim the exemption. The cagey old millionaire, grinning from ear to ear, took his grocery bag to the front of the room, took the oatmeal cookies out, and emptied the large bag on the table. Stacks and stacks of $100 bills came

tumbling out. A big whoop of surprise arose from the audience, and the IRS agent began to count the money. When he was finished counting—$268,000 it was—the agent said it wasn't enough. Again, playing to the audience, Redfield began pulling $1,000 bills out of the pockets of his bib overalls and tossing them on the table—130 of them in all. When it was still $52,000 short, the IRS agent finally agreed to go to the bank with Redfield and get the remainder of the money, which was soon accomplished.

That this gauche behavior was so atypical of the courteous, mild-mannered millionaire is probably the reason it has become such a popular piece of the Redfield legend. However, despite his normally quiet and unassuming demeanor, Redfield could be as ferocious as a pit bull when his interests were challenged. He would go to court at the drop of a hat to press an advantage or gain what he believed were the rights due him under law. An excellent example of his proclivity to seek justice—as he saw it—were his activities at the Riverside Lumber Company.

Harold Chisholm owned and operated Chisholm Lumber Company at 735 West Third Street as early as the late 1940s. Around 1952, he added the Riverside Lumber Company at 1775 West Second Street, and a few years later, he opened Lumber & Supply Company in Panther Valley, north of Reno. LaVere Redfield owned some adjacent land in Panther Valley, which is how the two men may initially have become acquainted. For some purpose, possibly to purchase an additional 360 acres of Panther Valley land that he had his eye on, Chisholm borrowed $250,000 from Redfield. In 1957, Chisholm was not able to make the payments on the debt, so he and Redfield agreed that Redfield would operate the Riverside Lumber Company and the Panther Valley lumberyard, keeping the profits until the debt was paid off. Or, the agreement stipulated, Redfield could sell the businesses if necessary to recoup the debt.

After a few years, and more than a few disagreements between the two men, Chisholm locked Redfield out of the businesses, causing the millionaire to seek a restraining order and injunction against his debtor. The district court judge agreed, and Chisholm relented. Although that battle may have been over, the war was just beginning. Chisholm filed a countersuit with a laundry list of accusations against Redfield that, by late 1959, had worked its way to the Nevada Supreme Court. Redfield again prevailed. For the next decade, Redfield continued running the lumberyards and keeping the profits to defray the large debt. In addition to the money, he seems to have enjoyed having something constructive to do. He spent a great deal of time at the West Second Street Riverside Lumber Company, and

he became a favorite of builders and do-it-yourselfers who frequented the lumberyard. One story typifies the reaction many of his customers shared when visiting the business.

Local attorney, and later federal judge, Proctor Hug did not know Redfield personally at this time. One day, he and his son were building a playhouse for the son's daughter, and they needed some plywood, he said in a personal interview. They drove to Riverside Lumber, where Redfield—dressed, as always, in his workman's clothes—waited on them and then helped load the lumber into their truck. As they were leaving, Hug said to his son, "Proc, I bet you don't believe this, but [the man who just helped us] is one of the richest men in the county."

Like many things Redfield touched, however, there would be controversy over the lumberyard. The property Riverside Lumber Company was situated on was actually owned by the Southern Pacific Railroad and held by Harold Chisholm on a long-term lease. Neither Chisholm nor Redfield was anxious to spend any money on the property, so it had fallen into disrepair. When a small tornado hit part of the city, it ripped the roof off the lumberyard's storage shed and downed some trees, adding to the problems.

In 1969, the Reno City Council began badgering Redfield to clean it up. Naturally, he balked. At a city council meeting, with Redfield in attendance, the property was declared a public nuisance. "Horsefeathers!" Redfield barked at council members from his seat in the gallery, and he told them he was tired of being harassed by the government. When they voted that Redfield had to abate the nuisance, he replied, "The only nuisance is Jon Petersen here [the city building inspector]." A local newspaper reported that Redfield uttered the charge with a grin and immediately shook Petersen's hand, giving rise to the idea that he was again simply playing to his audience and using it as a platform to espouse his antigovernment sentiments.

Knowing how long it often took the government to get anything done, Redfield held the city at bay for the next two years, likely chuckling under his breath at the city government's futility. Finally, the city threatened to condemn the property, and Redfield realized the jig was up. He closed the lumberyard and donated the remaining lumber to the Washoe County School District and the University of Nevada, Reno, and both institutions shared what was about $25,000 worth of good, usable lumber.

LaVere Redfield's life consisted, it seems, of a series of jousts between himself and other individuals and organizations with whom he disagreed. Like Cervantes's Don Quixote, Redfield's generally futile battles with the IRS, individuals with whom he did business and city, county and state

In this circa-1969 photo, LaVere Redfield appears in his most familiar garb: a plaid woolen shirt and blue jeans. The seventy-two-year-old man probably also had workman's boots on. *From the* Reno Gazette-Journal.

government agencies were legendary. Although these battles were often farcical to onlookers, to Redfield—just as to Don Quixote—tilting at windmills was serious business.

Redfield was a lifelong ultra-conservative Republican. When the Watergate incident was taking its toll on President Richard Nixon in the early 1970s, Redfield told an associate that he believed Nixon was one of the greatest presidents the country had ever had. He also praised President Dwight Eisenhower for at least trying to hold the line against the Democrats' social spending programs, but he castigated Presidents Franklin Roosevelt and Harry Truman for the public debts piled up during their administrations. He was a fierce believer that the least government was the best government, and he greatly admired the thrift practiced by Canadian government officials at the time. U.S. governments, however, whether local,

state or federal, had no right meddling in his affairs, he believed. But he reserved his greatest antagonism for the Internal Revenue Service. "He talked about the IRS quite a bit," said his friend John Metzker in a personal interview. "He saw it as a constitutional issue; the government didn't have the right to impose an income tax," Metzker said. Redfield's aversion to the IRS may have had its roots, at least partially, in the fact that he was sixteen years old before the federal government began taxing income in 1913. He and, to a greater extent, his older brothers had not grown up with the idea of a tax on money one earned by the sweat of one's brow. It was harder for people to accept back then when it was new than it is today, and Redfield likely carried that sense of injustice with him throughout his life.

He also always contended that his prosecution for income tax evasion in 1960–61, discussed in Chapter 10, was a matter of his sloppy bookkeeping, not intentional tax fraud. Because of his belief that government did not have the legal authority to tax him, he felt justified in using whatever means were necessary to retain his wealth. He bought property under the name of others, and he often set up his investment accounts in the name of relatives, even deceased ones, in order to dodge taxes. He was also vehemently opposed to the city and county governments' use of the laws of eminent domain and property condemnation, which were used against him a number of times over the years. He fought each of these battles tooth and nail, opposing them in court and through the appeals process to the bitter end. He always lost. Despite his antipathy toward all levels of government, Redfield was a strong believer in participating in the democratic process. He often told friends that the most repugnant part of that 1960–61 conviction for income tax evasion was that it cost him his right to vote. It is possible that some of Redfield's antigovernment sentiments also had their roots in his upbringing in the Mormon community of Ogden, Utah. Although his family had deserted the Mormon faith during his grandfather's lifetime, Redfield would have been keenly aware of the federal government's persecution of the Mormon movement from its earliest days in the late 1820s until the end of the nineteenth century. That certainly could have influenced his attitudes.

Regardless of the foundation of Redfield's beliefs, or their occasionally humorous undertones, he was serious about them. On several occasions during his lifetime, he considered leaving the United States, often investigating the tax situation in other countries. In 1968, he took a freighter cruise to Costa Rica for that purpose. He even spoke publicly about leaving the country during a Reno City Council meeting when he was being ordered to clean up some of his property. "I'm almost in a frame of mind to renounce

my citizenship and become a citizen of another country which doesn't have an income tax," he said, stating that he was tired of government harassment. In the end, of course, he never left. A friend said that he didn't leave in part, because he really loved America and in part, because his wife, Nell, refused to leave. Despite that, LaVere Redfield's ardor for justice—as he saw it—would continue until the day he died.

Another of Redfield's passions, and perhaps his only Achilles' heel when it came to his considerable fortune, was his penchant for high-stakes gambling.

8
The Big Wheel in Town

Born as a railroad town, Sparks, Nevada, initially named Glendale, has never achieved the recognition or fame of its next-door neighbor, Reno. But that doesn't mean the little city hasn't had its moments. In 1953, when neighboring Idaho decided to ban slot machines, Idaho native Dick Graves pulled up stakes and moved his slot machine route operation to Nevada. He opened or purchased a number of small gaming businesses in the state, but it was his Sparks Nugget, opened in 1955 with a new café and fifty slot machines, that would eventually put the city on the map. Graves put his young protégé, John Ascuaga, in charge of the Sparks Nugget, and he spent his time opening Trader Dick's restaurant next door. The restaurant had gambling, too, and it became a favorite dining and gaming destination for LaVere Redfield.

Graves was a master marketer—he made the famous performing elephant Big Bertha a permanent resident of the Sparks Nugget—and he was always on the lookout for a new promotional gimmick. To salute his favorite high-stakes customer, he ordered a quantity of special gaming chips with a Trader Dick's logo on the face and large "L.R." initials beneath it. If a man was willing to risk $10,000 in a day's play at his roulette wheel, Graves opined, he was certainly deserving of his own personalized betting chips.

Roulette, Redfield's favorite game, has been around for a long time. Originally played in the glamorous, sophisticated salons of Paris and Monte Carlo, when it first migrated to the United States, roulette found its greatest audience with the grizzled miners and greedy gold and silver speculators of the

Old West. The game eventually evolved into two basic forms. The Monte Carlo, or French, roulette wheel, used throughout Europe today, has the numbers 1 through 36 and a 0, for a total of thirty-seven numbers. The American roulette wheel has all of those plus 00—double zero—for a total of thirty-eight numbers. Thus the American wheel gives the casino a winning edge of 5.26 percent while the French wheel, with one less number, gives the casino a winning edge of only 2.7 percent, a huge difference for serious gamblers.

Roulette is also the casino game favored by systems players, those gamblers who believe that by betting or playing in a certain way they can reduce or eliminate the casino's winning edge and turn it in their favor. There are a number of roulette systems, each with its own devotees, but two are the most popular. The Martingale, or progressive, betting system calls for a player to double the wager after every losing even-money bet, but to succeed, it requires a table with no betting limit and a gambler with a huge bankroll. The other popular system is the repeating numbers system. Devotees of this style of betting believe that when a number comes up on the roulette wheel, it will likely repeat itself at least one more time in the next thirty-five spins, so they bet accordingly. If they're correct, they collect 35 to 1 each time it repeats; if they're wrong, they lose. In the old days, with purely mechanical roulette wheels, imbalances in a wheel could indeed produce repeating numbers; but with the technology that exists today, and the regular testing of all the wheels in the casinos, it's highly improbable that could happen, although many gamblers still swear by this system.

Nevada's most famous systems player was LaVere Redfield. When Redfield initially arrived in Reno in the mid-1930s, many of the kinks were still being worked out of legalized casino gambling. Raymond Sawyer, in his entertaining book *Reno, Where the Gamblers Go*, described the ten-year period from 1935 through 1944 aptly, writing, "[W]e ruefully acknowledge that Reno's gaming was...gaudy, still a little raw, a little vulgar, a little unpolished—more than a little unsure of itself and the future, yet determined to survive."

It is not known where LaVere Redfield played during his first few years in Reno, as no records exist and no old-timers' firsthand recollections of him from that era survive. It is fair to assume, however, that the man began gambling soon after his arrival in Reno, and we know for a fact that it continued up until his death in 1974. Redfield had made his first fortune in Southern California as a stock speculator—the most challenging gamble of all—so we can be certain that a gambler's blood coursed through his veins. It's likely that in his early years, he played at major downtown clubs like the Bank Club, the Palace Club and the Club Fortune.

In the late 1930s, Virgil Smith, a Lovelock, Nevada man who had been in Reno since early in the decade, leased a number of gaming concessions around town. In 1937, he added the gaming concession at Colbrandt's, a swank club that attracted the carriage trade. Smith immediately raised the betting limit on his roulette wheel from five dollars per number "straight up" (betting on one number only) to twenty dollars. For big bettors, he raised the straight-up limit to one hundred dollars, a practice that surely would have drawn LaVere Redfield to his club. From the beginning of his roulette playing days, Redfield was no small-time gambler; he played like the multimillionaire he was, not like the ultra-frugal penny-pincher that he also was. High-stakes gambling was Redfield's primary avocation, and since he could afford it, he allowed himself the luxury. Thus, during his entire gambling career Redfield favored casinos like Colbrandt's that allowed him to play high-stakes roulette.

The late 1930s and early to mid-1940s postwar scene saw a number of new casinos make their debuts in downtown Reno. One of the most notable additions to the casino scene, Robbin's Nevada Club, opened in 1941 at 224 North Virginia Street. In 1946, some new partners joined the Nevada Club's other owners. One, Lincoln Fitzgerald, had a spotty past, having run an illegal gambling club in Michigan before coming west. He would eventually become the sole owner of the club. But in 1949, Fitzgerald faced a similar but much more violent assault than the one Redfield had suffered just the year before. Fitzgerald was ambushed in the driveway of his home and shot twice with a shotgun, a revenge shooting always assumed to be from his Michigan past. It was a very close call, but Fitzgerald recovered. However, he and his wife moved into the Nevada Club, and he seldom ventured outside for the remainder of his life.

Fitzgerald and Redfield became friends. It was partly due to their shared fates, but there was also another, more practical reason why Redfield became a regular at Fitzgerald's Nevada Club. In the early 1950s, Fitzgerald introduced a Monte Carlo, or French, roulette wheel to his casino, the only one in northern Nevada. With the casino's winning percentage cut in half, Redfield quickly changed his loyalty to the Nevada Club. He was not alone; most of the high rollers who favored roulette did the same. Fitzgerald was always around when the big players came in, and he personally saw to it that they were treated well.

Delores Codega was an early female dealer in Reno's clubs and casinos. She joined the Nevada Club as a change person right after World War II, and worked there until the late 1950s. Fitzgerald saw something promising in

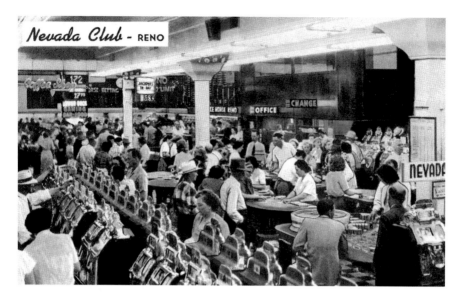

The Nevada Club, here in 1953, was co-owned by ex-Detroit gambler Lincoln Fitzgerald. He and Redfield became friends, and Redfield was a frequent customer at the Nevada Club after Fitzgerald introduced Nevada's first and only French roulette layout, which improved the player's odds. *Special Collections, University of Nevada,Reno Library.*

Opposite, top: The Reno archway has greeted travelers to the city's downtown casino corridor since 1926. In this 1958 photo, Harolds Club, the Nevada Club and the Riverside Hotel (in the center of the street, in the distance) were three of LaVere Redfield's favorite places to play roulette. *Nevada Historical Society.*

Opposite, bottom: Harolds Club in Reno, shown here in the 1950s, was one of LaVere Redfield's favorite haunts when he headed downtown to play roulette. *Nevada Historical Society.*

the young lady and taught her to deal twenty-one, roulette and other games. She dealt roulette regularly to LaVere Redfield, according to R.T. King's book *Every Light Was On: Bill Harrah and His Clubs Remembered.* Because he was such a good customer at the Nevada Club, Fitzgerald occasionally allowed Redfield to spin the wheel himself. This was an unusual perk and was only for the very top-level players, who are known in today's trade as "whales." "Fitzgerald did it once or twice, and that was when we had LaVere Redfield, the millionaire, playing on the game," Codega said. "Redfield didn't really like to do it, though. He didn't know how to do it right, but he'd do it once in a while." Codega recalled one time when the mild-mannered Redfield was anxious to replace her at the wheel. He had covered almost the entire roulette layout with bets. "I only had two numbers I could spin him out on,

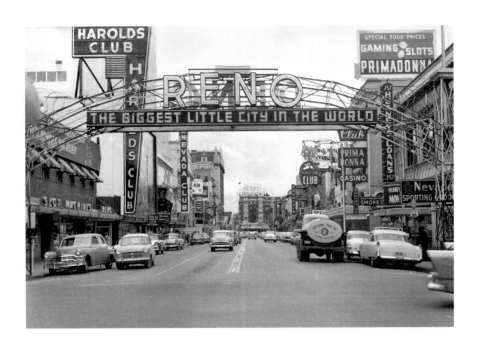

and I got one of those numbers," she laughed. "The numbers were three and ten, and I rolled ten." Redfield lost $17,000 on that single spin.

"Fitzgerald let him play on credit...and you had to keep up on every bit of money that he put on the table," Cordega said. She explained that Fitzgerald would signal her by holding up a certain number of fingers to alert her to what limit he would accept on each bet Redfield wanted to place. "He was the biggest [bettor] that I've ever known. Nobody could keep up with him," Codega said. "Every club in Reno wanted to get Redfield away from Fitzgerald, so they would offer the moon; but they couldn't produce," she laughed.

Another important postwar addition to the city's casino scene was Harrah's Club, opened by William "Bill" Harrah at 210 North Virginia Street in 1946. Harrah had gotten his start in the city in the late 1930s with a couple of bingo clubs. Harrah's Club, and the casino empire it spawned, would become a major player in Reno and Las Vegas and would, for a time, be the largest casino company in the world.

For his University of Nevada oral history interview, Bill Harrah spoke about the roulette system LaVere Redfield played at the competing Nevada Club during the 1950s: "He drove Fitz[gerald] up the wall, you know...'Course, Fitz, he gave him a big limit. Plus he had that single-0 wheel, which cuts the odds. Redfield really gave him fits...And Fitz finally had to cut him way down 'cause he was just—he couldn't get away."

It had likely been in the late 1940s that Redfield began devising his own roulette betting system. He had played the game for more than a decade and had become quite adept at it without following any particular system. But he was a precise man, and he probably figured that having a definite plan in mind would add profitability to his avocation. He had become friends with Nevada gaming pioneer Warren Nelson, who at the time was an executive with the Mapes Hotel-Casino, another important postwar establishment on Reno's casino scene.

"He [Redfield] truly believed he could beat the wheel," Nelson remembered in his book *Gaming from the Good Old Days*. "I used to sit with a paper and pencil and tell him what the percentage was and tell him why he couldn't beat it. And the more I told him, the more convinced he became that he could—so by telling...what the right thing was didn't deter him one bit."

In 1955, four young men from the University of Nevada tried to duplicate the winning system some young fellows from Chicago had gotten rich on in the late 1940s. Playing the wheel at Harolds Club, they used the repeating

numbers system. For weeks, they kept track of all the winning numbers, using careful notes and slide rules to perfect their system while making minimal bets. They finally settled on eight numbers that occurred most frequently and began playing those numbers seriously. At the end of seven weeks they had won $86,000.

Toward the end of their run, news of the achievement had leaked out, and large crowds assembled at Harolds Club to watch the action. One of the spectators was LaVere Redfield, who was still refining his own system. He even tried to ride on the young men's coattails and wager on their numbers; but the house limits were already being exceeded on the chosen numbers and Redfield was rebuffed.

Redfield played a lot of roulette at Harolds Club in the 1950s. The hotel/ casino had opened the same year Redfield arrived in town and had become one of the city's premier gambling establishments. One young roulette chip racker at Harolds, Christine Beck, recalled her days at the casino in correspondence with this author. She remembered LaVere Redfield well. "He was all business. It seemed clear to me he came to gamble, and that was all," she said. "He did not require much chatting from the dealer and certainly not from fellow players…[He] came in at that early hour just before the graveyard shift was leaving…some players felt it might tilt their luck to the good when dealers were most tired," she recalled. This was the period when Redfield was playing his roulette system. "I believe he did bring pen and paper. He had a system," Beck said.

Redfield was a math genius, and he had an astounding memory. He could remember and balance disparate figures in his head better than most people could do on a printed spreadsheet. Nobody was ever quite sure what betting system LaVere Redfield followed, because it was a hybrid system of his own design. Certainly he had enough money to play the Martingale, or progressive, system, and there is anecdotal evidence that he often doubled up on his bets until a winner appeared. Additionally, there is also anecdotal evidence that Redfield would sit for hours and carefully record each number as it occurred on the wheel, evidence of a repeating number system. In all likelihood, Redfield's method included portions of both of these popular systems, as well as bits and pieces from many others and perhaps even some unique elements of his own. We'll never know for sure.

Warren Nelson once remarked about his friend's play in his oral history book, *Always Bet on the Butcher*: "He was a 'system' player…and system players who have unlimited money are hard to beat…but although it takes more time, the house eventually wins." Nelson related a story that had occurred

Harolds Club opened the same year Redfield arrived in town. Shown here, the three generations of the Smith family who ran the hotel/casino discuss card strategy. They are (from left) Harold S. Smith Sr., Raymond I. "Pappy" Smith and Raymond Smith. *Special Collections, University of Nevada, Reno Library.*

while he was working at the Mapes Hotel in the early 1950s. "He [Mr. R, as Nelson called him] would come in six days a week, sit down for three or four hours, and grind out up to a thousand dollars a day." The Mapes had extended their normal limits for Redfield, allowing him to bet up to $250 on a single number (at 35-to-1 odds, a payoff of $8,750 when he won) and $10,000 on an even money bet like red or black, odd or even.

"At that time, that was an amazingly high limit, but he seldom bet it unless he was losing, when he would begin systematically progressing his bets higher with each loss and each roll of the ball, looking for the winner," Nelson said. After thirty days of losing continually to Redfield, the Mapes's bosses decided to shut him off, or reduce his limit. Nelson pleaded to be given one more week to allow the law of probability to catch up with Redfield. The bosses finally relented. After a few more days, Redfield's luck did indeed turn, and he was forced to bet the limit repeatedly, hoping to recoup his losses. But the losses continued, and they began to approach the $100,000

limit Redfield had deposited at the Mapes to play against. Finally, it all came crashing down. Redfield had multiple bets spread around the entire layout—all at the top of his limit—and as the roulette wheel spun one way and the ball the other, he deftly moved in and switched all his bets in an instant, a tactic that was allowed. The ball dropped into the number 3 slot—in the inside column of the betting layout from where Redfield had just moved his chips—and he was wiped out. Redfield's $100,000 loss is the equivalent of about $850,000 today.

"He had a sharp pencil and a pad on which he recorded every winning number," Nelson said, an indication of a repeating numbers system, "and when he finished writing down the number three, he remained motionless for many minutes…there's not much you can say to a man who's just lost a hundred thousand dollars," Nelson grimaced.

After about forty-five minutes of just sitting there and contemplating, Redfield rose and turned to Nelson. "Warren, I want to thank you very much for the grape juice," he said, referring to a small glass of juice he had been given earlier. "[He] was an amazing man," Nelson said admiringly. "He was tougher on a buck than anybody I ever saw…[but] some of the things he did were absolutely fantastic."

Regarding his "tough on a buck" statement, Nelson recalled another Mapes story. Redfield came in with a dividend check from Munsing Underwear Company for $47,400.04. He told Nelson he wanted to leave $20,000 at the cashier's office to play against and would like to receive the remaining amount in change. Nelson cashed the check with the cashier and sealed the $20,000 in an envelope. Then he handed Redfield his change, $27,400 in large bills and asked, "Is that right, Mr. R?" The multimillionaire looked at the money and casually said, "No, that's incorrect. You forgot the four cents."

"My God, I did forget the four cents!" Nelson said sheepishly. He handed Redfield a nickel from his pocket, saying, "That gives you a little the best of it." Redfield responded, "That's fine with me, Warren. I like a profit."

The Mapes wasn't the only casino that raised its betting limit for Redfield. A March 5, 1952 article in the *San Francisco News* stated that Redfield was "one of less than 20 [gamblers] with unlimited credit in Reno's top casinos, who could present a $10,000 bill and have it cashed without a blink of the cashier's eyes."

During the early 1950s, when he played regularly at the Mapes, Redfield preferred to play at one particular wheel that had a great view of the Truckee River through a large window behind the dealer. He

would go in on a weekday, during the small hours of the morning when he could have the wheel all to himself, and try out some elements of the system he was developing. Redfield would buy a large stack of ten-dollar chips to test his theories, and because he was alone at the wheel, he could methodically record all the numbers as they fell. He was betting repeating numbers, and rather than have the dealer sweep away the chips each time after a losing spin, Redfield would pay him the amount equal to all the losing numbers and let the chips ride on the layout. On each losing number, Redfield would add another ten-dollar chip, so he was also playing a progressive betting system.

Ray Sawyer, a popular local entertainer of the day, keno writer, casino habitué and author of the book *Reno, Where the Gamblers Go!* would often watch Redfield's early morning casino sessions. "The last time I was able to watch LaVere's bout with the Mapes' wheel, he started with a list of eight numbers," Sawyer said. "In the ensuing twenty minutes he enjoyed fourteen repeats, totaling some $5,000." Sawyer pointed out that the win was small by Redfield standards, but he was obviously playing only to test his unique system.

Sawyer related another incident in a different casino where Redfield was again testing his system with $10 chips. This time he had lost about $50,000, which hadn't fazed him in the least. But another player was also at the table, a gentleman who was betting a $1 chip on some of Redfield's numbers, and he had lost as well. After Redfield stopped playing and cashed in his remaining chips, he approached the man and asked, "How much did you lose?" "About sixty dollars. Why?" the man responded. "I'm very sorry we didn't do any better," Redfield said. Then he peeled off three twenties and handed them to the startled player.

Mike Goodman, a longtime Las Vegas casino dealer and author of many books about casino games, wrote, "God have mercy on systems players. Only idiots play systems...if they think systems could beat a gambling house that the owners have spent millions to build, they are nuts." Most casino executives agree with Goodman's assessment, but some still admit that Redfield's hybrid system did work, even if they never understood how or why.

"The only system player I remember that was really good was Redfield," said Bill Harrah, certainly an expert on the subject, in his book *My Recollections of the Hotel-Casino Industry.* "He was a genius, and he could beat you. He beat us many times, and I don't know, in the overall, I think he probably came out ahead of us. But he had a system that was a good one...and he had the capital and the nerve." Harrah continued: "But Redfield—and I've observed him...I watched him play...he would be betting ten thousand dollars on a number, or four numbers, and he got there by starting at four hundred or

something, and it would get to ten thousand…But he sure knew how to figure out the odds and also how to play the game. He's the best I ever saw." That was lofty praise, indeed, coming from one of the industry's giants.

Harrah recalled that despite his aggressive play, Redfield was very mild mannered and polite. He would go into Harrah's Club and win or lose $50,000 on the wheel, but when the managers would invite him to stay for lunch, Redfield would demur, or, Harrah said, "He would go and just eat a little bit, and then on the way out he'd thank me."

Many Renoites, including a lot of people who knew LaVere Redfield personally, have questioned how a man who held on so tightly to his money could also be a high-stakes gambler. Even though Redfield believed he could beat the roulette wheel, he was certainly smart enough to know that there were risks involved, and gambling was the only activity where he would risk throwing away money. Robert Laxalt asked him those very questions during an interview for *American Weekly* magazine in 1952.

"Gambling at roulette is pure illogical foolishness," Redfield told Laxalt. "The people who gamble are foolish, and I'm one of them. The only excuse I can give is that I enjoy it as recreation. And since I have the money, I can afford to indulge in at least one private and expensive habit." Laxalt said that Redfield told him he always set a limit of a few thousand dollars on his casino activities. "If he loses this limit, he quits," Laxalt said. That may have been the man's practice in the 1930s and 1940s, but as his confidence grew and he developed his own system for playing, he far outstripped that "few thousand dollar" limit. Stories of his losing $50,000 to $100,000 in a day are many.

In fact, he told a *Los Angeles Examiner* reporter in the early 1950s, "I know I can't beat roulette. I never play for more than $30,000 at a time." Today, that amounts to a cool quarter of a million dollars, a tidy sum by anyone's standards. He told a similar story to the *San Francisco News*: "Gambling is bad. You can't beat the odds. It's all right for me to do it, because I can afford to lose."

Redfield's wife, Nell, contradicted his statement that he'd quit playing after losing his limit on any given night. She told one of her estate attorneys, Clel Georgetta, after LaVere's death that when LaVere ran out of money downtown, he would come back home, go down to the basement where he stashed huge sums of money and valuables and get more $1,000 bills. Then he'd go back downtown and resume playing.

Of course, Redfield didn't always lose; in fact, he probably won more often than he lost. He told Robert Laxalt that on a winning streak, he'd

often ride his luck for as long as thirty-five hours in one sitting. Although that sounds like an incredibly long time, hard-core gamblers are known to play for very long stretches, win or lose.

Redfield provided Robert Laxalt another possible explanation for his gambling, saying, "After you've made a certain amount, money ceases to have any value…I have enough money so that most of it has no importance for me."

Warren Nelson said that because he and Redfield were good friends, the gambler faithfully followed him from club to club over the years. After his stint at the Mapes ended in 1954, Nelson spent nine years back at the Palace Club where he had gotten his start, and Redfield often played there. On April Fools' Day 1962, Nelson and five partners reopened the Club Cal-Neva at 38 East Second Street. True to form, his buddy Redfield would occasionally stop in to play the Cal-Neva's wheel, but he never became a regular. "When we first opened Cal-Neva, we didn't deal as high a place," Nelson admitted in *Gaming from the Good Old Days*, "so I didn't get that much business from him…he was still a tough player, but a nice guy to be around. I learned a lot about the business from him."

In the decades of the 1960s and '70s, Redfield continued to spread his business around. He still played often at his buddy Lincoln Fitzgerald's Nevada Club, where the Monte Carlo wheel gave him better odds, and Fitz granted him a high limit. Chuck Clifford, a longtime dealer at Harolds Club, said in a personal interview that Redfield continued playing regularly at Harolds, too. He had become a little more cautious about carrying large sums of money around with him by this time, and he would usually leave his winnings at the cage when he departed. One time, Clifford said, Redfield went to claim some of his money at the cage. He told the credit manager he had forgotten to bring his receipt. The manager, knowing Redfield as an excellent customer, gave him the money anyway. Redfield returned a few days later with the receipt and demanded to be paid again. He got his money—for the second time—but he was never allowed to collect again without a receipt in hand. "A lot of time people, if they've played for years, feel like they deserved it," Clifford explained about Redfield claiming the double payment.

There is a lot of anecdotal evidence that Redfield was not above a little bit of chicanery at the roulette table. Rumors of past posting (placing a bet after a winning spin), pressing (increasing a bet after a winning spin) and pinching (decreasing a bet after a losing spin) are frequent when discussing Redfield's play with old-time dealers. Chuck Clifford's explanation probably

comes closest to describing why some gamblers do those things. In Redfield's case, if the accusations are true, it certainly wasn't the money that would have motivated him.

Redfield occasionally played at the downtown Holiday Hotel-Casino after it added a roulette wheel in 1957, and he liked the ambience at the Riverside Hotel on the river. Real estate broker Preston Q. Hale told of encountering Redfield at the Riverside. "Norma [his wife] and I would go to the Riverside Hotel for dinner," he wrote. "When we'd go out into the casino we'd sometimes see a big crowd around a roulette wheel. I'd tell our dinner guests, 'There's LaVere Redfield.' We'd walk up and see stacks of $50, $100 and $500 chips around him. He always had a personal limit of what he'd gamble on a particular night. It averaged, I believe, about $25,000."

Finally, despite his preference to walk downtown to play at Reno's casinos and hotels, Redfield did continue to visit the Sparks Nugget, by this time renamed John Ascuaga's Nugget. He would often go for dinner and a show—Liberace was one of his favorites—joined by his wife, Nell, and his personal physician, Dr. Hoyt Miles, and his wife, Luana. At Redfield's direction, Mrs. Miles was named one of the executors of his estate at his death, and his personal relationship with her would add a lot of dirty laundry to the folklore surrounding the man.

Redfield also played roulette regularly at John Ascuaga's Nugget in the late 1960s and early 1970s, right up to his death in 1974, according to Ascuaga in a personal interview. As the economy had improved, Redfield's wealth had grown along with it, and his roulette bets had also escalated. He would play up to $10,000 a spin, Ascuaga recalled. Redfield still followed his betting system religiously. "His system worked sometimes, and sometimes it didn't," Ascuaga said. "All of the systems—none of them we've seen yet work all the time. You can't beat the house odds."

Ascuaga was tickled by one incident he and Redfield shared. The aging millionaire had offered to give Ascuaga his very special "W7" license plate number, one of the oldest specialized plates in the county. Redfield invited Ascuaga to visit him at his office to do the paperwork. Once everything had been signed, Redfield told him the price was $1,000. Ascuaga was bewildered; he had been led to believe the license plate was to be a gift. The casino owner chalked it up to experience and gave Redfield the $1,000. The license plate is still on Ascuaga's car to this day, perhaps as a reminder of a lesson learned.

Although it was the exception rather than the rule, Redfield occasionally gambled on other casino games. Unverified anecdotal evidence holds that

he sometime played blackjack, and he also liked to test his numbers picking skills on keno from time to time. The Golden Hotel at 219 Center Street traced its roots all the way to 1906, and by the early 1950s, following a parade of different owners, the hotel opened the Golden Bank Casino. The hotel-casino became one of downtown's landmark properties. Barbara Brooks worked as a cashier at the glamorous Golden Hotel-Casino. She recalled in a personal interview that in the late 1950s and early 1960s, a keno player could play a twenty-four-hour keno ticket in the casino. The player would mark up one keno ticket and pay in advance for every game that would be played over the next twenty-four hours, anywhere from fifty to one hundred games. The player did not have to be in attendance but could return a day later and collect whatever winnings may have accumulated from all the games. LaVere Redfield would often come in, Brooks remembered, and play a twenty-four-hour keno ticket. She could not recall if he was a winner or a loser, but he was often in the casino for that purpose.

Like everything else LaVere Redfield did in his lifetime, his gambling was always on a grand scale. Today, four decades after his death, whenever a group of casino old-timers gather to share reminiscences, there are always one or two Redfield stories swapped around the table. Such was the huge influence this extraordinary man had on everything he touched.

9
The Boudoir Burglary

The late 1940s and early '50s were reckless years in Nevada. The state's casino industry had been deeply infiltrated by eastern mobsters, and mob violence was not uncommon. The chances are mob violence did not have much of an impact on Reno resident LaVere Redfield. After all, his only connection to the gambling world was his penchant for the high-stakes roulette he played regularly in Reno's casinos. He was a friend and a substantial customer of Lincoln Fitzgerald, who had been gunned down in his front yard, and Redfield himself had suffered a terrible mugging and attempted robbery just a few years earlier, so he was familiar with the vagaries of violent crime in Nevada's gaming capitals. But little did the multimillionaire realize that crime would come calling on him again in the very near future. Unlike the coldblooded, mob-affiliated professional killers who had lately been in the news, however, the cast of criminals that would become involved in Redfield's life was very different. They were a ragtag bunch of amateur thieves so clumsy and ineffectual they could have won starring roles in a Mack Sennett slapstick comedy.

It was called the nation's record burglary at the time, and it was important enough that FBI director J. Edgar Hoover even commented publicly when the ringleader was arrested. Newspapers from as far away as Canberra, Australia, carried stories about the crime, and the Reno papers ran special editions to keep readers up-to-date on the status of the investigation. *Time* magazine reported on the brazen burglary, and its companion publication, *Life* magazine, dubbed it "the Boudoir Burglary." It was that big, yet it had

begun in a very small way, on February 29, 1952. It started like this, according to the *Los Angeles Examiner*: "A stocky [*sic*] 54-year old man, dressed in faded jeans and a loudly checkered wool shirt, and his plainly dressed plump wife strolled down Reno's main street. In the middle of the block they met a smartly dressed woman and stopped for a brief chat. Then Mr. and Mrs. Laverne [*sic*] Redfield went on to luncheon at the Riverside Hotel and a bit of roulette."

The "smartly dressed woman" the couple had encountered was thirty-six-year-old Marie Jeanne D'Arc Michaud. A French Canadian divorcée, she described herself as a songwriter and authoress. She knew the Redfields, or at least LaVere, and had been a dinner guest at the stone mansion on a number of occasions. Some months later, as the event heated up in the media, she even claimed to have shared a pillow with Mr. Redfield on many occasions, a dalliance from which he would quickly try to distance himself. She was also, surprisingly, the mastermind behind the record-breaking heist. She had planned the whole caper based, she claimed, on Redfield's broken promise to leave his wife, Nell, and marry her. But on this fair Leap Year Day, strolling casually down Virginia Street in downtown Reno, she had another, more important role: she was the lookout. She was to alert the rest of her merry little band when the Redfields were a safe distance away from their house and otherwise occupied.

With her personal knowledge of the stone mansion's layout, she had recruited six other bunglers to assist her. It was an odd group: Louis "Young Firpo" Gazzigli, a forty-four-year-old ex-pugilist, casino bouncer and occasional bricklayer; his brother Anthony, a forty-one-year-old casino janitor; and sixty-five-year-old Benton Henry Robinson, a caretaker at the Stardust guest ranch just outside the Reno city limits on Dickerson Road. Joining these three Reno men were a trio of out-of-towners from Milwaukee: ex-convict Andrew Robert Young, forty-six; Frank J. Sorrenti, thirty-six, a house-to-house soap salesman; and John B. Trilliegi, thirty-seven, who enjoyed the same profession. The three Wisconsin men had just recently motored into Reno in a big Cadillac owned by one of the trio.

Ms. Michaud had an eye for planning and detail. Each of her accomplices had been assigned specific tasks so nothing would be overlooked. The ex-boxer/bricklayer had been the go-between. He had brought the three out-of-towners, who were the actual hands-on burglars, into the plan. Using a crowbar, they entered the Redfield house through the rear kitchen door after receiving word from the songwriter that the Redfields were safely out of the way. One of the three men removed an appropriate treat from the

Redfields' refrigerator and gave it to the watchdog to occupy him. A meaty hambone was selected, a good choice, as it turned out, and the Kerry blue terrier named Mac happily surrendered his post in return for the bone.

The Milwaukee men then went straight to a closet in LaVere's bedroom on the ground floor. In the back of the closet, hidden behind some clothing and luggage, was the prize: a four-hundred- to five-hundred-pound green metal Yale safe that Redfield had told the songwriter held lots of valuables. Or so she later claimed. Her original plan called for the three men to open the safe and cart the swag away. However, the ex-convict who was in charge of the safe cracking found the job too complex, so the men decided to take the safe with them. They had more strength than wisdom, and they dragged the heavy strongbox through the kitchen and out the back door and wrestled it into the trunk of the Cadillac. Fortunately for Redfield, they had failed to search through the suitcases in front of the safe, one of which held another $1 million in negotiable securities.

Meanwhile the casino janitor arrived at the scene in a borrowed green truck. His assignment was to lead the Milwaukee Cadillac and its occupants back to the guest ranch, where the co-conspirators would tally their take. While Mac, now tethered in a rear bedroom, continued to chew contentedly on the hambone, the four men drove away.

At the guest ranch, the elderly caretaker and the ex-boxer/bricklayer waited. The caretaker's job was to hide the safe until the booty could be divided by some prearranged formula. He initially put the safe under the ranch house but would later move it to the barn. The bricklayer had been brought along as muscle, should the need arise.

Unaware of all this activity, LaVere and Nell Redfield were still at the Riverside Hotel. They may have chatted about the suspicious activities that had occurred around their stone house some weeks previously. They had heard prowlers outside. On another occasion, Nell had even opened a door and seen a stranger hurriedly leaving their yard. Another time, they discovered footprints in the snow circling the large house, and there had been repeated telephone calls where the caller remained silent. They had reported these suspicious happenings to the police, but when the incidents ceased, they put them out of their minds. As it turned out, most of this mischief had been the heavy-handed plotters' idea of surveillance.

After lunch, Nell attended a fashion show at the Riverside Hotel while LaVere played roulette. He returned home alone at about 2:00 p.m. and discovered the burglary. He immediately went to a neighbor's house and called the police. When they arrived minutes later, he was sitting quietly

on a large boulder on the vacant lot he owned next to the house with his thoroughly sated watchdog Mac by his side. When newspaper reporters, advised of the huge burglary, arrived on the scene later that day, he refused to provide any information on the value of the stolen goods. "It really does nothing but make people's curiosity aroused more," he said. "It might even obstruct justice."

He also refused to lay any blame at the paws of his friend Mac. "They can have the money as long as they didn't kill my little dog," Redfield said.

The first local newspaper report of the incident the next day startled Reno residents. "If police estimates on the amount in the safe prove correct, the burglary will be one of the largest on record," the *Nevada State Journal* reported. "The largest cash robbery in history was the $1,219,000 holdup of Brinks Armored Car office in Boston in 1950." One of the policemen on the scene went a step further: "This makes the Brinks job look like kid stuff."

Lieutenant Francis Quinn of the Reno Police Department was the man in charge of snapping photographs of the crime scene, the equivalent of today's CSI activities. He was the first one to discover the suitcase with the $1 million in signed securities that the burglars had overlooked. He also made another odd discovery in LaVere's closet, recalled his son, bank investment officer Dave Quinn. There were about three dozen brand-new men's suits hanging neatly on the clothes rack, all of them apparently unworn, with their price tags still hanging from the sleeves.

The initial police estimate of the loss, provided by Redfield, was $300,000 in currency, from $1 bills all the way up to $10,000 bills, including some of the old-style large notes that had not been in production since the 1920s;

An unidentified law enforcement officer is photographed removing evidence from a sofa in LaVere and Nell Redfield's Mount Rose Street home after the record-breaking burglary in 1952. *Special Collections, University of Nevada, Reno Library.*

Opposite: In this illustration from an article on the famous Redfield burglary that appeared in the *American Weekly*-Sunday supplement in 1952, LaVere Redfield, with his watchdog Mac, is interviewed by police officers following the heist. It was the largest burglary in U.S. history at that time. *Permission for use, Hearst Corporation; copy of illustration, Special Collections, University of Nevada, Reno Library.*

$50,000 to $100,000 worth of jewelry belonging to a friend and debtor of Redfield, Mrs. Louise Root; and securities worth $1 to $2 million. Redfield had signed all the securities, so they were completely negotiable, like a signed check. Later it was learned that Mrs. Root's jewelry consisted of twenty-one pieces, mostly family heirlooms. The total haul was reportedly close to $3 million. However, the final tally provided later by the FBI was $2.5 million, more than $20 million at today's currency rate. Redfield confirmed that none of his stolen possessions were insured, but Mrs. Root's jewelry was.

When quizzed by a reporter if the theft would wipe him out, Redfield replied, "Just say that I don't want anyone to feel sorry for me." He also pleaded a *mea culpa* in an interview with another newspaper reporter the following day, saying, "The radio says I'm a famous figure today. I would say I'm a stupid figure."

Despite the record-breaking burglary, and his mugging four years earlier, Redfield said he still loved living in Reno. "It was just a money saving matter [when he moved to Reno from California]...But I love Reno. I've found something to enjoy here. I've never been in a place where I was so pleased with the year round joys of living." The very private millionaire's good-natured responses to the reporter's questions evaporated, however, when he was asked if he had any more safes in the house that were stuffed with money. "Why do you ask me that?" he snapped. "If I'm lucky enough to have 25 or 50 cents left, why advertise it? Do you want them to come back and get that too?" End of interview!

The crime and its attendant publicity would change the lives of LaVere and Nell in many ways. Despite their wealth, they had been able to largely maintain their anonymity in Reno for seventeen years. LaVere was, the *Nevada State Journal* said, "the least known multi-millionaire in the United States." No more. "When the burglary happened, I had a premonition of what was to come, and it scared me," Redfield said. Newspaper and radio reporters from around the West converged on the house at 370 Mount Rose Street at all hours of the day and night. They were allowed to enter the kitchen, but they could go no further, and they had to take a gentleman's oath to leave all cameras outside.

One week after the crime, during an interview with a United Press news syndicate reporter, Redfield made a bold statement about his loss of privacy. "There is a likelihood I may quit my gambling. [Before the burglary] I could come and go as I wished and not many people knew who I was. Now, everyone will know my identity. They will follow me when I gamble. I don't want to be the goat leading the sheep...I guess I'll have to find something

else to do." Of course that would turn out to be a hollow promise; he never stopped gambling.

It would only take a few days before tips began coming in to police and clues were uncovered. Neighbors reported seeing an old green Ford pickup truck in the neighborhood that didn't belong there, and Reno chief of police Roy Greeson said a small wrapped bar of soap from the St. James Hotel in Davenport, Iowa, was found in the closet. Detectives opined that the soap had been intended for use in the safe cracking but had been abandoned when the robbers decided to take the unopened safe with them. A brown suit button was also found under the bed that did not match any of Redfield's suits. These had obviously been well-dressed burglars.

The day after the burglary, a Cadillac with four men and a woman was stopped in Butte, Montana, and they were held for questioning. However, they were soon released when they were able to provide a perfect alibi: they had been in a jail cell in Elko, Nevada, for slot cheating at the time of the crime.

Meanwhile, back at the ranch, the three Milwaukee men, the elderly caretaker and the ex-boxer/bricklayer had abandoned the last vestiges of the delicate art of safe cracking and had taken a sledgehammer to the heavy metal box. It worked. Out tumbled all the goodies—bundles of 1920s-era oversized $10 bills; packets of neatly banded $1,000 bills with chubby-cheeked Grover Cleveland glowering beneath his droopy moustache; Mrs. Louise Root's treasured emerald-and-diamond brooch; crisply signed securities issued by the sewer pipe manufacturer Gladding, McBean and Company of San Francisco; and assorted other valuables almost too plentiful for the five conspirators to comprehend.

The men loaded the battered safe into the truck, and the ex-boxer/bricklayer, Young Firpo, drove away to dispose of it. Whether by irony or simply bad karma, Young Firpo threw the safe down an abandoned mine shaft that just happened to be located on a piece of property owned by LaVere Redfield.

Somehow, somewhere, the gang reassembled within a couple days and divided the loot. The songwriter, the brains of the operation, immediately split town with part of her share, deservedly the largest portion. The caretaker stuffed his share and the remainder of the songwriter's share into a pillowcase and shoved it under the seat cushion of his easy chair. The two soap salesmen headed back to Milwaukee in the Cadillac, happy to be getting out of Reno with a lot more money than they had arrived with. The third Wisconsin man, the ex-convict, decided to stay on in Reno for a few more days. It seems he had met a girl at Harolds Club the morning after the

burglary—pretty, four-time divorcée Leona Mae Giordano—and he wanted to spend a little quality time with her. We'll label the thirty-year-old Ms. Giordano the "pickpocket" for reasons that will soon become evident.

After a few drinks together at Harolds, the ex-convict invited the comely pickpocket to join him on a shopping trip; he wanted to buy some natty new clothes before returning to the Midwest. While he was struggling into a nice pair of slacks at Herd & Short's clothing store, the pickpocket worked her magic on a wallet in his old pants, which were hanging over the wall of the fitting room, and she found an additional $1,700 in his coat pocket. Quickly she exited the menswear store and made her way home. When she opened the wallet, she was amazed to find $9,100 inside. What the pickpocket had planned as a small peccadillo had turned out to be a bonanza. She tucked most of the swag inside a box of soap chips—soap seems to have played a big part in this drama—took a few bills and headed to her favorite casino. When the ex-convict discovered the theft, he raised hell all around town but could never find his ex-paramour. He went back to the casino janitor and browbeat him out of a little more cash. Then he caught the next plane out of town.

The first big break in the case—the loose thread that would eventually unravel the entire caper—came only ten days after the historic heist, when the now flush pickpocket had a run of bad luck at a blackjack table and decided to cash one of the $1,000 bills. It was the break the police had been waiting for. Redfield, wisely, had recorded the serial numbers of most of the large bills in the safe, and the police had alerted every casino in town to the serial numbers of the missing bills. The FBI had entered the case by this time, and the pretty pickpocket was picked up for questioning. Realizing what a nasty pile she had inadvertently stepped into, she quickly told the FBI that a handsome fellow from Milwaukee had given her the money. The pickpocket was soon released and immediately fled to Los Angeles, where she would later be rearrested when the truth of her light-fingered activities was exposed.

Police in Milwaukee were alerted, and within a few hours, the ex-convict was back behind bars. The two soap salesmen joined him there in short order. The casino janitor had fled to Sacramento, but he was soon picked up, returned to town and thrown in the Washoe County jail. The French Canadian songwriter was the next domino to fall. She had left Los Angeles on a first-class ticket to Chicago on the Santa Fe's California Limited. She was unceremoniously plucked off the train in Flagstaff, Arizona. Taken from her was $50,000 in cash, all of Mrs. Root's jewelry and more than 180,000

The leader and alleged "finger woman" of the massive Redfield burglary, Marie Jeanne D'Arc Michaud, thirty-six years old, is shown at the Coconino County jail in this United Press Telephoto picture after she was arrested in Flagstaff, Arizona, while fleeing to Chicago. *From the United Press.*

shares of negotiable securities from fifty-seven different companies. After secretly gulping a handful of sleeping pills and sobbing something about "revenge"—supposedly directed toward LaVere Redfield—she was jailed in Flagstaff, to be returned soon after to Reno.

In the meantime, however, she tried to explain herself and her pure motives to the editor of the Flagstaff newspaper. "I planned the whole job

and made all the arrangements," she sobbed. "My parents taught me to be generous and to help needy people. I intended to use the money for good purposes." She went on, "I made up my mind that as long as I was going to be LaVere Redfield's sweetheart, I was not going to be without the price of a room." And speaking of Redfield, she said, "That old miser had a couple of million dollars laying around the house, besides many other millions. I decided this money should be placed in circulation." As to the revenge she had earlier mentioned, she would only say that she had "personal reasons for my desire for revenge" against Redfield.

The FBI, in announcing these arrests in the newspapers, also corrected the figure that had been floating around about the size of the burglary. They said the take had been $1.5 million, not the $2.5 million initially claimed. The difference was in the value of the negotiable securities, which Redfield had said were worth between $1 and $2 million. The chastised millionaire explained, "I guess it just depends on which of the figures you use in arriving at a total."

Four days later, the roundup continued. The pickpocket was rearrested in Los Angeles, and Young Firpo, the ex-boxer/bricklayer, was picked up in Reno. They joined the others in Chief Greeson's Washoe County lockup. The elderly caretaker was the last domino to fall, and his money and some of the songwriter's was discovered still stuffed under the cushion of his easy chair. His link to the others became clear when it was discovered that the songwriter had been living at the guest ranch for the past few months.

Once all the conspirators were in custody, each one began weaving a different story. The songwriter contended she had taken the money in order to get it into circulation; the elderly caretaker claimed he had just been helping out a friend; one of the soap salesmen said he had heard about the burglary from an associate but knew nothing more about it; and the ex-boxer/bricklayer said he could identify the location of the mine shaft where the safe had been dumped. All of the confessions, and the gathering library of background material the media continued to uncover about the thieves, provided a steady diet of articles for the newspapers for months. Meanwhile, the U.S. attorney's office carefully crafted its case against the wrongdoers.

On April 1, barely a month after the nation's record heist, six people were indicted by a federal grand jury in Las Vegas. Not named in the indictment were Reno's Gazzigli brothers—the casino janitor and the ex-boxer/bricklayer—but they would join the others shortly. The rest of the gang was indicted on federal charges of transporting stolen money across state lines, charges that would keep them in custody while the wrinkles were being worked out.

Mrs. Leona Mae Giordano—the pickpocket—was the first scheduled to go on trial on Wednesday, June 18, 1952, in federal court in Carson City, a forty-five-minute drive from Reno. By this time, the FBI had recovered all but about $170,000 of the massive $1.5 million take, and they were justly proud of their work. But an unforeseen problem surfaced: LaVere Redfield had disappeared after being issued a subpoena to appear at trial.

The victim of the crime was one of the prosecutor's chief witnesses. Without Redfield testifying, could it even be proven that a crime had been committed? U.S. assistant attorney Bruce Thompson had been trying to contact Redfield since the previous day, and nobody, including his wife, knew where he was. It was believed he might be in Los Angeles attending a stockholders' meeting for one of the many companies he held a stake in, but he couldn't be found. The pickpocket's trial went forward, and federal judge Roger Foley ordered that Redfield be arrested and held under a $50,000 bond.

Two days later, Reno's *Nevada State Journal* reported on Mrs. Giordano's trial, writing, "While the trial was in progress, FBI agents and officers of the U.S. marshal office scoured the West for some trace of Redfield. The latter is a reluctant witness." Reluctant witness may have been the understatement of the decade. For reasons of his own, the millionaire wanted no part of the proceedings. Despite his wishes, however, the FBI finally tracked him down the following day at the home of friends in Sebastopol in the north Bay Area, and the reluctant Redfield was unceremoniously dumped in the San Francisco jail. By posting the $50,000 bail, the judge told him, he could be sprung, but Redfield had another surprise in store for officials. He told them he could raise the money "in a minute, but it is not my desire to make bail. My only reason for this is to avoid pictures being taken," he explained to the judge. "You can make it [the bail] $100,000 if you want. I don't care. My only desire is to thwart these photographers. They're all nice fellows. I like to visit with them, but I don't want my picture taken. I'm not very good subject matter."

Many times during his lifetime Redfield would exhibit this fanatical aversion to being photographed. His desire to remain unrecognized was a core part of his desire for anonymity. Because of this, there are only a couple press photographs of Redfield where he is not attempting to cover his face in some way.

The pickpocket's trial went on without the reluctant victim, despite protestations by her attorney that Redfield should be present. The jury found Mrs. Giordano guilty.

Redfield, meanwhile, was returned to Reno and spent the night in the county jail, in a cell that was uncomfortably close to the cell of his ex-friend and victimizer, the songwriter Mrs. Michaud. It turned out to be old home week, as lodged in the same cell as Redfield was the guest ranch caretaker, Mr. Robinson, who had pleaded guilty for his part in the crime. It's not known if the three exchanged any pleasantries, but it was a bad night for Redfield, as a *Nevada State Journal* photographer managed to snap a pretty good photo of the elusive millionaire with a shocked look on his face as his fingerprints were being taken. However, the soft-spoken Redfield quickly regained his equanimity, and his sense of humor. During his booking, one of the deputies asked his occupation, and Redfield calmly answered, "Unemployed." He decided later in the morning that he would post bail after all rather than spend another night with so many old acquaintances.

The following morning, Monday, June 23, was the big day. The songwriter, Mrs. Michaud—dubbed by the press as "the alleged finger-woman"—was to go on trial for her part in the caper. The victim, Redfield, who would be testifying against her, arrived in court in his normal uniform, faded blue Levis and a tieless tan shirt, which he described to the judge as "my Sunday best." First to testify was the casino janitor, Anthony Gazzigli, who had turned prosecutor's witness against the others. He told how Mrs. Michaud said she wanted to get revenge on Redfield. When asked about the specifics of the conversation, he replied, "All about Redfield...how cheap he was, and that sort of stuff; that he kept saying he was in love with her...that he played her so dirty she wanted to get revenge." He also told about how Mrs. Michaud, through the elderly caretaker, had first approached him about the scheme and how she had later provided him with floor plans of the Redfield house.

LaVere Redfield also testified. With his wife, Nell, sitting in the front row, he told jurors how he and Mrs. Michaud had first met when he went to her apartment to discuss her wish to borrow some money. She could not use normal loan channels, he explained, because she had entered the United States illegally. "That's not true!" Mrs. Michaud yelled out in a heavy French accent as she jumped up from her chair. Following the judge's warning to the defendant, Redfield continued. Mrs. Michaud had visited him at his home while Nell Redfield was vacationing out of the country, he said. Once, she had hidden in the bedroom when some friends came to call, and that was likely when she discovered the safe, he guessed. He also said she had gone through his wallet in the bedroom, an incident that spurred him to call her "a snoop." He said he gave her a little money—about thirty dollars—and had never seen her again until the day of the burglary, when they had

encountered each other in front of the Riverside Hotel. Day one of the trial had been a gossip bonanza for the spectators, the press and the general public, and everybody was anxious for the trial to resume the next morning.

Day two was everything trial watchers had hoped for. The alleged finger-woman took the stand in her own defense. She agreed with Redfield's story that she had hidden when friends of his and Nell's had knocked on the front door, but she claimed she had hidden in the closet, not the bedroom. It was at that time that she discovered the safe, Mrs. Michaud stated, inferring that she had not been snooping as Redfield had charged. Upon leaving the closet, and to the titters of the spectators and the jurors, she said she had then taken off her shoes and skirt, and feeling tired, had taken a nap on LaVere's bed. After some time, she said, she awoke and Redfield was standing over her. He told her not to get up, saying, "I like to see you in my bed."

Then, she testified, the conversation turned to the safe she had seen. "You've talked about making me financially independent. This would be a way to do it," she testified she had told the millionaire. In ten minutes time, according to Mrs. Michaud, she had convinced Redfield to give her the contents of the safe. So Mrs. Redfield would not get suspicious, Mrs. Michaud suggested she could send some henchmen to pretend to steal it. Wouldn't the henchman take some of the loot? Redfield asked her, and she replied with a straight face, "I would pick honest thieves."

"He was trying to kiss me, but I said, 'No, I will never be yours again unless this is a deal.'" When pressed for more details by the prosecutor, Mrs. Michaud said, "We sealed the deal. You don't have to do it with pen and pencil. There are other ways."

In the same contrived language, Mrs. Michaud testified about how cheap Redfield was. At one point, she said he wore different colored shoelaces on his thirty-year-old boots, but at the same time, "[he] pays $5,500 or $6,000 for a mink coat." She did not identify the recipient of the mink coat, but few in the courtroom needed to have it spelled out for them. She also said that during the previous December, she and Redfield had met in Los Angeles and taken a room at the El Rey Hotel under the names Mr. and Mrs. Arthur C. Grant, which was the same name she had used when fleeing to Chicago after the burglary.

Following Mrs. Michaud's riveting, but occasionally rambling, testimony, an FBI agent took the stand. He had taken a confession from her at the Washoe County jail during which she said of herself and Redfield, "We became very friendly…[he] has even gone so far as to indicate he would divorce his wife and marry me." After the testimony of this witness, the

federal prosecutor rested his case. Through all this, Nell Redfield sat stoically in the front row.

When the trial resumed the next day, there was a bombshell of an announcement from the FBI. Agent D.K. Brown testified that among the contents of the safe the FBI had recovered from the bungling burglars was a holographic will, handwritten and signed by the eccentric Redfield. Part of the will instructed his wife, Nell, to destroy the pages that contained the following instructions: "No one knows of the currency on hand. The government can't tax wealth which can't be located. Burn this and tell no one lest the government instead of you be the beneficiary via the estate and income tax. Carry on as though no coin or currency was left until such time as you can safely and wisely use it."

A note attached to the will explained where the coin and currency could be found:

> *Find the exact center of the wall at the north end of the basement at 370 Mt. Rose St., and drive a hole through it large enough to permit you to crawl through. There you will find coin in the amount shown on the three accompanying sheets.* [These sheets were never made public.]
>
> *PS: I suggest that you retain it as is, for the reason that some of it commands a premium at this time and all of it should increase in value over a period of years.*

Today, this would be called an "Aha! moment" for the FBI. Agents had quickly followed Redfield's instructions, and behind a thirty-nine-inch concrete wall, they discovered $20,000 worth of postage stamps and 270,000 silver dollars, weighing more than two and a half tons. The FBI had the cache transferred to a local bank for safekeeping.

As for the bedroom bargain Mrs. Michaud had testified to, in his closing argument the prosecutor alluded to the secret cache of silver dollars, saying to the jury: "Doesn't it strain your credibility to believe that Mr. Redfield would give her permission to steal a safe containing papers showing the location of 270,000 silver dollars?" It was a convincing argument. After deliberating for just over two hours, the jury found Mrs. Michaud guilty of transporting $147,000 of the Redfield loot across state lines, a federal offense. Mrs. Michaud; Mrs. Giordano, the pickpocket who had previously been found guilty; and Henry Robinson, the guest ranch caretaker who had pleaded guilty, were ordered to appear on June 30 for sentencing.

On June 30, the three co-conspirators went back to court. With little fanfare, the songwriter, Mrs. Michaud, stood quietly before Judge Roger Foley dressed in a tight-fitting black suit with a red silk scarf around her neck. The judge admonished her, "This venture could have resulted in death" and then sentenced her to five years in a federal women's prison. She displayed no emotion as she was led, shackled, from the courtroom.

A contrite Mrs. Giordano, the pickpocket, who had no prior record, told the judge she would like to make restitution for the $10,800 she had taken from the ex-convict's trousers and coat. The judge told her, "You need time to sit down and think things over" and sentenced her to one year and one day in a federal women's prison. And finally, the sixty-five-year-old Robinson, the dude ranch caretaker who had pleaded guilty, was sentenced to four years in federal prison.

In late July, two of the three men from Milwaukee—the ex-convict and one of the soap salesmen—were returned to Reno, where they went on trial on state charges for burglary. The federal charges against them had been dropped. Both pleaded guilty and were sentenced to five years in the state prison in Carson City. The third Wisconsin man, Frank Sorrenti, was released when neither county nor federal authorities believed they had enough evidence against him to proceed.

On September 12, the Gazzigli brothers from Reno were re-arrested and went to trial the following week. Anthony, the casino janitor, had cooperated with prosecutors and had testified at the trial of Mrs. Michaud. "I'm singing to save my skin," he had told reporters. He was given probation as a reward for his songs. Young Firpo—the ex-boxer—was not as lucky. He was given a one- to five-year term in the state prison.

After the record-setting burglary and trial were finally over, a nagging question still remained. About $170,000 of the cash Redfield purported to have had in the safe was never recovered. However, given the millionaire's penchant for obscuring the truth when it came to his wealth, there remain questions to this day about the true amount of the haul.

And finally, there is one fascinating footnote to the story of the Redfield burglary. Police had discovered that a suitcase placed in front of the safe in Redfield's closet was filled with more than $1 million in negotiable securities, but it had been completely overlooked by the burglars. Subsequently the FBI discovered the 270,000 silver dollars secreted behind a concrete wall in the basement. But even with all these lawmen poking into every nook and cranny in the old stone mansion, they had still missed something.

Ken Walker was the president of the Farmer's and Merchants Bank in Long Beach, California. LaVere Redfield had long maintained an account

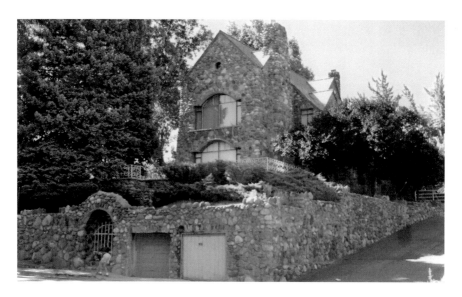

This photo of the Hill/Redfield stone mansion shows the two garages dug into the hillside at the bottom of the knoll, fronting Mount Rose Street. It was in this garage, jammed in front of a vintage Lincoln automobile, that Redfield had carefully hidden a crate loaded with approximately $600,000 worth of collectible coins. *Photo by Marilyn Newton*, Reno Gazette-Journal.

at the bank, dating back to his residence in Long Beach. Walker and Redfield had become chums, and Walker would also assume an important role years later working for Nell Redfield and the Redfield estate team after LaVere's death. LaVere had related the following story to Walker after the 1952 burglary, probably in a little show of one-upmanship against the inscrutable J. Edgar Hoover and his FBI agents.

As Redfield related to Walker, behind the padlocked doors of one of the garages, down the hill from the house at street level, was stored an ancient 1922 Lincoln that Redfield had acquired somewhere. The front bumper of the car was about eight feet from the stone wall that formed the rear of the garage, and between the two was a huge pile of debris: boxes, cans, broken lumber, smashed furniture and other junk heaped higher than the hood of the old Lincoln. Buried underneath all the debris—completely unknown to the FBI—was a large, rotting wooden crate, four-feet wide, four-feet high and about eight or ten feet long, covered with dust, dirt, grime and cobwebs. LaVere had hidden the box there in 1951, Walker said Redfield had told him.

The box was full of cloth sacks stuffed with more silver dollars, along with some silver bars. Most of the cartwheels were uncirculated, and many dated

from 1879 and 1880. At the time of the eventual discovery of the hidden crate, Ken Walker estimated that the face value of all the coins inside the box was easily $2 million. At least one Redfield family member, who wishes to remain anonymous, was not the least surprised by this finding. She said that Redfield family folklore insists that there was a large amount of money and silver that has never been recovered up to this day.

This cache of silver in the garage would not be discovered until after Redfield's death more than twenty years later.

It was March 12, 1954, and the local papers had been carrying news on a daily basis of a string of home robberies in Reno—sixteen in all—that only served as a constant reminder to Redfield that $170,000 of his money had never been recovered. The police and the newspapers had labeled the thief the "Daylight Burglar" because he always struck in broad daylight. Although he was obviously audacious, he was not very effective, as most of his heists would prove. He had taken $0.64 from one home, $1.50 from another, a cheap fountain pen from another and a light lunch of chicken and milk from yet another. His biggest haul had been $20.00 in cash and $430.00 in men's clothing from a gentleman's apartment at 226 California Avenue, a real bonanza for the Daylight Burglar. His crime wave had included both private homes and offices. Police had become more concerned when the man took two handguns, along with $10.00 and a hat, from a home at 25 St. Lawrence Avenue.

At 4:30 p.m. on March 12, LaVere Redfield arrived back at his house after a visit downtown. Nell was away somewhere. Redfield entered through the rear door as was his custom, and upon entering the house, he heard the front door close. Strange, he thought, as he walked to a front window and peered through the glass. He saw a handsome, broad-shouldered man with wavy black hair wearing a spiffy tan suit hurriedly leaving his property on foot, clutching a canvas bank sack in his hand. Redfield immediately ran to a neighbor's house and told her to call the police. Then, keeping a safe distance behind the man, Redfield began to follow him as he walked casually down the street. After about a block, Redfield spotted a police patrolman who, according to the newspaper, "was doing some off-shift cruising" in the neighborhood, looking for the burglar. Redfield joined him in the car, and they continued shadowing the suspect from a distance. Eventually the two men were joined by three other police officers, and they saw their prey enter a bar at Mount Rose and Virginia Streets.

The whole crowd went into the bar, and forty-two-year-old ex-convict William S. Clark was taken into custody without incident. The tan suit Clark was wearing was the same one he had lifted from the apartment on California Street. In the canvas bank bag was probably the best haul he had ever made: twelve silver dollars and perhaps one hundred other old coins from Redfield's house.

Clark told police he had just arrived in Reno and registered in one of the city's more expensive hotels as a Houston, Texas oil company executive. But, he admitted, that was not true, and he told them he had been released from Huntsville Federal Prison in Texas only a month earlier.

"I didn't even know who Redfield was until the cops told me," he told the local newspaper later, likely lamenting his poor choice of targets. Reno chief of police L.R. Greeson, a neighbor of Redfield's, remarked that the millionaire did "a fine job in helping us catch this bird."

But it was probably a quote uttered by a detective in the burglary squad that resonated most strongly with LaVere Redfield. "We got to stop it," he said of the break-ins. "This is getting personal."

Trouble Brewing for LaVere Redfield

Long before northern Nevada entered the brewpub era in 1987, many Nevadans had a taste for another locally made brew, Sierra Beer. Lovingly crafted by the Reno Brewing Company since 1903, Sierra Beer was not without local competition. Even before the dawning of the twentieth century, many different beers and ales were turned out in breweries in Carson City, Virginia City and throughout many smaller towns across the Comstock region. Beer was a staple in Nevada's mining towns, more trustworthy than the water in most places.

But the Reno Brewing Company had staying power. Long after all the others had closed, the company continued to brew Sierra, One Sound State and other companion brands. In fact, Sierra was in production all the way up to 1957, when it was finally forced to its knees and closed the doors forever. Seven years before that, a lengthy newspaper article on the brewery described its primary product: "Sierra is a Nevada beer in every sense of the word. Not only is it made at the only brewery in the state; it is sold almost exclusively in Nevada…Its principal market is in the 15 northern counties of its own state."

The company had been founded in 1903 by Montana brewer Peter Dohr and two associates whom he would eventually buy out. Dohr ran the company until 1941, when his son Roland took the helm. For its entire half-century existence, the Reno Brewing Company turned out its products from a plant at 900 East Fourth Street in Reno, although the facility was regularly upgraded and expanded. World War II had a deleterious effect on the company. It

The Reno Brewing Company on East Second Street had been brewing Sierra Beer since 1903. In 1940, famed architect Frederick DeLongchamps designed the Art Moderne bottle works shown here in the forefront. *Nevada Historical Society*.

caused shortages of many products vital to the manufacture and bottling of beer and caused Reno Brewing to lose market share, a situation from which it would never completely recover. Despite slumping sales, the Dohrs spent considerable money in 1948 renovating the plant and equipment, an action that would only exacerbate their shaky financial situation.

By 1954, the brewery was desperately in need of cash. On May 26, a deed and bill of sale were recorded turning over the buildings and land and all the equipment to LaVere Redfield as collateral for an $80,000 loan. In return, Redfield had paid off $56,411 in company debts, and over the next year and a half he would advance the brewery just over $2.25 million in cash for business operations and investments. Speaking to a newspaper reporter when the transaction was first made public, Redfield said, "The property will continue to operate," but when asked if it would operate under his ownership, he replied, "I have no comment at this particular time." Brewery president Roland Dohr, however, saw it differently. He said details of the contract with Redfield "call for the business to continue on a more aggressive basis than in the past, operating under the same name, with the same management."

Regardless of Redfield's comments, there can be little doubt that the crafty millionaire had more in mind than just sitting on the sidelines as a silent investor. His investment career was littered with attempts at manipulating for-profit businesses he was heavily invested in. He would try unsuccessfully to take over the San Francisco–based Gladding, McBean, a large manufacturer of clay tile products in which he had held a large stake since the early years of the Great Depression. Other evidence indicates he tried to do the same with a large manufacturer of industrial scales. In 1955, he also attempted to block a merger between the Naumkeag Steam Cotton Company, in which he held 35,120 shares, and the Indian Head Mills Company after shareholders had already approved the merger. Again, he was unsuccessful. Finally, Harold Chisholm, owner of three Reno-area lumberyards, also testified in court that Redfield granted him low-interest loans for the intended purpose of taking over his businesses, which Redfield eventually did.

The same thing seems to have been true in the case of Reno Brewing Company, but this time, Redfield's plan would backfire with unintended consequences. Some time after gaining control of the company, Redfield removed Roland Dohr as president and installed Mrs. Myrtle Dohr, Roland's wife, as the new president. Not surprisingly, this sticky situation would ultimately lead to the Dohrs' divorce, and Mrs. Dohr would soon become Mrs. O.R. Lindesmith. In addition to gaining a new title and a new husband, she also benefitted by having a $20,000 mortgage paid off with company assets, a rather cozy arrangement between her and the company's chief stockholder, LaVere Redfield.

By 1956, Redfield's plan began to unravel. The board of directors, ignoring Redfield's wishes, fired Mrs. Lindesmith. She claimed that thanks to her excellent leadership, and Redfield's stock market savvy, the company was back on its feet, but directors knew otherwise. They were forced to cancel a $400,000.00 contract for an entire year's output of Sierra Beer, saying that the company stood to lose $0.26 on every case produced. And with the exception of Mrs. Lindesmith, the board charged, all the stockholders of the failing brewery who went to Redfield for a financial life preserver were left foundering in the wake of his financial gain. "There was nothing left… not a dime," said family member Raymond Dohr.

The Reno Brewing Company would never turn out another bottle of beer, and Sierra Beer would disappear like the foamy head on a glass of warm brew. But LaVere Redfield's problems were just beginning. The crux of the problem—and the reason for Redfield's fall from grace—was a stock trading account he had established in the Reno Brewing Company name

from a portion of the $2.25 million he had advanced the company in 1954. By putting the trading account in the company's name, Redfield believed he could sidestep any personal income tax obligations that might result as the account grew. And it might have worked if he hadn't gotten greedy. The original agreement between the brewery and Redfield stipulated that when Redfield was repaid the money he had advanced the company, he would reconvey the deeds to the property and equipment back to Reno Brewing Company and its other stockholders. But when he refused to do so, the company filed suit against him. In the filing, the company claimed that Redfield had been completely repaid his principal and that he had also taken an additional $243,229 from the stock trading account. The contractual plan had been that any profits made in the investment account would go to Redfield. The difference in the amount he would normally have paid in income taxes in his high tax bracket and the amount the brewery would have to pay in its low tax bracket would go to the brewery. It was a sweet deal for everybody, except the IRS.

In April 1958, the trial of *Reno Brewing Company v. LaVere Redfield* concluded when a settlement was reached by the two sides after all the testimony had been heard but before the judge had rendered a verdict. District court judge Grant Bowen said it was the most complicated legal lawsuit in his judicial experience. The newspaper reported that during the testimony, "One witness for the company said Redfield's investments were so good that the brewing firm had to pay income tax in one year even though it had lost $150,000 in the brewing business."

Two other interesting developments came out of the trial. First, in the only instance most Nevadans could recall, LaVere Redfield appeared without his denim overalls, checkered shirt and workman's boots. The Washoe County courts had recently insisted on more formality in its courtrooms, and Redfield appeared nattily attired in a gray business suit. Second, and much more foreboding, was the lurking presence of IRS agents in the audience at the Washoe County courthouse. The IRS had had its eye on Redfield ever since his 1952 burglary had resulted in the discovery of the cache of 270,000 silver dollars in his basement, accompanied by a note saying that the IRS couldn't tax money it did not know existed. That was akin to taking a cold beer out of the hand of a thirsty cowpoke, and the IRS had not forgotten. Although nobody else in the courtroom had particularly enjoyed the complex, often boring testimony offered at the trial, the IRS agents certainly had. And it wouldn't take them long to act on what they had learned, setting into play an imbroglio the likes of which the contentious Redfield had never faced before.

Chester Coe Swobe is a lifelong Renoite. By 1960, he had graduated from the University of Nevada, Reno, had received his law degree from the University of Denver College of Law and had just been hired as the assistant U.S. attorney for Nevada, a plum job for any young lawyer. Swobe would earn his spurs quickly. He was made part of a federal prosecution team that had Redfield clearly in its crosshairs. Swobe admitted in a personal interview to being a little nervous when he received the assignment. "I knew LaVere Redfield," he said. Redfield, and occasionally his wife, Nell, often walked by the Swobe house at 1210 Forest Street on the way downtown, and Coe and his father had even offered Redfield a ride on occasion.

One of Swobe's first tasks was to prepare and sign the arrest warrant against his friend and neighbor, which he accomplished with some trepidation. It had been a mild Sunday afternoon—May 29, 1960, to be precise—and LaVere Redfield was enjoying some quiet time at his Mount Rose Street home when the doorbell rang. Standing at the door was a federal marshal, and he served Redfield with Swobe's warrant. The day prior, the millionaire had been named in an eight-count indictment by a federal grand jury in Carson City on charges of evading $302,847 in income taxes from the years 1953 to 1956. The maximum penalty Redfield could face was forty years in prison and an $80,000 fine. His arraignment was scheduled for June 10.

Since the city jail was being remodeled, Redfield was sent to the Washoe County jail. It was déjà vu for the sixty-two-year-old millionaire; he had last visited the jail's cellblock eight years earlier when he was arrested for refusing to testify at the 1952 trial of the bungling boudoir burglars. Redfield didn't seem to be particularly bothered by his new surroundings, according to assistant U.S. attorney Swobe, who went to visit the defendant at the jail. "I found him sitting behind the sheriff's desk, calling his stockbroker," Swobe said. "The sheriff told me, 'Well, Mr. Redfield needed some privacy and he had some business with his stockbroker.'" Redfield also placed a phone call to Reno attorney John Squire Drendel, whom he had known casually in the past. Grubic, Bradley & Drendel had opened in Reno in 1957. By the time Redfield called, partners Eli Gubric, William "Bud" Bradley and John Drendel were on their way to building an excellent reputation in the legal community.

"I got a call one day from the jail," Drendel recalled in an interview with the author. "Redfield had been arrested and asked me to come see him." Drendel went to the jail, and arranged a $10,000 bail bond to free Redfield. Then they began to talk. Redfield asked Drendel to represent him in the upcoming IRS trial, but the two men couldn't agree on a fee. "John, that's too expensive for me," Drendel remembered Redfield telling him. The

always-frugal millionaire then asked Drendel if he could borrow a textbook on trials, and the lawyer agreed. So despite Drendel's strong warning that he was making a big mistake, LaVere Redfield became his own attorney.

An extremely litigious man, Redfield was not without courtroom experience. The transcript of his later request for a retrial listed sixteen individual lawsuits in which he had been either the plaintiff or defendant since arriving in Nevada. And that was only a partial list. His first lawsuit had occurred in 1936, the year after he had arrived in Reno, when Otto Steinheimer, from whom he had purchased his house on Mount Rose Street, had sued him. Following that inauspicious beginning, Redfield sued or was sued by financial institutions, utility companies, the City of Reno, Washoe County and scores of individuals and companies with whom he had done business. He had also served as a member of the federal Grand Jury, according to a statement by the U.S. attorney in an October 7, 1961 story in the *Nevada State Journal*.

Redfield was also a habitué of local courthouses even when he wasn't involved in a lawsuit. The late William "Bill" Raggio, attorney and thirty-eight-year member of the Nevada State Senate, was Washoe County district attorney from 1958 to 1970. In a personal interview, he said, "Redfield used to come to the criminal trials where I was involved—major criminal trials—he would come and watch the trials." Redfield would often visit Raggio at his law office, too. "He would come and bring his proxy statements [from companies in which he held investments] and have me give him free advice on how he should vote," Raggio said. "He was obviously eccentric, but I had a good rapport with him." In the early 1970s, following his term as district attorney, Raggio said Redfield came to his office with an offer. He asked Raggio how much money he had made as district attorney, and Raggio told him the salary was $19,500 per year. Redfield said he'd like to hire Raggio as his personal attorney. He'd pay him $19,500 a year, but Raggio would not be able to handle any other clients. Raggio thanked him but declined the offer.

So, in spite of Redfield's practical experience and the court trial textbook he borrowed from attorney Drendel, Redfield would prove to be woefully inadequate for the job ahead, despite putting on a brave, often arrogant, show of confidence. The trial began on October 4, 1960, with federal judge John Ross presiding. The charges against Redfield were eight counts of evading income taxes, four counts each for himself and his wife, whose taxes he prepared, for the years 1953, 1954, 1955 and 1956.

Selection of a jury got underway immediately. Eight housewives, a rancher, a mining man, a real estate agent and a barber were finally selected

to serve, with the real estate agent chosen as the jury foreman. For four weeks, as the trial progressed, LaVere Redfield flapped helplessly about in the courtroom. It was an extremely complex case, and the fact that Redfield was more familiar with the investment specifics that formed the core of the case did not provide him with his hoped-for edge. His lack of knowledge about courtroom procedure, tactics of cross-examination, eliciting testimony from witnesses and the fine points of law left him constantly foundering.

One rare exception was his cross-examination of "reluctant" prosecution witness Mrs. Myrtle Lindesmith, the woman he had appointed president of Reno Brewing Company after he took control. Under Redfield's cross-examination, Mrs. Lindesmith said her husband, whom she had replaced at the helm of the company, "was belligerent...[and] said he didn't want me to make a success of the business if he couldn't." But the same day, the judge strongly admonished Redfield a number of times, according to newspaper accounts. "You must be careful, if you're going to be both defendant and counsel, that you don't exercise both offices at once. If you want to testify, then take the witness stand." And later, "Mr. Redfield, an attorney may not argue with a witness. If you were an attorney, I'd throw you out of court."

During the trial, the IRS did not limit its evidence to Redfield's wrongdoings with the Reno Brewing Company. It also presented evidence that Redfield had set up a system of trading stocks in brokerage accounts he established in the names of other people: a dead brother, a dead nephew, a former University of Nevada coed he had met at a Chinese New Year's party, a seventeen-year-old Reno High School honor graduate, other assorted living relatives and even brokerage house employees. In his defense in these instances, Redfield, the attorney, said the accounts were set up because they gave Redfield, the defendant, the chance "to help good and deserving people."

The IRS also testified that Redfield had carried on a scheme similar to the one he utilized at Reno Brewing Company at the Oregon Nevada Lumber Company, a shell corporation he set up with the lumberyards he had taken over from Harold Chisholm. Chisholm had accused him of that since their business relationship had soured in the 1950s, although Redfield would continue to run the lumberyards until the early 1970s.

Redfield was admonished a number of times for derogatory comments he made toward the court, IRS employees and the prosecutor. At one point, he charged, "In our government we have a lot of little men in big jobs. Some of them are so small they would have to stand on a soap box to stroke the fur of a common house cat." This insult even brought a smile to Judge Ross's normally stern face.

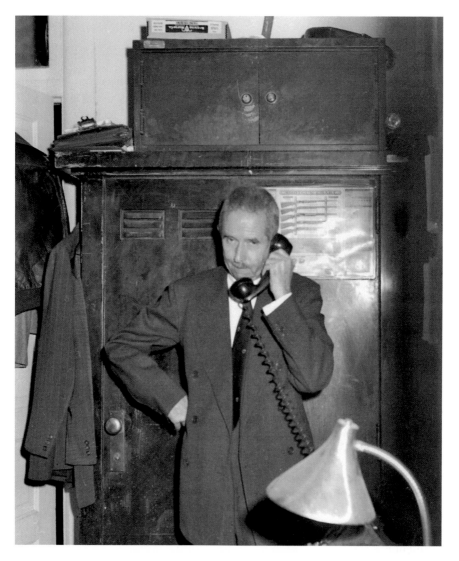

Camera-phobic LaVere Redfield was captured by a newspaper photographer as he talked on the telephone during his 1960–61 IRS tax evasion trial. Redfield's business suit was unusual; his normal dress for all occasions was jeans or overalls, a plaid shirt and work boots. *From the* Reno Gazette-Journal.

Toward the end of the trial, jurors and courtroom spectators were anticipating the moment when Redfield, the defendant, would take the witness stand in his own defense. However, everyone was surprised and disappointed when he decided not to do so. Speculation was that he was

afraid of the prosecutor's cross-examination that would follow his testimony, but he denied that charge to newspaper reporters. "I'm not afraid of any questions," he bravely stated. But if Redfield disappointed courtroom observers by not taking the stand, he made up for it in his closing argument in which he appealed for acquittal. "Unbelievable...incredible!" wrote the *Nevada State Journal* in quoting some of the people present for the spectacle. And a spectacle it was, as the newspaper reported:

> *The bashful millionaire ran the gamut of emotions in his two-hour performance before a packed courtroom. Portions of his often-interrupted presentation were meek, forceful, indignant, outraged, sorrowful, apologetic, sarcastic, egotistic and bitter...He talked on philanthropy, economics, hand-holding, the thrift of the Canadian government, the spendthrift waste of the American government, the personalities of prosecution lawyers and Internal Revenue Service agents, his childhood philosophy, the high cost of legal representation, tax laws, and the ingratitude of the tax collectors.*

Redfield's histrionics were disparaged by the judge, the prosecutor and the IRS, and they constantly apologized to the jury for the remarks made by "this baron of Mt. Rose Street," as the prosecutor called Redfield. Despite attorney-in-fact Redfield's rambling rhetoric, it was the strong evidence provided by the IRS that would ultimately be his undoing. The prosecution presented eighty-eight witnesses and nearly five hundred exhibits that testified to the defendant's history of hiding assets. However, Redfield's sarcasm, pandering to the jury and disrespect for the court did not serve him well either.

On October 28, one day before Redfield's sixty-third birthday and following ten hours of deliberation and twelve ballots, the jury in the case of the *United States of America v. LaVere Redfield* found the financier guilty on six of the eight counts against him, resulting in his having cheated the government out of $335,800 in income taxes. He was found not guilty on the two counts for the year 1956. Judge Ross set November 10 for sentencing. Redfield could have received a maximum of thirty years in prison and $60,000 in fines on the six charges for which he was found guilty. However, he would eventually be sentenced to five years imprisonment on each of the six counts, the terms—to his good fortune—to run concurrently. He would also be assessed $50,000 to pay for the cost of the trial.

Newspaper reporters who were in the courtroom for the verdict wrote that Redfield was "shaken [and] bewildered...and swallowed up in disbelief" by

the verdict. Judge Ross immediately revoked Redfield's bail. As he was being whisked out of the courtroom by marshals, a reporter asked if he would appeal. "I...I don't quite know the procedure," Redfield stammered as he was led away, his hubris now completely gone.

As soon as Redfield returned to jail, the now more humble do-it-yourself attorney made another phone call to John Drendel, whose proposed fee for representing him at trial must now have appeared much more reasonable to the contrite felon. Drendel and his partner, William "Bud" Bradley, agreed to represent Redfield in filing a motion for a retrial. Bradley also attempted to get Redfield released from jail pending the outcome of the retrial motion, but the court rejected the request. Redfield's rant against the U.S. government during his closing argument had convinced the court that he would be a flight risk, so Redfield would remain behind bars.

Among the reasons cited for a new trial by Bradley was that Redfield's defense "was so inadequate and incompetent as to unconstitutionally deprive him of liberty," which must have been a bitter pill for the proud Redfield to swallow. Also, it was declared that the reason he represented himself was that "[the] defendant was not capable of competently and intelligently waiving his constitutional right to assistance of Counsel." These findings came from two psychiatrists who had been retained to evaluate Redfield, one by the court and one by Redfield's attorneys. As to the findings of the two doctors, the newspaper, quoting one of the psychiatrists, reported, "His [Redfield's] obsession with making money so consumed him that he was unable to act competently when he refused a lawyer and chose to defend himself."

Although Redfield's motion for a retrial would ultimately be denied, the motion did result in some revealing information from the psychiatrists who examined him, Dr. Raymond Brown and Dr. William Toller, about what made the unconventional man tick. It was their statements about Redfield that appeared on the public record that proved most interesting. "He has quite literally placed money above his life in his perspective of values," Dr. Brown wrote. Redfield, he concluded, had a distorted sense of values that related to his great desire for money.

The psychiatrists agreed that Redfield "has certain eccentric characteristics...which show that defendant is parsimonious," a finding that anyone who knew the man could have testified to. The doctors were asked by the court to pinpoint a specific mental disorder that could have caused Redfield to waive counsel just so he could save some money. The official court record stated: "Dr. Raymond Brown speaks of 'extreme obsessive compulsive traits' and Dr. Toller states that the defendant 'has a psycho-

neurosis, compulsive type.'" In the end the two psychiatrists agreed that Redfield did not have a psychosis, a very serious mental disorder that would have impaired his contact with reality. On the other hand, he did suffer from a deep-seated neurosis, a milder personality disorder typified by feelings of anxiety and obsessive or compulsive acts. In other words, it was difficult, if not impossible, for Redfield not to be overly concerned about his money, no matter how much he had, in the doctors' analyses.

The court, however, did not believe these findings justified a retrial. The record for Judge John Ross's rejection of the motion for a new trial read: "Defendant has hit upon quite a scheme: waive counsel, take your chances with the jury, then if the jury disappoints you, merely point out that you are a poor substitute for a lawyer, thereby gaining another trial with the concomitant chance that you will find the one juror who will keep you from paying the penalty which the law extracts."

LaVere Redfield was back to square one. It was now early December 1960, and he had been behind bars at the Washoe County jail for six months. During the hearing for the retrial, attorney John Drendel had also filed an appeal to the Ninth Circuit Court of Appeals in San Francisco. Following Judge Ross's thumbs down on the retrial motion, he had again denied bail to Redfield. But a week later, the Court of Appeals overruled Judge Ross and ordered that Redfield be freed on $75,000 bail pending the outcome of his appeal.

That was the good news; the bad news was that the stress of the past year had caught up with the sixty-three-year-old man. Just prior to his release on bail, on or about April 7 or 8, Redfield had a heart attack in his cell. The leg irons he had been forced to wear since his incarceration were removed, and he was rushed to Washoe County Medical Center, where he would remain for the next six weeks. "The doctor told me today I need three months of complete rest," Redfield told a newspaper reporter from his hospital bed. "That's the only way to recover from a severe heart attack."

Redfield would remain free on bail for the next year while his appeals went forward. However, the U.S. Court of Appeals refused to hear his case, and the U.S. Supreme Court twice rebuffed his request for a hearing. So in late April 1962, LaVere Redfield was dispatched to Terminal Island Federal Penitentiary in Southern California to begin serving the remainder of his five-year term. Two weeks after he began serving his sentence, the *Nevada State Journal* sent a reporter to visit Redfield. "From the window of his new home Reno's multi-millionaire LaVere Redfield will be able to view the blue Pacific Ocean surrounding him, the causeways connecting Terminal Island to the mainland, and the scrubbed white homes of San Pedro and Long

Beach, Calif.," the reporter wrote. "But," he warned, "iron bars will obscure the shimmering vista, and thick hard walls will dull the pleasure."

Warden R.W. May told reporter Norman Cardoza that Redfield's plight would not be too bad and that he would likely be classified for light duty and minimal supervision. If Redfield's health permitted, Warden May said, he would spend his time puttering in the lawns, gardens and flowerbeds around the prison. Terminal Island penitentiary, which was primarily a white-collar prison, also offered a library, movies, television and a hobby center. "He'll be busy all the time," the warden remarked.

Redfield lived in the dormitory-style barracks along with other prisoners, mostly younger men. There was a separate compound that housed women, but the two groups were completely segregated. The food at the facility, according to the warden, was the best in the federal prison system. Redfield would also have access to medical, dental and psychiatric care. All in all, the facility sounded like a comfortable spot, given that it was a prison. While he was incarcerated, Redfield continued working on legal maneuvers to get his sentence overturned, or reduced. Working now with California attorneys, he continued to have no success in his endeavors, but it did help him pass the time.

Nell made occasional trips to see her husband; however, few others from his large extended family visited. A niece, Ethel, a daughter of LaVere's brother Fred, stepped in and handled the Redfields' financial affairs during his incarceration. LaVere had always kept Nell at arm's length from all the couple's finances, so she was completely unschooled in even the most basic day-to-day bookkeeping chores. Ethel wrote out all the bills and signed all the checks, and probably did an accounting overview for LaVere on his investment portfolio. Redfield had promised Ethel he would pay her for her service, but he apparently never did. Eventually, after LaVere passed away, Nell gave Ethel $10,000 for her help.

Redfield's favorite niece, Hazel Warner (H.B.R. Bushard) may have made at least one visit to her uncle all the way from Brazil, where she was living with her second husband, according to her daughter. But whether she visited or not, Mrs. Warner was often on Redfield's mind as he whiled away the days in his small prison cell. Mrs. Warner was now in her early fifties, but she was not in good health. She suffered from Pick's disease, a form of dementia, and the calculating Redfield was aware of the complications that could arise for him if she passed away while much of his property was still in her name. So he hatched a scheme to get all that property redeeded into his own name. The details of this transaction are murky,

but they involved some questionable tactics by Redfield, the end result of which was a transfer-of-ownership contract conveying the legal rights to all the H.B.R. Bushard property to Redfield. A total of 236 individual parcels in the mountains and within the city of Reno were involved. The contract was dated June 29, 1962, and supposedly signed by both parties. Many years later, there would be claims that Redfield had forged Mrs. Warner's name (H.B.R. Bushard) on the document, but no legal recourse has been sought on the issue to date. Strangely, Redfield did not actually rerecord all the deeds in his own name until 1970, but having the transfer of ownership contract in hand did protect him in case anything happened to Mrs. Warner.

While he was in prison, Redfield did have an interesting correspondence with a man he had known casually in Reno. Real estate broker Preston Q. Hale had received a telephone inquiry from a Texas corporation seeking to buy some large landholdings in town that it could develop over the next ten to twenty-five years, according to Hale's book *From Coyotes to Corporations*. Hale told the corporation's representative, "The largest property owner here is LaVere Redfield, and he's up in federal prison…for tax evasion." That didn't faze the Texas folks, and they asked Hale to check with Redfield to see if he'd be interested in selling. How much land did they want, Hale asked. All of it, he was assured.

Hale called Nell Redfield, who suggested he write to LaVere at the prison. Hale followed up with a letter outlining an offer. When Redfield responded, he showed that he hadn't lost his sense of humor. In the upper corner of the envelope where the return address appears, he'd written "U.S. University." In his letter, Redfield wrote that he was getting out in three weeks—his sentence had been shortened because he had had another heart attack—and that he would call on Hale when he got back to Reno. Later, when he went to Hale's office, the real estate man spread out a lot of quadrant maps he had prepared of Redfield's landholdings. "The maps showed more than 500 sections, and Redfield glanced over them," Hale said.

"You missed this twenty-acre piece up here," Hale said Redfield noted. "And while I was in prison, I bought this one up here."

"I couldn't believe it!" Hale marveled. "How could he keep all the pieces of his empire so clearly in his mind?"

Hale asked Redfield if he had a price in mind, and Redfield said he wanted $23 million for all of it. When Hale asked how he would want to be paid, Redfield answered in typical fashion, "Is there anything else but cash?" The Texas corporation executives were not fazed by the price, and Hale had

Leaving the sheriff's office with an unidentified man following his release from Terminal Island Federal Penitentiary in Southern California, LaVere Redfield sported a beard and longer hair. *From the* Reno Gazette-Journal.

visions of a huge payday. But as the deal moved forward, Redfield stalled, and eventually, the whole thing collapsed.

On Monday, October 28, 1963, LaVere Redfield was released from Terminal Island penitentiary. He walked out the front entrance with a bus ticket to Reno and a new suit of clothes, and a warning from a probation officer that he would remain free as long as he exercised "good common sense." He had spent just two years incarcerated out of a five-year sentence. His early release, according to prison authorities, was the result of his "suffering from a severe heart condition." His caseworker remarked that Redfield was especially glad to be going home as his wife, Nell, had suffered two heart attacks while he was in prison.

Once back in Reno, Redfield was anxious for his life to return to normal. It was true that the word "felon" would forever be attached to his name, but public acceptance was never important to the man anyway. Mostly, he

regretted the loss of privacy he would have to endure, and the loss of his voting privileges. The two heart attacks LaVere had suffered in prison, while Nell was suffering a like number at home, were also a warning to him that he was not invincible. An unidentified friend and business associate told the newspaper, "I visited him in Reno recently, after he had one of his first heart attacks," the friend said. "He [Redfield] said it was a great surprise to him that he had had one, because he didn't think it would ever happen to him."

"Obviously, people of great wealth feel invincible," the friend observed.

Perhaps the IRS conviction and the two heart attacks had mellowed the now sixty-six-year-old man. At least it appeared that way to his IRS trial adversary, Coe Swobe. By the time Redfield was released from prison, Swobe had left the U.S. attorney's office and gone into private practice in Reno. Swobe said Redfield seemed to bear no grudges. He continued to accept rides with the young attorney and even hired him on a few occasions to do some legal work. "There were no hard feelings," Swobe said. "We still liked each other."

11

Twenty-four Robbers at My Door

The lyrical little jump-rope ditty cited above has been chirped by young girls at play for as long as most adults can recall: "Not last night but the night before, twenty-four robbers came knocking at my door." It must have felt like that to the Redfields, who were robbed, burgled and assaulted with alarming frequency during their four decades in Reno. Counting the burglaries Redfield suffered at his Riverside Lumber Company, they had been the victims of crime five times up to the early 1960s, and things were not about to improve.

On the evening of December 15, 1961, LaVere was still out on bail awaiting a decision on his appeal from the U.S. Court of Appeals. That night, he and Nell went to the Riverside Hotel to attend the opening of "Life Begins at Minsky's," a remake of the burlesque show that had introduced Abbott and Costello to America's entertainment scene a quarter-century earlier. When they returned home at 10:00 p.m., their festive mood was broken when they discovered the back door had been pulled off its hinges by a crowbar that was thrown on a table just inside the house. Police speculated that two burglars had broken into the stone mansion while a third stood outside as a lookout. Neighbors reported hearing a short period of excessive barking by the couple's two watchdogs but had seen nothing out of the ordinary. The two burglars, who police claimed were not amateurs, had gone into the basement and punched out the dials on two one-thousand-pound safes. When they left the premises they abandoned their tools: a wire cutter, a sledgehammer, two types of punches and the crowbar.

History Repeated: Amount Unknown
Safecrackers Again Visit Reno Millionaire Redfield

The *Reno Evening Gazette* featured this headline on the second major burglary at the home of LaVere and Nell Redfield in December 1961. This break in, done by professionals, would haunt Redfield even more than the historic 1952 burglary. *From the* Reno Evening Gazette.

Redfield was reluctant to tell police what had been taken from his home and the total value of the haul, most likely as a result of his conviction the year before for federal income tax evasion. Police officers said Redfield was "very uncooperative about the whole thing." One investigator added, "We'll probably never know how much was taken. He's involved in this other situation, you know." Redfield did tell police that among the stolen items were $100 and $1,000 bills, some jewelry, and a number of rare 1850 uncirculated silver dollars of which only 1,100 had been minted. He reported that a number of signed, negotiable bonds from Pacific American Fisheries had also been taken. Clues were few. Police, however, did discover footprints in the deep snow left by the safecrackers that indicated they had parked a car across the street, right in front of the house of Washoe County sheriff C.W. "Bud" Young.

Although Redfield would never reveal the amount of the loss, speculation at the time placed it between $1 and $2 million ($7 to $14 million in today's dollars.) Also, it has always been assumed that none of the burglars have ever been brought to justice. There are two true stories about this burglary; one is amusing and part of Redfield folklore, but the other is chilling and not commonly known.

The first story involved the footprints the burglars were assumed to have left in the snow as they cased the house before entering and then making their escape. Young Renoite John Metzker and his father, J.K. Metzker, had spent a couple years trying to arrange a lumbering deal with Redfield for his mountain property, a deal that would eventually go forward. The senior Metzker had been trying unsuccessfully to discuss the deal with Redfield but had never been able to corral him at the Riverside Lumber Company. So in the early evening of December 15, 1961, he decided to go to Redfield's house.

After news of the burglary broke in the newspaper the next morning and revealed that police were studying the footprint evidence, Metzker phoned his son John who was away at college. "My God, don't tell anybody," he said, "but those were my footprints."

"He had gone over to [Redfield's] house and knocked on the front door," John Metzker said. "Nobody answered, so he walked around to the back door. So those were his footprints," Metzker laughed. "Dad was the international suspect. [We] never told anybody."

The second story is far more chilling. The 1961 burglary irritated Redfield even more than the big one in 1952 for a number of reasons. In that earlier case police and FBI had recovered most of the stolen property, and the perpetrators had been caught and punished. Also, Redfield himself accepted some blame because of his relationship with the ringleader of the gang. But the unsolved 1961 burglary festered in him. One arrest was made in late January the following year, but the suspect was released for lack of evidence. No other arrests have ever been made for the crime, even now, more than a half-century later.

By the mid-1960s, a few years after the heist, Redfield had developed an unlikely friendship with Nevada brothel owner and tough guy, Joe Conforte. Redfield had done a number of favors for the twice-convicted felon, and one day, while the two were together, Conforte related in a personal interview that Redfield had said to him, "There's one favor you can do for me. Can you find out who did the [1961] robbery?" Conforte had the kind of shady connections that could answer that question if anyone could, and he promised Redfield he'd check around. Conforte said he discovered that the $1,000 bills—difficult to pass because of the denomination and the burglars' fear that Redfield had again recorded the serial numbers as he had in 1952—had been laundered at 40 to 50 percent of face value through longtime criminal figure Bill Graham, who at the time was retired in Reno. Conforte also found out that the leader of the burglary at Redfield's house was a man named Newman, who was still in town. He relayed this information to Redfield, and he said Redfield asked him, "Can you do me some justice?" Once more, Conforte told his friend he'd see what he could do, but he could not make any promises, he insisted. Soon both men were saved any further grief, according to Conforte, when Newman's dead body turned up in a barrel of cooking oil. "'Course," Conforte said, "nobody, includin' us, knew how [it] got there."

LaVere Redfield rubbed shoulders with many famous and infamous characters during his day, but perhaps none was as noteworthy as his

Brothel owner Joe Conforte, with the help of his friend LaVere Redfield, managed to set up the first legal brothel in the United States, the Mustang Ranch just outside Washoe County. The two men were unlikely friends. *Photo courtesy of David Toll.*

unusual friendship with Joe Conforte. Conforte was born in Sicily in 1926 and immigrated to Dorchester, Massachusetts, with his family as a teenager. By World War II, he was driving a taxi in Oakland, California, where he had discovered the enormous profits that could be made by ferrying soldiers, sailors and dockworkers to the illegal brothels that huddled on the nearby border of Alameda and Contra Costa Counties. Once he got his first taste of the profits he could make in the flesh trade, Conforte was hooked. He ran his own prostitution ring for a time in San Francisco's Chinatown, but things were getting dicey and he began considering moving on.

Conforte was still driving his taxi in the mid-'50s when he picked up a promising fare. It was a San Francisco man, now living in Reno, who was back in town to attend a boxing match, one of his passions. Bill Graham's roots in Reno went all the way back to the Roaring Twenties, when he and his partner, James McKay, had begun running liquor, illegal gambling and prostitution in the small town on the Truckee River. When gambling was legalized in 1931—the pair is often credited with pulling the strings behind the passage of the gaming law—they were among the earliest to obtain

their gaming licenses. Now, as Conforte drove Graham to the boxing arena, he told the old hoodlum that he'd like to make a fresh start in the brothel business, and Graham suggested Reno would be a good place for him to set up such an enterprise. "So Bill Graham was the guy responsible for me going to Reno," Conforte laughed.

A dozen years had passed, and Conforte had become a prominent figure in the Nevada prostitution trade. He had also done two stretches in prison and was just being released in December 1965 from a tax evasion charge. Conforte realized he was going to have to start over and began looking for a new spot to set up shop. A place just downriver from Lockwood, Nevada, where he had earlier operated, looked perfect. It was in the more lax jurisdiction of Storey County but only a short drive to Washoe County's well-populated Reno-Sparks area. There was already a brothel there, a place called the Mustang Bridge Ranch, which was composed of four doublewide trailers and owned by a fellow named Richard Bennett. It had recently been torched, but Bennett said he planned to rebuild. Right next door was an eighteen-acre parcel of land with an old 1920s motor court, a few ramshackle houses and a couple dilapidated trailers. The whole setup looked perfect to Conforte.

He went to visit LaVere Redfield at his Riverside Lumber yard. Though Conforte did not know Redfield at the time, he did know that Redfield owned the eighteen-acre parcel near Lockwood that Conforte had his eye on. Perhaps it was their mutual dislike for the IRS, which had granted both men lengthy stays in prison, or maybe it was because both men had a quirky nature. Regardless, they hit it off at once. "We liked each other from the beginning," Conforte said to the author. "He always treated me fair. I loved the guy."

Through a series of shady deals, Conforte purchased the burned-out brothel and the adjoining eighteen-acre trailer court from Redfield. Conforte told Mr. R—"I always called him that, out of respect," the younger Conforte said—that he didn't have much money; but Redfield said, "Go ahead and take it, and just give me some money out of your profits." The Mustang Ranch was on its way into the history books.

By 1971, Conforte had two of the three Storey County commissioners supporting him, and the commission wrote a brothel-licensing ordinance that was included on the upcoming June ballot. Conforte visited potential voters throughout the sparsely populated county, pointing out the benefits of legalized prostitution. One story says he would visit a voter with a frozen turkey in one hand and a bottle of Wild Turkey whiskey in the other, saying,

"Take your choice, but cast your vote with me." With that, plus Conforte's little trailer park voting bloc, the ordinance passed. Storey County, Nevada, became the first jurisdiction in the United States with a law specifically legalizing prostitution. Just prior to the vote, on May 24, 1971, Conforte had purchased the eighteen-acre trailer park site from Redfield on, what he described as, "some real good terms."

George Flint knew Joe Conforte well, even considering him a friend. The owner of the Chapel of the Bells Wedding Chapel on West Fourth Street in Reno and a longtime lobbyist in the Nevada legislature, Flint said many people in northern Nevada looked up to Conforte as a sort of folk hero and had a certain respect for him. Despite those feelings, Flint admitted, most people didn't want to get too close to the man, fearing it would tarnish their reputations. "Redfield didn't feel that way," Flint said in a personal interview. "He judged Joe Conforte as an individual, not as a brothel owner." Flint added that Conforte was a generous contributor to local charities once he began to make some serious money, and he had a lot of civic pride.

Flint cited one incident where LaVere Redfield worked with Conforte to assist the community in a time of need. In mid-1969, Pioneer Bus Lines, Reno's only citywide bus service, closed its doors due to financial problems. Many of the city's residents needed the service, and city fathers anxiously tried to find someone to fill the gap. A few applications were filed with the Nevada Public Service Commission, but all asked for some sort of financial subsidy to ensure their success. Finally, another company, JC Bus Lines of Reno, filed an application to establish a bus line, asking for no financial aid. JC Bus Lines was, essentially, Joe Conforte. "My only interest is to see that the people of Reno have bus service," Conforte said. Although Conforte's bid was eventually denied, it did come to light that LaVere Redfield was Conforte's secret banker for JC Bus Lines, and Redfield later said he was still ready to invest $1 million in the project if it went forward.

On the death of LaVere Redfield in 1974, Conforte published an advertisement in the newspaper, addressed to Nell Redfield personally, publicly proclaiming his respect and admiration for the man who supported him when few others would: "[He] was one of the few great men that I have ever met in my life, a man whose word was his bond, and a man who was compassionate of all people," Conforte's ad proclaimed.

Over his years in Reno, LaVere Redfield earned a less-than-flattering reputation as a philanderer. Unfortunately for his long-suffering wife, Nell, news of his affairs would often make it into the papers and into Reno's very active small-town rumor mill. In the trial of the 1952 home burglary,

the French Canadian divorcée who masterminded the caper testified to a bedroom tryst in Redfield's own home and to a getaway trip to Los Angeles, where the two shared a room. After LaVere's death, and during the five-year effort to probate his estate, a number of women came forward with lurid stories of their affairs with him in an attempt to extract some money from the deceased millionaire's estate. With a total lack of sensitivity, LaVere had even appointed one of his mistresses, Luana Miles, as a co-executor of the estate, forcing Nell to work side by side with the woman for years.

None of this came as a surprise to Nell Redfield. She told her estate attorney, Clel Georgetta, "I know LaVere was having a hot affair with Luana but I didn't care. He had so many women down through the years, I got so I didn't care at all. I just decided I would hang on until he died, and I did." It was a shocking revelation, and certainly one that has tarnished the image of the eccentric millionaire in the years since.

Redfield seemed to be unconcerned about people's opinion regarding his marital infidelity. He never tried to hide it. According to his grandniece Jilda Warner Hoffman, some of LaVere's extended family members were aware of his indiscretions, and it drove a wedge between them. Mrs. Hoffman remarked that Redfield always liked to have a pretty woman on his arm, and she had even known and liked one of these women from her frequent visits to Reno while a student at Stanford. The woman owned a dress shop in town and had a longtime relationship with the millionaire, Hoffman said.

John Metzker, whose father J.K. Metzker left his footprints in the snow at the Redfield house the day of the 1961 burglary, held LaVere Redfield in high regard. John was fresh out of college when his father, J.K., who had known LaVere earlier in Los Angeles, introduced his son to the mild-mannered millionaire. John admits he was an impressionable young fellow at the time, and he really liked and respected Redfield, both for his personable nature and his tremendous business accomplishments. "He had a good sense of humor," John recalled to the author, "and he could laugh at himself," something most men in a like situation found it difficult to do. The senior Metzker owned a sawmill, Tahoe Timber Company, in an industrial area west of town. (Today, the Patagonia warehouse sits on the same property.) He also owned another company, Feather River Lumber Company, in Loyalton, California. The secret to success in the lumber business, J.K. often told his son John, is in how well you buy the timber; if you buy it right, you'll be OK, he said.

Around 1966, after John had been working for his dad for a couple years, J.K. had it in his mind to sell all his lumbering interests, so he was trying to build his timber portfolio to enhance the value of his companies. The largest

privately owned timber supply in Nevada was the fifty thousand plus acres of mountain land controlled by LaVere Redfield. It contained an estimated thirty to thirty-five million board feet of timber. J.K. Metzker decided to try to obtain the timbering rights to Redfield's land.

Timber on the land had last been logged nearly one hundred years earlier for the construction of the Comstock boomtowns of Virginia City and Gold Hill and for the vital timbers necessary for shoring up the one hundred plus mines working the Comstock Lode. Most of the regrowth was Jeffrey pine, not a top-grade lumber but still valuable. As part of John's training, J.K. assigned his son to try to make a deal with Redfield. John was anxious. "I was really nervous about this," he said. "This was LaVere Redfield; he was a local legend." But he obediently went to the large stone mansion on Mount Rose Street and knocked on the door. Redfield couldn't have been more pleasant, John said. They sat in the garden beside the house and talked for quite a while, and John put everything he had into his sales pitch. It would take a couple years to finalize the deal, but Redfield agreed to sell timbering rights to forty-seven thousand acres to the Metzker family for $2 million in cash.

In 1968, J.K. Metzker sold his enterprise to the DiGiorgio Corporation, a huge fruit/wine/land/lumbering conglomerate that owned massive tracts of farmland in California. The sale included the Redfield option for the timbering rights, and in late 1970, the DiGiorgio subsidiary, Feather River Lumber Company, was ready to exercise those rights. The announcement of the timbering set off a big hue and cry from Nevada conservationists who feared DiGiorgio would denude the forest. But conservationists and representatives from the Nevada State Forester's office met with DiGiorgio executives and were convinced that the logging firm would comply with the Nevada Forest Practices Act and with all other laws and regulations. Damage to the scenic terrain would be minimal, company executives insisted.

So late in 1970, Feather River Lumber Company began to cut timber on Redfield's land, in groves between the Callaghan Ranch and Galena Creek, in the foothills off the Mount Rose Highway. Nevada legislators, however, had yet to have their say. During the 1971 legislative session, they passed Senate Bill (SB) 168 that essentially changed the Nevada Forestry Act, prohibiting further cutting of many of the trees. It took little time for DiGiorgio Corporation to file suit against the state for damages and to challenge the constitutionality of the new SB168. Negotiations eventually led to the 1973 legislature passing an amendment to the law that included looser restrictions and the lawsuit was dropped, allowing the timbering practices to continue with fewer restrictions.

The biggest question arising out of this entire episode concerned LaVere Redfield's motivation in selling the timbering rights. Nearly four decades earlier, when he had begun amassing his huge mountain holdings, he often remarked that he wanted to keep the land in pristine condition. "He told me one time he wanted to see the land stay in its natural state," a power company friend said. Perhaps the lure of a $2 million contract was too strong for the money-absorbed millionaire to turn down, or perhaps he sincerely believed that thinning the trees would be good for the land, as he was terribly frightened of forest fires and believed thinning would reduce that danger. We'll likely never know Redfield's true motivation; it's part of what makes this enigmatic man so confounding. In the end, however, the fact that Redfield never sold any of his mountain land did provide many benefits for the state and its people. It restricted commercial and residential development in some of the most valuable real estate in the state and preserved the land for future generations to enjoy.

The pleasures in Redfield's life, both before his IRS problems and after his return from prison, were simple ones. Of course, his serious gambling was his primary avocation, but he also took pleasure in many more mundane activities. He and Nell ate out and went to shows at the casinos, and as mentioned earlier, he enjoyed watching criminal trials as they unfolded at the courthouse. Redfield also liked to travel. He was a regular patron at the Durkee Travel Bureau, owned and operated by a neighbor. Verne Durkee, who began working at the travel bureau in 1961, said his dad, Verne Sr., had worked for Greyhound Bus Lines for many years, so when he started the travel agency, he always did a big business in Greyhound tickets. In those days, the agency had books of blank tickets, and they would be filled out with dates, destinations and so forth as the tickets were sold. Once, he recalled in a personal interview, Redfield came into the agency and asked how many blank Greyhound tickets they had in stock. Durkee Sr. checked and gave Redfield the number. The frugal financier ordered a large number of the tickets for Los Angeles, San Francisco, Sacramento and Salt Lake City and paid for them with gaming chips. Redfield often attended shareholder meetings in these four cities, and he always traveled by bus, thus the large purchase.

Redfield occasionally enjoyed taking vacation cruises, but always on less expensive, less formal freighters. His grandniece Jilda Warner Hoffman recalled one freighter trip to Costa Rica in the late 1960s. Redfield had received the $2 million payoff from the DiGorgio Corporation for the timbering rights to his mountain land. Costa Rica was one of the hot spots at the time for American citizens looking to shield their wealth, and Redfield

was interested in seeing if it might be a good place to establish residency in order to get out of the reach of the IRS. Although Redfield usually traveled alone, he did not speak Spanish, so he wanted someone to accompany him as a translator. One of his grandnieces agreed to go with him, but the trip turned out to be a disaster. The frugal Redfield had reserved only one stateroom, and he set such rigorous rules for his grandniece that she had a miserable time. But Redfield was also miserable; he hated Costa Rica and couldn't wait to get back to the United States, IRS and all.

Verne Durkee said LaVere and Nell always traveled separately. "I don't ever recall the two of them going anywhere together," he said. "Nell was a very private, stay-at-home person…she led a very confined life. She never had a lot of money; he didn't share much [money] with her." Durkee did say that during LaVere's incarceration, Nell would call for airline reservations to visit him at the prison in Southern California.

Redfield also had another travel-related hobby that he enjoyed. Richard Dokken, who worked at the downtown Reno library for years, recalled in a newspaper article that Redfield showed up every Wednesday, right until the time of his death in 1974, to watch the free travel movies. He also used the encyclopedias in the reference department and would take advantage of the free periodicals the library offered, and he read all the financial magazines. "I don't think he ever checked books out," Dokken said. "I'm not even sure he had a library card." Ray King, the projectionist who showed the travel films, said, "He [Redfield] never criticized a film, but he would praise many." He added that the old-timers—those who attended the movies regularly, as Redfield did—would rib the quiet millionaire. Usually the kidding referred to Redfield's wealth, or his gambling, but he always took it good-naturedly, King said.

The decade of the 1960s would end for the Redfields in the same way it had begun: with another home burglary. This one, however, was much more frightening than any of the previous ones. On Friday, July 25, 1969, at about 3:20 p.m., Nell Redfield was going about her regular household chores when she heard a rap on the back door. When she opened the door, two men stood on the stoop, one holding a half dozen long-stemmed lavender carnations in his arms. Before Nell even had time to take in the scene, the two men forced their way inside, pushed her into the living room and demanded to know where the safe was located. She insisted she had no idea where—or even if—there was any money in the house. For the next hour, one of the burglars made two or three phone calls while Nell and the two men waited anxiously for LaVere to return home. When he arrived, Redfield entered

the back door, his normal practice. Just as he opened the door to step in, the quick-witted Nell motioned to him, and Redfield immediately saw one of the burglars pointing a gun at him, motioning him to come inside. Without a second's hesitation, Redfield dodged to the left and ran from the door. He circled the house and ran into the street, stopping a motorist and telling him to call the police.

Back in the house, the two burglars were completely unnerved by the Redfields' quick action. They ran out the back door and jumped over a short stone wall and kept going. When the two men had first arrived at the house and approached the door, a passing motorist had noticed them getting out of a car being driven by a third man. With all this information and solid identifications, police were able to eventually capture the three men. Because of Nell's and LaVere's clear thinking and quick actions, nobody was harmed, and nothing was taken from the home. This would be the final burglary the couple would have to endure.

12
The Death of a Legend

It was Thursday, September 5, 1974, a typically warm, breezy summer day in Reno, and the annual Nevada State Fair was opening at the Washoe County Fairgrounds. The Redfields hadn't expected to attend, but events like the dairy goat show would have interested LaVere, and Nell would undoubtedly have enjoyed the cookie bake-off. The couple's deteriorating health, however, had slowed them down considerably, and they left the stone mansion only when necessary. Nell had been mostly homebound for years, as much by choice as by her ever-present heart condition, and LaVere's activities had been seriously curtailed by a stroke he had suffered less than four months earlier. Perhaps because he did not go out as often, he appeared changed, too. He let his hair grow long, and he had grown a beard. Both were completely gray and described by acquaintances as "fluffy."

Redfield had suffered chest pains off and on all day long. Nell and his personal physician, Dr. Hoyt Miles, finally decided to have him taken to Washoe County Medical Center for observation. At 4:00 p.m. the next day, Redfield had a massive heart attack and passed away quietly and quickly. He was seventy-six years old.

Before his death, Redfield had given Dr. Miles a written statement donating his body to science. His body was to be embalmed at O'Brien & Rogers Mortuary and taken to the University of Nevada for its medical studies program. He also stated that he wanted no funeral ceremony whatsoever. Redfield's illnesses during those last few months had been a harbinger, and being the precise man he was, he would have taken steps to make sure

IN MEMORY OF LAVERE REDFIELD

DEAREST NELL,

Very seldom in our world does one have the opportunity to meet and know a person like your husband. I consider myself to be fortunate in having known his as one of my dearest personal friends. To fully appreciate this man one would have to know him as intimately as I did. To me LaVere Redfield was one of the few great men that I have ever met in my life, a man whose word was his bond, and a man who was compassionate of all people. Without the understanding concern of LaVere Redfield I would not have the success that I enjoy today. I find words inadequate to express my deep feelings of sorrow at the passing of your husband and my very dear friend.

Sincerely,

Joe Conforte

JOE CONFORTE

Following LaVere Redfield's death in September 1974, Nevada brothel kingpin Joe Conforte ran a quarter-page ad in the Reno newspapers addressed personally to Nell Redfield. In the ad, Conforte praised the character of his friend. *From the* Nevada State Journal.

everything was in order. He had always operated with a holographic will, eschewing lawyers, most of whom he did not trust. Attorney Clel Georgetta had offered to draft a formal will for him earlier, but Redfield told him he preferred his own handwritten will because he could change it any time he was struck by a new whim. Accordingly, on May 22, 1974, just two days after his stroke, he had handwritten a new will, making extensive changes to the previous ones. Or had he? That question would become one of the cornerstones of the messy five-year brouhaha that would follow Redfield's death, as attorneys, friends, relatives, past paramours and his wife, with a fascinated public looking on, would attempt to navigate the legal morass the peculiar eccentric had left behind.

Clel Evan Georgetta, known to his friends as "Judge," was a semi-retired, seventy-three-year-old attorney and one-term district court judge when Redfield passed away. Georgetta wasn't in the best of health himself, but with the help and support of a new lady friend, he persevered. In the mid- to late 1960s, Georgetta had represented Redfield in a contentious trial against two former tenants of his old University of Nevada farm property who Redfield claimed owed him money. The case, *Redfield v. Turner*, was found in favor of Redfield, and he had come to trust Georgetta more than he trusted most lawyers. When Georgetta offered to draft a will for Redfield, the offer was declined, but the old eccentric had indicated he'd like Georgetta to handle his estate upon his death.

Clel Georgetta had been an avid diarist since his teenage years. He had penned his first diary entry in 1916 and boasted that during the entire fifty-eight-year span from then until 1974, he had missed recording his day's happenings on only three occasions. Georgetta passed away in 1979, and twenty years later, the Georgetta Trust donated his papers, including every one of his personal diaries, to the Special Collections Department at the University of Nevada, Reno. It is from these extensive diaries that the majority of our knowledge about the inner workings of the probating of LaVere Redfield's estate comes.

When Georgetta learned—from his auto mechanic, of all people—that his ex-client had passed away the previous day, he wasted no time driving over to pay his respects to Nell Redfield at 370 Mount Rose Street. But Judge Georgetta wasn't the first person—or even the first attorney—to arrive at the house that day. Already inside the thick river stone walls of the house was a young tax lawyer from Oakland, California, Gerald C. Smith, who had done some successful tax work for the Redfields, and Redfield's family physician, Dr. Hoyt Miles, and his wife, Luana. Also present was Ken Walker,

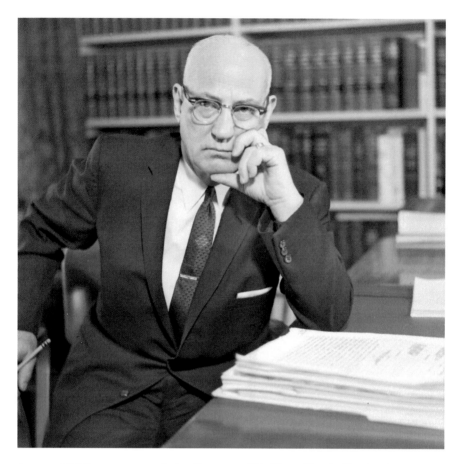

Attorney Clel Georgetta spent the last five years of his life working for Nell Redfield and the Redfield Estate following the death of LaVere Redfield in 1974. Georgetta's personal diaries provided much of the information we have during this crucial period. *Special Collections, University of Nevada, Reno Library.*

a longtime friend of Redfield and president of the Farmers and Merchants Bank in Long Beach, California.

Mrs. Redfield told Georgetta she had already retained Smith to handle all the estate's tax issues, but since Smith's firm, Fitzgerald, Abbott & Beardsley, was not licensed to practice in Nevada, she would also need a local lawyer. "Well, Judge here has always been nice to me and came to see me when LaVere was in jail," she told those present, "[so] I'd like to have Judge Georgetta here do it." So Clel Georgetta joined the legal odyssey that would occupy him for the remainder of his life.

The two estate attorneys were about as different as two men could be. Smith was young, thirty-two according to Georgetta, and according to the *Martindale-Hubbell Law Directory*, he had been practicing law for only nine years. The older attorney also contemptuously remarked that Smith was "strong willed, [and the] most conceited man I have every known. He knows everything, and is never wrong" [emphasis from the original source]. Georgetta, on the other hand, had been practicing law for over forty years. However, he, too, was a man of strong opinions, and he could be self-righteous and pompous, judging from the tone of the prodigious portfolio of diaries he left behind. Georgetta was also a man of racial, religious and sexual prejudices, of which he made no secret. The two men were destined to dislike each other, and they would constantly be at odds as they tried to work through the mess Redfield had left in his wake.

Two other holographic wills had been discovered by this time. One was dated 1947 and the other 1952. Georgetta and Smith had no idea at the time that they had just scratched the surface, but they did realize that another, more recent will had to be in existence somewhere. They knew Redfield had a large number of safe deposit boxes scattered around the city; they had found a key ring with a number of safe deposit keys on it. So they guessed one of the boxes must hold a more recent will. Nell Redfield was soon legally appointed as the estate's special administratrix with authority to open and inventory all the boxes. The treasure hunt was on.

In the days to come, the legal team would find numerous valuables. In one box, they discovered a large quantity of diamonds, each with a tag on it and a notation of who owned the diamond and how much collateral was owed to Redfield before the jewel could be redeemed. The man had become a virtual pawnshop. At another bank, they found seven bags of valuable old silver coins with a face value of $28,000 and, at another, a large box full of old socks stuffed with coins. At still another bank, they discovered bundles of silver certificate bills of $100 and $1,000 denomination worth perhaps $100,000, and in this box, they also found what they were looking for: another holographic will, dated 1972 [incorrectly dated in Georgetta's diary as 1973] that would become the "real" will—at least, for a time.

They also discovered something else at many of the banks they visited. Redfield had taken out a number of loans for various purposes: to pay back taxes, to buy investments because the market was down and so on. This was very unusual; Redfield rarely took out loans for any purpose because he hated to pay the interest. The total debt would ultimately run into the millions. The early published estimates of the estate's value was between

$70 million and $200 million. Georgetta said Smith had informed him that based on an earlier appraisal, the estate's value was probably in the range of $80 million to $90 million. However, at the time of his death, Redfield had most of his assets tied up in land, precious metals, rare coins and stocks; thus, the old man seemed to be cash-poor.

The following day, September 10, Clel Georgetta made his first excursion down to the fabled Redfield basement. Like all Renoites, he had followed the 1952 Redfield burglary and the later IRS trial in the newspapers, so he knew about the fabulous silver cache that had been discovered by the FBI behind a false concrete wall. Despite that, he was not prepared for what he found this day or on two subsequent trips into the basement:

> *I was just amazed at what I saw. There is barely room to squeeze along the center between stacks of crates and boxes clear to the ceiling. There are hundreds of cases of canned foods, now old and so spoiled the cans are puffed. There must be 2,000 or 4,000 cases of a game once put out by Shell Oil Company, a cardboard map of the U.S. with a round hole in each state, and 48 circular pieces of copper with a state name on each.*
>
> *There are boxes and boxes and boxes of empty bottles of every kind, shape and size. Stacks and stacks and stacks of old newspapers and old magazines. God know[s] what. Everything imaginable. I have heard people say Redfield was crazy. Now I am beginning to believe it.*
>
> *I recall seeing six big architect's drawing boards and dozen and dozens of airplane wheel blocks. Old camp stoves. [More] cases and cases of canned goods.*
>
> *At the rear end of the house there is a stone stairway that leads from the back yard down to a door into the basement. The entire stair well had been filled with wooden boxes, tin cans, bottles and other junk, so no one could possibly go down it without cleaning it out.*

There was no doubt in the mind of any of the people who subsequently entered the basement that LaVere Redfield had been a real, honest-to-goodness hoarder. In his diary, Georgetta repeated the story of Redfield's 1948 mugging where he was hit on the head more than a dozen times with a brick. Then he added: "Today Mrs. Redfield told me that before that event, the basement was clean. After that, he started going to auctions and buying about everything in sight."

Dr. Miles also told Georgetta that Redfield had instructed him to reveal that a vintage Cadillac stored in the garage should be searched in the event

of his death. "[W]e edged our way along to the stairs that led down to garage level," Georgetta wrote. "The garage doors [are] completely barred, so it is impossible to open them from the outside. We found the old Cadillac [and the old Lincoln mentioned earlier]…The lock on the trunk [of the Cadillac] had been completely removed, but it could not be opened. We sawed the handle off with a hacksaw—no success. So then we sawed the hinges in two. Inside we found eight or ten huge account ledgers and lugged them all upstairs" [emphasis from original source].

In the days to come, the two attorneys continued their treasure hunt of Redfield's safe deposit boxes. Before the search was over, they would find fifteen boxes spread across Reno and Sparks. Bags of silver dollars continued to turn up everywhere. The downtown branch office of the First National Bank of Nevada partitioned off a room inside the main vault that was six feet wide by eleven feet deep, with a nine-foot ceiling, where the attorneys could safely store all the Redfield estate valuables as they were uncovered. The room quickly began to fill. They also found records in the hidden ledgers from the Cadillac's trunk indicating nearly $1 million in Swiss bank accounts.

A phone call from Ken Walker, the Long Beach bank president, alerted Smith and Georgetta to what Walker believed was another false wall in the basement, probably hiding more silver. Redfield had reclaimed the 270,000 silver dollars the FBI had banked after the 1952 robbery, and there were simply too many to have been dispersed between the safe deposit boxes. Georgetta remarked that it was impossible to even see a wall with all the things stacked floor to ceiling. Walker said he was coming back to Reno the following week with three men to help carry everything outside so they could search for the fake wall.

The day arrived, and Walker, the two attorneys and three burly workmen wiggled and squirmed their way through the basement, carrying load after load of material up the stairs and into the backyard, where it was neatly piled. Finally, there it was! "We met a solid wall of small, flat boxes, about 12 inches square and 4 or 5 inches thick, piled one on top of another from the floor to the ceiling, and wedged in tight at the top with shingles and pieces of board, so the piles could not fall," Georgetta wrote. It was the false wall Walker had described, built entirely out of some of the small boxes of the Shell Oil games Georgetta had discovered earlier. Redfield had purchased the entire 17,000-box lot from Shell Oil Company for a dollar each, and built a wall to replace the concrete one the FBI had torn down in 1952.

Almost in a frenzy now, the men tunneled through the wall of boxes, being careful not to cause the whole thing to collapse in on itself, until finally they

hit paydirt. It was like Nevada's famous Comstock Lode silver discovery all over again to the six men in the dank cellar. Georgetta described the scene:

> *A huge pile of canvas bags, all filled with coins. Some were sealed; some were not. One bag that broke as we handled it contained uncirculated silver dollars dated 1879. On a tag it said $1,000…We found fourteen huge silver bars, each worth $3,500, and six smaller bars, worth how much? I do not know. Some of the bags the men carried and piled near the back door must have weighted at least 100 pounds. Others were smaller, and some still smaller bags we believed must contain gold coins or gold bars, but we did not take time to open them.*

The first of four armored trucks hired by the estate arrived at the scene at about 3:00 p.m., was quickly loaded with all the treasure that would fit inside and headed for the First National Bank's secure vault. The other three armored trucks followed as quickly as they were loaded. Soon the men moved to the garage, and in front of the 1922 Lincoln, they discovered the rotted wooden crate of silver dollars described in Chapter 9. The *Nevada State Journal* had been alerted to the goings-on and dispatched a photographer to the scene. In the next morning's paper, a large photo of the armored trucks with shotgun-bearing guards watching intently graced the front page of the paper.

As the sun went down that evening, 668 canvas sacks full of coins and twenty silver bars had been delivered to the bank vault. Georgetta, stunned, estimated they had discovered over twenty tons of silver. Less than a month later, attorney Smith would find seven more bags of silver dollars, two bags of twenty-dollar Double Eagle gold coins and a barrel of rare stamps hidden in the house. He moved all of it to the secure vault at the First National Bank.

The 1972 will, discovered in one of the safe deposit boxes, was the prevailing estate document at this time. It called for three women to be named executrixes of the estate: Nell; Luana Miles, LaVere's physician's wife; and, strangely, Candida "Candy" Larena, a bank clerk who handled the safe deposit boxes at the Nevada National Bank. According to Georgetta, attorney Gerald Smith asserted that Ken Walker, the Long Beach bank president, should take Mrs. Redfield's place since her health was precarious. Nell's sister and a niece had already taken up residence in the house to assist her through the estate process due to her poor health. Because sizable fees would go along with the executors' duties, however, Georgetta objected to replacing Nell, saying that Mrs. Redfield should retain her position, as LaVere had intended. This

Two of six armored vans await the treasure-trove of coins, stamps and other valuables that were discovered in LaVere Redfield's home after his death. *From the* Reno Gazette-Journal.

was the first of what would become many disagreements over the potentially massive fees the estate would generate: arguments over the executors' fees and who should serve, arguments over the attorneys' fees and how they should be divided, arguments over fees to other attorneys who were scrambling to jump on the bandwagon. These fights were the one constant throughout the entire five-year ordeal.

Nell Redfield did finally approve Ken Walker to act as her agent and to receive her commission as an executor, against Georgetta's advice. Both attorneys tried to get the other two ladies to act likewise, as neither had the requisite experience to serve. But the dollar signs were beginning to dance in their heads—each woman's fee could be as high as half a million dollars—and they opted to stay in place. To further complicate matters, Mrs. Miles, the doctor's wife, had been a longtime mistress of Redfield's and had expected to be generously remembered in the will, so she was not about to give up whatever control the executrix position might grant her.

The estate attorneys' most pressing need was to raise cash to meet all the outstanding obligations Redfield had left behind. Early on they were aware

of at least $3 million in outstanding loans, and more were turning up with regularity. Redfield had pledged stock securities as collateral for most or all of the loans, but stock prices had dropped significantly since the loans were initiated. The banks were now demanding additional collateral, as well as interest payments that were due. Furthermore, just as they couldn't locate a more recent will, Smith and Georgetta couldn't find any of the actual stock certificates pledged as collateral for the loans, according to Georgetta's diaries. So the treasure hunt continued.

Executrix Luana Miles hired her own attorney to represent her interests, and her lawyer insisted that he and his firm should also be added as attorneys for the estate. A week later, executrix Candida Larena did the same thing, hiring longtime local attorney Proctor Hug to represent her. Georgetta suggested to Smith that they try to have executrixes Miles and Larena dismissed—and obviously, their attorneys as well—due to conflicts of interest. His reasoning was that Miles was a longtime Redfield mistress, and she and her husband owed the estate $90,000 to boot. Larena's sister, they had discovered, had also been a Redfield mistress. Also the two women, plus a Mrs. Kathleen Stuart, claimed they had been promised they would receive the $900,000 Redfield had deposited in Swiss banks, adding a further complication. Eventually, both Miles's and Larena's lawyers would be added as estate attorneys, sharing in the large fees.

Predictably, people were beginning to line up to feed on LaVere Redfield's financial carcass. One of the first, Olga Covelli, was a self-described countess, former Ziegfeld Follies showgirl, casino hostess and recently failed candidate for the Nevada Democratic gubernatorial nomination. She said she had borrowed $8,000 from her "longtime friend" LaVere for her gubernatorial campaign and had given him some expensive jewelry and a fur coat as collateral. She had paid the money back, she insisted, but had never retrieved her jewelry and fur. Thus, with her attorney in tow, she filed a petition to the court to be added as an executrix, which had suddenly become the most lucrative and sought-after position in Reno. It went without saying that her attorney would also expect to be added to the growing list of estate attorneys, but they were denied.

Another attorney said he represented a woman who had a seventeen-year-old illegitimate daughter by Redfield. She, too, wanted to be named an executrix. The claim was ignored until Georgetta and Smith discovered that Redfield had indeed lent money to the woman and her late husband for a mortgage on their house. When they failed to repay the debt, Redfield foreclosed on the house and sold it. Still, they doubted the claim of a child

because the woman had a police record as a forger. Eventually, she and her attorney withdrew her petition.

Toward the end of September, the court released some elements of the 1972 will to the press and the public for the first time. Since Nevada is a community property state, Nell Redfield would automatically be granted 50 percent of the estate's value after all obligations were met, so all the quibbling and in-fighting involved only LaVere's half, still a very sizable fortune. The newspaper announced that an Idaho niece of Redfield's, the third daughter of LaVere's brother Jay, was his sole heir. Contacted at her home by the newspaper, the niece, Mrs. Dorothy Deschamps, was stunned. She said she hardly knew her uncle. "Another of my sisters and I stopped to see the folks [LaVere and Nell] a year ago. But I haven't seen him since I was a kid...I'd write a note at Christmas time, but other than that, we didn't correspond very often," Mrs. Deschamps said, her voice shaking. Naturally, Mrs. Deschamps also appointed an attorney to represent her with the estate, and the team of estate lawyers continued to grow.

On October 10, the most recent holographic will was probated in court. All three women mentioned in the will—Nell, Mrs. Miles and Miss Larena—were officially appointed as executors. The court also authorized the appointment of three estate appraisers. Not surprisingly, the court also appointed another estate attorney to represent absent heirs, those people who by law would inherit if the will was found to be inadequate. However, Larena's attorney, Proctor Hug, said the absent heirs' attorney was never an active member of the committee of attorneys and executors who would meet monthly for years.

Finally, a widow's allowance of $10,000 a month was approved for Nell Redfield. Among those in the crowded courtroom when these things were decided was an older man who had been a friend of the deceased millionaire. After Nell Redfield's monthly allowance was stipulated, the friend remarked, "She's never seen that much money in her whole life."

Through the winter months, the behind-the-scenes maneuverings of the team of executors and the team of estate attorneys often resembled a soap opera. According to Georgetta's descriptions, executrix Luana Miles was constantly bickering and trying to find ways to enhance her position or to remove one of the others from the team. The team of attorneys, too, had numerous disagreements. Most of the attorneys were not sole operators, but represented their legal firms in the fight. So a team of, say, eight lawyers actually became fifteen or twenty when other partners were brought into the fray. Georgetta tagged the entire legal team as the "unholy trinity." Some of

Mysterious Redfield will surfaces

University gets bulk of estate in document sent to Gazette

Mystery envelope

The Reno Evening Gazette of November 4, 1974, stunned the northern Nevada area with its page-one banner headline about the discovery of a previously unknown holographic will supposedly written by deceased millionaire LaVere Redfield. *From the* Reno Evening Gazette.

the lawyers' infighting had to do with how the estate's huge legal fees would be split, and naturally each man—there were no women in the group—had his own opinion.

While all this was going on, the U.S. Forest Service had begun preliminary negotiations for the acquisition of some or all of Redfield's mountain lands. The land had last been assessed in 1971–72 for tax purposes at $2.12 million, a figure that placed Redfield as the largest individual taxpayer and tenth-largest total taxpayer in Washoe County, behind only large corporations like Sierra Pacific Power, Nevada Bell, Harrah's, First National Bank of Nevada and Southern Pacific Railroad. Nevada state senator Coe Swobe said, "[T]he people…would be missing a once-in-a-lifetime chance if those portions of the 50,000 acres which could be used for park, recreational or wilderness area were not converted to public ownership."

Amid all this, the next bombshell in the Redfield estate circus exploded on November 4, 1974. Over the first weekend in November, a letter was received in the mail at the *Reno Evening Gazette*. It arrived in a regular three- by five-inch white envelope, marked "Personal" and addressed to "WARREN LERUDE, GAZETTE, RENO." The zip code on the envelope indicated it had been mailed from somewhere in northern Nevada and cancelled at the Post Office's Riverside annex. On Monday, Lerude, then the executive editor of the *Reno Evening Gazette* and the morning *Nevada State Journal*, opened the envelope and was amazed to find a handwritten document headed, "Will of LaVere Redfield." When Lerude noted the will was dated May 22, 1974, he immediately realized the significance of it. Unfortunately, Lerude admitted years later, the amazing find was passed freely around the newsroom, and

when the FBI, hoping for fingerprint evidence, inquired if anyone had touched the document, he sheepishly agreed that they had.

But fingerprints or not, the new find was explosive; it completely changed everything. Mrs. Deschamps, Redfield's sole heir in the 1972 will, was reduced to $1 million, which she was to share with her father, Jay, one of LaVere's brothers. Eleven million dollars was bequeathed to charity for educational purposes. The recipients were the University of Nevada, the Nevada State Penitentiary, the City of Reno, Veterans Hospital in Reno and the Carmelite Monastery. Some different executors were also named: Nell Redfield and Candida Larena would remain, but Redfield's mistress Luana Miles was out. A physician and an attorney Redfield barely knew would join the team in her place. A new provision was added that, although never enacted, has become a persistent myth in Redfield folklore. The will directed that $1,000 was to go to every lawyer in Reno because, it stated, "in this way I can be sure they will keep an eye on each other and upon my estate." The new will was written in the same style as the older ones, and to the eyes of a layman, it appeared to have been written by the same hand.

Regardless of that, the new will immediately came under fire. A handwriting expert who the newspaper brought in to examine both the old and new documents was skeptical of the new will. "I'd dispute it," he said but admitted that was only a tentative opinion. But other problems surfaced, too. All Redfield's earlier holographic wills had ended with a postscript. The 1972 will stated, "What you leave at your death, let it be without controversy, else the lawyers will be your heirs—this I have endeavored to do." The statement was eerily similar to the message the FBI found in Redfield's safe after the 1952 burglary, the note that spurred their discovery of the huge silver cache in his basement. However, there was no postscript on the newly discovered will.

Some people close to Redfield claimed he could not have written the new will because he had suffered a stroke just two days before the date on the new will indicated it had been prepared. However, the most telling evidence that the new will may not have been legitimate was the clause that left $1 million to be shared by Mrs. Deschamps and her father, Jay Redfield. Jay had been dead since 1960, a fact LaVere was certainly aware of.

Every individual and organization named in either of the two competing wills—the 1972 will, currently under probate, and the new 1974 will—began to take sides. Not surprisingly, each party backed the will in which he, she or it stood to gain the most. The attorneys retained and the expert handwriting analysts hired by each participating party also approved the will that served him or his employers most beneficially.

Nell Redfield, who had verified the initial 1972 will as being by the hand of her husband, was never directly asked about the second will's authenticity, or if she was, her response was never made public. However, Mrs. Redfield did dispute the idea that her husband could not have written the new will because of his stroke. She stated that he was "mentally alert and in full command of his faculties" at the time the new will had been dated. Mrs. Redfield also told the court she was ready, willing and able to serve as executrix under the terms of either will.

Shortly after LaVere's death, Nell had traveled to Canada to spend some time at her sister's home. She was not well, and the stress of her husband's death and settling the estate had taken a toll on the eighty-one-year-old woman. Her presence was not required for the day-to-day chores of probating the estate, as she had hired Ken Walker to handle those responsibilities for her. She would not be affected one way or the other by the second will, as her half of the community property would remain intact regardless of which of LaVere's will was deemed the legitimate one. She was also able to distance herself from the squabbling between the executors and the estate attorneys. Most of those contentious affairs involved how much money each participant would be able to wring out of the estate. Nell Redfield realized that she would end up with more money than she had ever had before. If some of the involved parties managed to squeeze an extra 1 or 2 percent out of the estate's assets, she didn't really care. Mrs. Redfield had endured a great deal of emotional pain and suffering from the antics of her husband of fifty-two years, and she was not about to get down in the dirt at this point in her life.

There was a little-known clause in both the 1972 and 1974 wills that did raise some eyebrows. In the 1972 document—the one under probate at the time—Redfield asked Nell to renounce her community property interest in the estate, with the provision that she would be provided for by the estate trust. The 1974 will asked her to renounce her community property interest except for $3 million. Neither clause was ever enacted.

During Nell Redfield's extended stay in Canada, the Hill/Redfield mansion received a major renovation. She assigned the task to Ken Walker, who hired Reno contractor Allen Galloway for the $25,000 job. Once the home's rehabilitation was complete, Walker hired Eleanor DeWitt, owner of a local interior design business, to assist Nell in redesigning the interior of the unique house. In an article in the newspaper following the project's completion, the reporter wrote, "Mrs. Redfield now seems proud of the home she once disliked." It must have been a real pleasure

for Nell Redfield to finally put her own personal stamp on her home of thirty-eight years.

As 1974 came to a close, one of the two men named as executors in the newly discovered 1974 will filed to have the will probated. That was the necessary legal step that set into motion either an authentication or denial of that mysterious document. Renoites, who had been hungrily following every step of the Redfield drama as it unfolded in the newspapers, television and through a very active rumor mill, went to sleep on December 31, 1974, full of anticipation of what the new year would tell them about the mysterious couple who had lived in the stone mansion high atop the hill on Mount Rose Street.

The year 1975 began with a wave of new filings against the Redfield estate by individuals who wanted a small slice of what they believed would be a very large pie. The sister of executor Candida Larena, the one who had had an affair with Redfield, wanted $30,000 on top of her one-third claim for the $900,000 in the Swiss bank accounts. A Kathleen Stuart from Los Angeles also wanted $30,000. A local real estate man asked for $500,000 as a commission on the sale of a piece of Redfield's property that he had listed but never sold. A man who said he had been a driver for Redfield wanted $24,000 for his unpaid services. A Mrs. Washington wanted to recover a piece of property that Redfield had purchased at a tax auction. A Redfield niece wanted to recover $17,000 he had invested for her but had refused to return. Dr. Hoyt Miles, husband of executrix Luana Miles, wanted $65,000 for medical services rendered before Redfield's death. And on and on and on it went.

On March 5, 1975, attorney Clel Georgetta's diary entry disclosed the first interesting item of the year. It had been discovered that Redfield had rented a warehouse in Reno. The contents of the building offered further proof of Redfield's hoarding tendency. A local drugstore, Hilps, had had a fire sale, and Redfield had purchased fifty cases of liquor and stored it in the warehouse. This was a man who never touched hard liquor. There were also 1,086 square cartons and 33 one-hundred-pound kegs of nails. Attorney Smith, who inventoried the warehouse, said, "It's just a lot of junk. There wouldn't be much loss if we threw the key away and forgot it."

The vital issue of which will would prevail was finally resolved in June 1975. Washoe County judge John Gabrielli, after hearing from all sides and consulting some of the top document examiners in the country, declared the 1974 will to be a forgery. The 1972 will would stand. To the present day, it has never been discovered who forged the 1974 will and sent it to the newspaper or why it was done. That is, of course, if it really was forged. There are people who still believe it was genuine.

The entire year of 1975 was taken up by intermittent court appearances and by the normal routine of settling a large estate. One of the major items that continued to surface was the claim of the three women against the $900,000 sitting in a number of Swiss bank accounts. At least two, and possibly all three, of these women had been paramours of Redfield. One, Mrs. Miles, was now an executrix of the estate; another was the sister of executrix Candida Larena; the third woman, Kathleen Stuart, had worked as a secretary, chauffeur, gardener, housekeeper and companion of the Redfields when they lived in Los Angeles in the 1920s.

Redfield's Long Beach friend and banker, Ken Walker, told the others that in 1968, Redfield had asked him how to go about getting some money out of the country. Walker advised him to put the money in Swiss banks. Redfield gave Walker $500,000 to start, and they selected five banks in which to deposit the funds. Eventually the amount would rise to over $1 million with interest. Walker gave Redfield five blank signature cards to fill out. Each one was to have Redfield's signature and the signature of two other people who could act as powers of attorney for withdrawing funds. Redfield told Walker those two people would be Walker himself, and the grandniece who had accompanied him on the unhappy freighter trip to Costa Rica. However, when Redfield returned the signature cards to Walker, the grandniece's name had been crossed out and three other names, with their signatures, had been substituted. Those names and signatures were those of the three women who now sought to claim the $1 million as their own. Redfield explained to Walker that he did not want his wife, Nell, to know about these accounts, so all three women had been sworn to secrecy.

As this situation heated up in 1976 and 1977, the attorneys who represented the two executrixes were anxious to see their clients—or the client's sister, in one case—get this money, but the other attorneys did not believe the women were legally entitled to it. Worse, this latter group felt it was a conflict of interest for the two women. They were supposed to be protecting the estate in their role as executrixes, yet they were attempting to direct some of the estate's assets to themselves or their relatives. It was a contentious issue, and despite the constant filing of legal claims and counter-claims, it raged unresolved.

Finally, in 1977 the estate attorneys agreed to pay each woman $60,000—20 percent of what they were claiming—to dispose of the lawsuit they had filed against the estate. The women accepted. Nobody was unhappy to see the sordid mess put behind them, and attorney Georgetta spoke for many of the attorneys when he said, "It gripes me to give those three lousy golddiggers $180,000, but there seems to be nothing I can do about it."

Another issue on the front burner was the federal estate tax that would be due the IRS once the probating of the will was complete. That tax was not actually due and payable until the end of the process, but interest began accruing on the due amount nine months after Redfield's death. The attorneys had decided that the total value of the Redfield estate for tax purposes—both LaVere's share and Nell's share—was $40 million, a much lower figure than initially estimated. The tax would be about $14 million. If it went unpaid until the final resolution of the estate, interest would be about $1 million a year, seriously eroding the amount Nell Redfield and LaVere's heir Mrs. Deschamps would receive. Thus the attorneys decided it would be wise to begin paying on the tax immediately. To do that, however, would require disposing of some assets to raise cash.

The attorneys for the cash-poor estate decided to try to swap some of the mountain land to the IRS to settle the tax debt. The U.S. Forest Service badly wanted the land. The plan was to swap about $15 million worth of land to the IRS, which would then be passed along to the Forest Service. However, such a scheme would require an act of Congress. Attorneys Proctor Hug and his partner, Bill Woodburn, began working on it. Meanwhile, the City of Reno, Washoe County and the State of Nevada were all interested in the land as well. Fortunately for the public, all the governmental agencies that were in the hunt wanted to preserve the land as parkland or open space.

Hug and Woodburn went to Washington and conferred with Nevada senator Howard Cannon. Cannon was chairman of the Senate Rules Committee, and he knew how to get things done. The men prepared a short paragraph approving the transfer of the land from the Redfield Estate to the U.S. Forest Service that would cover the IRS estate tax, and Senator Cannon had it attached to an appropriations bill that was awaiting approval. When the appropriations bill was approved, the piggybacking land trade paragraph went along for the ride. Proctor Hug, who would leave the estate team in mid-1977 to accept a seat on the U.S. Court of Appeals, said this action preserving the land for the public was his proudest moment as a member of the Redfield estate team. Just under thirty thousand acres of forest land in the Toiyabe National Forest was involved in the trade, which brought the estate a $9,915,758 million tax credit, which completely retired the IRS debt. After the death of Nell Redfield in 1981, another ten thousand acres would be traded to the Forest Service to cover her estate taxes.

While that was going on, the estate team also devoted its energies to selling the non-mountain land that was in Redfield's huge property portfolio. Three local real estate companies were chosen to handle the job. The estate

decided to pay a healthy 7 percent commission on improved real estate and 10 percent on open land, and the real estate men hungrily bent to the task. One key piece of land had brought an attractive offer even before the three real estate contracts were let. Billionaire Kirk Kerkorian was considering construction of a large high-rise hotel and associated amenities in Reno. The property he was after was the Redfield estate's old 208-acre University of Nevada farm on South Virginia. The appraisal on the property was $3.8 million, and Kerkorian's bid was $4.8 million, an attractive 26 percent premium over the appraised price. According to Georgetta, the other estate attorneys nixed the deal, saying they would consider $7 million. "We may kill the golden goose," Georgetta said he told the others. Sure enough, six weeks later the Kerkorian people withdrew, writing to the effect, "Forget it. We have scratched Reno off our list." Just the previous year, Kerkorian had opened the MGM Grand Hotel in Las Vegas—now Bally's Las Vegas—then the biggest hotel in the world. He eventually opened the current MGM Grand on the Las Vegas Strip. One wonders if that could have all happened in Reno if "golden goose" Kerkorian had been allowed to purchase the Redfield land.

Despite their constant bickering, credit must be given to the estate attorneys. They handled a virtual parade of lawsuits, counter-lawsuits and filings against the estate. Everyone, it seemed, wanted a piece of the action, and there was little relief from the day-to-day stress. In January 1978, Clel Georgetta discovered he had cancer and was forced to step down from active participation in probating the Redfield estate. He formally resigned from the team a year later, and on April 20, 1979, Georgetta passed away. The honest observations—although often prejudiced and self-congratulatory—that Georgetta recorded faithfully in his diary have allowed future generations an unprecedented look behind the scenes into the contentious activities of the Redfield estate team. Without these documents, we would know little about the process.

For all intents and purposes, the probate of the Redfield estate ended in early November 1979. It had consumed five years and one month. The final value of the estate was set at $46 million, half of which went to Nell Redfield as community property. After all taxes, legal fees and assorted expenses, Mrs. Dorothy Deschamps, as LaVere Redfield's sole heir, inherited just over $5 million. As a group, the Redfield Estate attorneys earned about $3.5 million for their efforts.

There was one other critical and high-profile aspect of the Redfield estate probate that has not been mentioned. That was the disbursement

of the massive silver coin collection LaVere Redfield had assembled. The sale was the largest ever of the silver coins that became known in the numismatic trade as the "Redfield Hoard." To this day, forty years later, silver coins are often sold at a premium if they carry the designation as having come from this unique collection. Selling the collection would be a historic moment.

13

The Redfield Hoard

From the Random House Dictionary
HOARD:
noun: a supply or accumulation that is hidden or carefully guarded for
preservation, future use, etc.: a vast hoard of silver.
verb: to accumulate for preservation, future use, etc., in a hidden or carefully
guarded place: to hoard food during a shortage.

The shy, thirty-two-year-old coin dealer nervously fingered the pile of silver dollars spread out before him on the table, while slivers of sunlight shining through the partially opened blinds reflected off the polished surfaces of the century-old cartwheels. He was sitting in an unused office on the fourteenth floor of the First National Bank of Nevada Building in downtown Reno. It had been set up just for this photo shoot, and the two-man film crew that had been hired out to all three television networks were busily getting their cumbersome cameras and lights set at just the right angles. This was BIG news.

Steve Markoff was generally a pretty cool customer. But each time he glanced down at the oversized cardboard check strategically placed as a prop in the middle of the pile of silver dollars, he winced a little. It was his own familiar company logo on the check—A-Mark Coin Company, Inc.—but the number on the check was enough to make anyone just a little skittish: $7,300,000.

It was January 30, 1976, and it was the biggest cash deal in the history of coin collecting to that time. For his money, Markoff had received

approximately 407,000 silver dollars, at an average price of eighteen dollars each. When he had purchased his first coin in Southern California at the tender age of twelve, young Markoff had likely never dreamed of such an audacious stunt. But here it was, and he was right in the middle of it. Fifteen floors below, in a large sub-divided area within the bank's huge, secure vault, sat 407 carefully numbered canvas bags, holding the treasure he had just purchased at auction. The press and the numismatic community had labeled it the "Redfield Hoard," over eleven tons of silver. The contents of bag No. 225 had been dumped on the table for the newsreel footage, and as the cameras began to roll, Steve Markoff cleared the cobwebs from his mind, smiled broadly and began speaking toward the foam-covered mike at the front of the table.

The first U.S. silver dollar, the Liberty dollar, was struck in 1794, and since then, silver dollars have been struck at six mints: Carson City, Nevada; Denver; New Orleans; Philadelphia; San Francisco; and West Point, New York. Mintmarks began to appear on coins when three new branch mints joined the original Philadelphia mint in 1838; and they have continued in use since then, with the exception of the three-year period 1965–67. The most abundant cartwheels, as they are affectionately called, are Morgan dollars, which were minted from 1878 to 1905 and again in 1921, and Peace dollars, which were minted from 1921 through 1935, minus a five-year hiatus due to the Depression, and for a short period in 1964 but dated 1965.

The value of a silver dollar to a collector is based on three factors: the mintmark—the U.S. mint in which the coin was struck; the rarity—how many were struck and how many are still known to exist, and the condition. A coin's condition is graded on a seventy-point Mint Scale, or MS; thus, an MS 1 coin is in extremely poor condition, while an MS 70 is an uncirculated, unscratched coin in perfect, or mint, condition.

Renoites, and indeed people across the remainder of the globe, had first heard about LaVere Redfield's huge cache of silver dollars in early 1952, when his home was robbed of $1.5 million. But when the story of that record heist disappeared from the front pages of the world's newspapers, Redfield had quietly returned to his habit of accumulating silver dollars. He had evidently been collecting cartwheels from as early as the 1940s. His wife, Nell, said Redfield's penchant for hoarding food, liquor and other household items did not begin until after the life-threatening 1948 mugging he suffered, and perhaps that applied to silver dollars, too, but we can't be sure.

Was Redfield's passion for silver dollars about collecting, investing or simply hoarding? Coin expert Paul M. Green, writing about A-Mark Coin Company's purchase of the Redfield Hoard for *Numismatic News*, said:

> *It is worth remembering that in the 407,000 coins reported we have not a collection but a hoard. Redfield bought what was available, which explains the large number of mixed circulated coins as well as original Mint State $1,000 bag[s]. He could not have been expected to know which bags might be better and which would be ordinary...Even if he had tried to hand select better dates, he would not have managed much of a success rate. Of course, Redfield did not try. He just wanted dollars, and he got them.*

Another well-respected numismatist and author of the book *American Coin Treasures and Hoards*, Q. David Bowers, echoed Green's statement, writing, "Silver dollars were his passion, and although he had a passing numismatic knowledge, he preferred quantity to quality."

So according to Green and Bowers, Redfield's cache of cartwheels was not a collection; the man was just looking for hard assets, as one might buy gold bars or a large diamond or a choice piece of property. Dates, mintmarks and other numismatic hallmarks didn't interest Redfield very much; it was primarily a numbers game with him. Still, there is some evidence that he did search for valuable coins within his huge hoard. Redfield's friend and banker, Bill Leonesio, said that when silver dollars were in ample supply in Reno, Redfield would go from bank to bank and purchase sizable quantities. Then he would cull through the bags and take out those with rare mintmarks or dates and set them aside. He'd replace the rare coins with run-of-the-mill cartwheels from his own supply. Then he would go around to the casinos and offer them the $1,000 bags at a 5 percent discount. It was a great deal for the casinos and for Redfield, and the banks didn't seem to mind either. For the Reno banks, just as for the Federal Reserve Bank in San Francisco, a silver dollar was a silver dollar was a silver dollar.

Another story also indicates that Redfield not only possessed some knowledge of coins, but that he also had a personal collection of rare coins that was quite valuable. Numismatic expert Q. David Bowers wrote that Redfield often bought silver dollars from a man named B.A. Brown of Fallon, Nevada, an amateur numismatist who often attended national coin shows and conventions. Bowers also wrote that Redfield was a frequent visitor to Reno coin shops. This would confirm what Redfield family members say, which is that despite what most serious coin experts believe, Redfield did have more

than a passing knowledge of rare coins and their values. In fact, they insist, he had a personal coin collection that was quite valuable. Where this personal collection ended up after his death, however, remains a question mark.

Regardless of the reason Redfield was accumulating his silver dollars, he was a man in the right place at the right time. Reno was the legal gambling capital of the United States from the passage of Nevada's open gambling law in 1931 until the first half of the 1950s, when Las Vegas supplanted it atop the gambling mountain. But even as it tumbled to second place, Reno remained an important gambling center. The gamblers' favorite icon, the silver dollar, was king in Reno, and they flooded downtown casinos and hotels. Bags upon bags upon bags of silver dollars—one thousand to each canvas bag—came in weekly to all the leading banks in town from the Federal Reserve System in San Francisco, and from there, they went straight to the casinos to be put to good use in slot machines and at craps, blackjack, roulette and poker tables. But occasionally—this was the exception rather than the rule—a fellow would wander into a bank and ask to exchange a few paper dollars into silver dollars so he could enjoy the jangling noise the coins made in his pocket as he swaggered down Virginia Street. It may have started that way for LaVere Redfield, too. But soon he began requesting an entire bag of the cartwheels, instead of just a few, and before long, he would become a regular customer at a number of banks, exchanging a handful of the one-hundred-dollar bills he always had handy for a heavy bag of silver dollars.

Redfield did a lot of business with local banks. He had safe deposit boxes at many of them, and he transacted a lot of his important real estate business at the bank. He even maintained checking accounts at some of them. But when it came to savings, he eschewed banks, preferring to keep his savings in the form of a stock portfolio and in hard assets like property and silver. But he still conducted enough business at leading banks that he was considered an excellent customer, and he was afforded the special treatment banks reserved for their best clients. That generally included being able to swap paper money at the banks for bags of silver without a service charge. This was usually the case, but not always.

Reno real estate broker Preston Q. Hale, with whom Redfield did a lot of business, recalled in his book *From Coyotes to Corporations*, a story of the man's frugality, told to him by his friend Gene Small, who was vice-president of the Nevada Bank of Commerce. Redfield had gone to the bank and asked Small for ten thousand silver dollars. "He craved hard assets—silver and land," Hale said. Small told Redfield it would take a couple days to gather them up. Hale was present at the bank when Redfield returned, and he

verified Small's story. Redfield parked his old red Dodge truck in an alley next to the bank, and Small had two bank employees haul the ten heavy bags of silver out and load them into the truck. "They made quite a pile," Hale remembered. After all the bags were loaded into the truck, Small told Redfield, "That'll cost you $10 a bag," which was a very reasonable service charge. Chagrined, Redfield told Small to have all the bags carried back inside, and he cancelled the transaction.

Regardless of the outcome of that particular business deal, it is obvious that Redfield was not collecting his silver dollars a few at a time, or even a few bags at a time. Although we have no hard evidence, it's difficult to imagine that buying silver dollars in huge quantities like Redfield attempted to do at Gene Small's Nevada Bank of Commerce was not simply business as usual for the wealthy investor.

Another local banker, Dave Quinn, also spoke of Redfield's frequent purchases in a personal interview. Toward the mid-1960s, after Redfield got out of prison and when silver dollars were beginning to become scarce, Redfield would go regularly to Quinn's bank and buy bags of silver dollars, returning a few days later with the empty bags to have them refilled.

Finally, as one of the most prolific gamblers in Reno history, Redfield could also have collected silver dollars in the city's casinos. The coins were in wide use for dollar slot machines, but they were also used at table games, including poker, blackjack, craps and roulette. From the 1930s until the mid-1960s when the shortage of silver dollars pushed the price up too high, few casinos used $1 chips. Silver dollars filled that role. Casino dealers had a saying, "color for color," which meant that if a player was betting silver dollars, winning hands would be paid off in silver dollars, and if he was betting with house chips, he would be paid off in house chips. All of the cashier cages had $1,000 bags of silver dollars, and a good customer like Redfield could get all he desired in exchange for paper money. All of this indicates that the crafty Redfield cast a wide net in his ongoing search for silver dollars.

The belief has prevailed in the numismatic community for years that burglaries at the Redfield home had eroded his hoard of silver dollars by the time Markoff purchased the collection. Like much Redfield legend, that's an exaggeration. As described earlier, very little if any silver was lost in the 1952 burglary, nor in any of the other Redfield home burglaries, with one exception: the unsolved 1961 burglary. That crime occurred while Redfield was still attempting to obtain a retrial for his 1960 conviction of income tax evasion, and any admission of his losses, he believed, could taint his

appeal for a retrial and perhaps even subject him to additional problems with the IRS. Police told the press that the theft included "$10,000 in silver...[which] must have weighed about 500 pounds." And in another interview with Redfield, a different newspaper wrote, "The loot included many silver dollars which are mint new and...rare 1850 silver dollars of which only 1,100 were minted."

In his book on coin hoards, Q. David Bowers wrote that 100,000 silver dollars were taken in the 1961 burglary. However, Bowers gives no source for that estimate, and he inaccurately states the burglary occurred in 1962, so his figure is doubtful. But apparently 10,000 silver dollars were stolen in 1961, and that figure would have amounted to only a small fraction of the total size of the Redfield Hoard.

The Redfield estate legal team had been grappling with a number of issues for nearly a year and a half when it came time to finalize the disposition of Redfield's massive store of silver dollars. It badly needed cash to cover outstanding debts, including a large IRS debt, so the sale of this valuable asset was a top priority. Like everything else the team had faced, however, disposing of the silver would be contentious. But on November 4, 1975, the probate court granted the estate permission to sell the coin collection at a private sale.

A New York appraiser, Benjamin Stack, was hired to come to Reno and appraise the collection. After carefully examining the coins he put a value of $5.328 million on them, a low-ball estimate according to estate attorney Clel Georgetta, as Stack hoped he would be allowed to sell the collection on consignment. But on December 12, the three estate executrixes signed an agreement to sell the coins to Steven Markoff of A-Mark Coin Company, a Los Angeles corporation, for $5.9 million. A representative of A-Mark had gotten wind of the potential sale during the appraisal process, and he had also been allowed to examine the coins, whereupon the company made its bid. But word leaked out about the private sale. A consortium composed of two corporate bidders filed a petition in court asking that the A-Mark sale be set aside and that it be allowed to examine all the coins, too, a request that was denied. A few days later, the consortium filed a written offer to purchase the coins for 10 percent more than A-Mark's bid, or approximately $6.5 million.

Naturally, there was disagreement among the estate attorneys over whether to honor the private sale to A-Mark or open it up for bids. According to Georgetta, attorney Gerald Smith wanted to honor the sale to A-Mark at $5.9 million while the other attorneys wanted to accept the higher bid. Opening it up to all interested parties essentially meant going public with the inventory

of coins, which could depress the value of the collection. Why? Say there was an uncirculated silver dollar in the collection with a mintmark and date that was rare. That one coin, theoretically, could have been worth $1,000. But if there were fifty such coins in the collection, the $1,000 value would fall dramatically. Since a large part of Redfield's collection/hoard had been purchased by the bag, rather than by the individual coin, it was very likely that this situation would be repeated again and again, lowering the value of the asset considerably, at least in the opinion of some of the attorneys.

The team finally decided to expunge the mintmarks and the dates and make the inventory available to other potential bidders in that fashion, if the judge decided to vacate his earlier order for a private sale. After hearing a number of witnesses, the court did vacate the earlier ruling, saying that the A-Mark $5.9 million bid would be considered the opening bid only, and the consortium's $6.5 million the second bid. The bidding would pick up from that point.

Naturally, this spurred threats and counter-threats of lawsuits by everyone and against everyone. But on January 27, 1977, in Carson City, the date set by the court for the auction of the Redfield silver hoard, the bidding picked up at the $6.5 million level where it had left off after the consortium had entered its written bid. Six potential bidders attended the auction, according to Rusty Goe, co-owner of Southgate Coins in Reno and an expert on silver dollars. However, only Markoff and the consortium bid on the collection. Bidding in $100,000 increments, the two bidders went at it, until finally A-Mark Company's $7.3 million bid won the day.

It didn't take long for the coin collecting dealers who hadn't participated to begin coming out of the woodwork. A New York dealer said if the collection had been divided into six or eight separate lots, it would have easily brought $3 or $4 million more. An Indiana dealer said it should have brought at least $10 million; and another New York dealer said it could have sold for up to $20 million. Since none of these dealers had seen the inventory list with mintmarks and dates, little attention was paid to their sour-grapes rants.

Despite his victory at the auction, Steve Markoff was also angry. He sued the Redfield estate and the competing consortium for the extra $1.4 million he had had to pay after, he claimed, he had already been awarded the contract. Two and a half years later, after a district court trial and a state Supreme Court appeal had both failed for Markoff, the strange case of the largest silver hoard in history was finally over.

The contents of the Redfield Hoard were never made public, but over the years, a number of well-respected numismatists have cobbled together lists

they say likely comprised the cache. There seems to be general agreement that the collection included around 407,000 Morgan and Peace silver dollars. According to coin expert Goe, about 360,000 of the cartwheels—or 86 percent—were uncirculated. Most were from the San Francisco Mint, but there was also an amazing collection of rare Carson City Mint Morgan dollars. The affect of such a large supply of collectible coins coming onto the market had an impact. That impact was lessened somewhat by the release of the huge silver dollar supply from the U.S. Treasury in the 1960s and 1970s, but it still resonated throughout the numismatic community. According to coin expert Paul Williams, the Redfield Hoard caused a lot of fear and anxiety in the coin collecting community. Since there was no public information on the composition of the Redfield Hoard, most coin collectors and investors were concerned about price stability once the huge cache flooded the market.

Arnold Jeffcoat of *Numismatic News* echoed that sentiment in an article in the *Nevada State Journal*. The newspaper reported, "Jeffcoat said if a significant quantity of rare-date coins…are put on the coin market at the same time, the value of such individual coins owned by other private collectors would drop." Jeffcoat provided an example from the 1962 Treasury sale of silver dollars. One type of 1903 silver dollar that was valued at $350, he said, dropped to $25 after the Treasury release.

As it turned out, however, the purchaser of the Redfield Hoard, A-Mark Coin Company, did not simply dump the coins on the market. According to *Coin World* magazine, the coins were dispersed systematically over the years by A-Mark's sales and promotion representative, Paramount Coin Corporation, well into the 1980s. In June 1976, Paramount Coin made the first release of the Redfield Hoard to the numismatic community and the general public.

Its thirty-two-page promotional brochure for the sale boasted,

We know full well that here is an opportunity for you that may never occur again. During this initial sale, the least expensive offering from Redfield's basement were 1879-S through 1882-S (San Francisco Mint) silver dollars, all arguably declared in MS-65 condition. Price for these coins was $12 each, five for $56.25, or a roll of 20 for $195.00. Pricier offerings, all in MS-65 condition, were 1893-P (Philadelphia) dollars for $200 each; 1893-CC (Carson City) dollars for $925 each; and 1895-S dollars with "lovely satin cheeks and exceptional radiant lustre" for $2,100 each.

Left: Shown here is an 1891 Carson City Mint Morgan silver dollar from the famous Redfield Hoard. The coin is in the official red/maroon Paramount International Corporation cardboard frame that verified its provenance. The copy says, "A SILVER DOLLAR from THE REDFIELD COLLECTION, MINT STATE 65." *Courtesy Rusty Goe, Southgate Coins, Reno, Nevada.*

Below: For serious collectors who purchased seven silver dollars from the Redfield Hoard, Paramount presented the coins in a stylish wooden box. *Courtesy Rusty Goe, Southgate Coins, Reno, Nevada.*

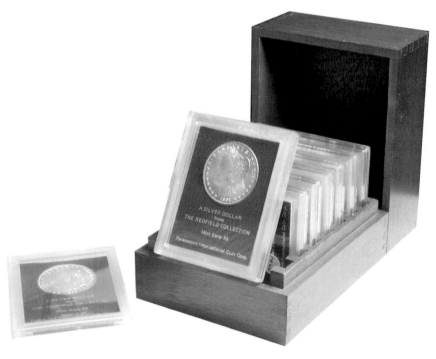

```
CERTIFICATE OF AUTHENTICITY
          AND GRADE

    This is to certify that the U.S. Silver Dollar(s) accompanied by this
    certificate is an authentic Mint State 65 coin from the famous LaVere
    Redfield Silver Dollar Collection. Paramount unconditionally guarantees that
    our Mint State 65 Dollars are equal to or better than the Gem BU, MS-65+,
    MS-70, and Superb Gem BU Dollars offered elsewhere.

    Paramount also guarantees that the Redfield Dollar(s) accompanied by
    this certificate may be returned for a full, immediate refund, including
    postage, at any time within 6 months from the date on this certificate.
    Coins must be in original packaging.

    11/29/77
    Date Issued          President
         Invoice #259055  PARAMOUNT INTERNATIONAL COIN CORPORATION
```

An ornate "Certificate of Authenticity and Grade" was given to each purchaser of a Redfield silver dollar. *Courtesy Rusty Goe, Southgate Coins, Reno, Nevada.*

A dozen years later, in 1988, another rare coin dealer purchased the last six thousand silver dollars from A-Mark. No purchase price was disclosed.

Today, a collector can still purchase a Redfield silver dollar. Rusty Goe said the premium on these coins could be anywhere from 50 to 100 percent because of their unique history. However, potential buyers are warned that some cartwheels advertised as being from the Redfield Hoard may not genuinely be from LaVere Redfield's basement or garage. The best way to ensure the coin is genuine is to purchase one that is still in the original Redfield holder with the printed identification "Paramount International Coin Corp." Even then, however, experts say there are counterfeit holders on the market with silver dollars that are not Redfield's, as promised. Thus, the common warning, *caveat emptor*, should always apply, and the coins should only be purchased from reputable coin dealers.

Perhaps the most succinct summary of the Redfield Hoard's impact on the coin community was offered thirty-five years later by Paul M. Green in

Numismatic News. By that time, Green was able to see with a high degree of accuracy what affect the sale of Redfield's silver dollars had actually had when he wrote:

> *Naturally without the chances to examine each of the 407,000* [silver dollars] *individually it is hard to know precisely what impact Redfield Hoard dollars have had on the supply in a certain grade. Even so, the dates involved and the numbers make it very clear that the Redfield Hoard had a significant impact and is responsible for a large number of the silver dollars being traded today. Each one of those dollars has a special story to tell as part of a fascinating and important hoard.*

14
The Redfield Legacy

History may never know the real LaVere Redfield. He represented different things to different people. He was a generous friend to those he liked; a quiet, mild-mannered gentleman to strangers; a good-humored man who smiled at his own foibles; a self-made man; an intelligent businessman; a great lover of animals; and a stern protector of the natural environment. But he was also a public philanderer, a corporate raider, a tax cheat, an unrepentant felon, a chronic gambler and a litigious gadfly.

Which one was the real LaVere Redfield? Or were they just two different sides of the same enigmatic man? An article in the *Los Angeles Times* on the occasion of his death said of Redfield: "He was a study in contrasts. He haggled with grocery clerks over pennies—and then threw away thousands of dollars at roulette without turning a hair. He sometimes barricaded himself in his three-story stone chateau in Reno to avoid the press—and then came out prattling merrily about his legendary miserliness and his reputation as an eccentric."

And what about Redfield's unsavory habits and traits? Were they simply eccentricities, were they character flaws or were they—as his wife, Nell, speculated—the result of a brain trauma suffered in that terrible 1948 mugging? In 1961, psychiatrists Dr. Raymond Brown and Dr. William Toller were the first medical people to note possible psychiatric causes for Redfield's odd behaviors and phobias. They were hired to analyze the man during his hearing for a retrial following his 1961 conviction for income tax evasion. However, those parts of the findings of the two doctors that have become

public record are cursory and gave only the briefest details of their diagnoses. In relation to Redfield, Dr. Brown did note "extreme obsessive compulsive traits," and Dr. Toller said he was "a psycho-neurosis, compulsive type."

Portions of the manuscript for this book were submitted to Dr. Ira B. Pauly, an eminent Nevada psychiatrist, for his observations and opinions. Dr. Pauly served on the faculty at University of Oregon Medical School and, in 1978, went to the University of Nevada, Reno to become professor and chairman of the Department of Psychiatry and Behavioral Science. During his sixteen-year tenure he led the department in establishing a successful undergraduate and postgraduate program in psychiatry. Currently, Dr. Pauly works part time at the Northern Nevada Adult Mental Health Services after having served as medical director for several years.

Naturally, Dr. Pauly was not able to provide a definitive diagnosis on LaVere Redfield four decades after his death and never having personally interviewed the man. Still, his observations closely matched those of doctors Brown and Toller from 1961. "What you describe in your biography suggests two possible psychiatric disorders: Paranoid Personality and Obsessive-Compulsive Personality," Dr. Pauly wrote. "I believe Mr. Redfield meets some of the criteria for each of these." Dr. Pauly explained that the term Dr. Toller used, "psycho-neurosis, compulsive type," is no longer in use. Today, it is called an "Anxiety Disorder, obsessive-compulsive type." These two possible conditions, agreed on by Dr. Pauly and Drs. Brown and Toller would certainly go far in explaining many of Redfield's odd behaviors: hoarding, parsimony, preoccupation with being exploited, litigious behavior, excessive discipline and phobias.

However, according to Dr. Pauly, it is highly unlikely that either of these two conditions could have resulted from the 1948 mugging Redfield suffered, as Nell Redfield had speculated. "The two conditions," Dr. Pauly said, "are lifelong...they are an inherent part of [a person's] personality." A head trauma, such as the one Redfield suffered, would not have altered his basic personality traits. Dr. Pauly explained, however, that Redfield's violent 1948 trauma could certainly have changed some of the couple's habits and could have resulted in a new feeling of vulnerability, but it would not have influenced his basic personality traits.

Nell Redfield passed away on April 5, 1981, at eighty-six. She had out-lived her husband by almost seven years. Considering that she had been born with congestive heart disease and had endured over a half century of her husband's bizarre behavior and cruel womanizing, that fact is a testament to her strength of character.

Nell Redfield left a lasting legacy for northern Nevada with the endowing of the Nell J. Redfield Foundation, which has poured more than $70 million into her community since her death in 1981. *Nevada Silver & Blue, University of Nevada, Reno.*

It would be an oversimplification to say that Nell should have left her husband if she was not happy with him. To a woman born in 1894, the choices were not as simple and straightforward as they are today. As a young woman, she had lost one husband to an early death, and when she married LaVere, it was for life. That was simply the way it was done in Nell Redfield's time. She was a gracious and generous woman, one about whom nobody ever had a bad word to say. People who knew her well also point out that she was a very intelligent woman. Although she had hired a stand-in, Ken Walker, to carry the bulk of her responsibilities during the lengthy probate of her husband's estate, she made the important decisions herself. Her attorney Gerald Smith said in a personal interview that in those situations, Nell would be given the facts and would carefully and intelligently consider them before rendering her decision. Although the probate was a stressful time for all concerned, and she was not well during most of the process, Mrs. Redfield did not abrogate her responsibilities as an executrix of the estate.

Shortly after her husband's death in 1974, Nell set into motion the creation of a foundation that would carry on her charity interests for the

remainder of her life and thereafter in perpetuity. She appointed a board of directors that included Ken Walker, her banker; Jeane Jones, her niece; and Gerald Smith, her attorney. Upon Mrs. Redfield's death in 1981, the unsold land that had been part of her community property after the death of her husband passed into her charitable foundation. In the years since, some of that land has been donated to worthwhile northern Nevada organizations. However, the bulk of it has either been sold to fund the foundation's ongoing charitable grants or is still owned by the foundation and is slowly being liquidated as the strength of the real estate market dictates.

Like all 501(c)(3) private foundations, the Nell J. Redfield Foundation operates under strict federal laws and regulations. It was established to operate "in perpetuity." All foundations are required to give out grants amounting to at least 5 percent of their total assets each year.

Director Gerald Smith estimated in 2009 that the Nell J. Redfield Foundation had distributed funds in excess of $50 million since its inception, a figure that has likely risen to near or above $70 million. As of the close of the fiscal year 2012, the foundation had assets of just over $67.3 million.

Because of the foundation's work, the Redfield name is appended to a number of significant buildings and projects in Washoe County, Nevada, keeping the name of Nell J. Redfield alive in the memories of its citizens. It has been especially generous to the University of Nevada, Reno (UNR). A 2010 $2 million grant prompted late university president Milton Glick to remark, "The Nell J. Redfield Foundation…has always been there when we've needed it." As a matter of fact, an April 2012 letter from the foundation to the UNR Board of Regents stated that the foundation had given out more than $40 million to UNR since 1983. In 2014, the foundation donated another $2 million toward the establishment of a student achievement center on the UNR campus.

Of all the projects the foundation has supported, one is especially close to the hearts of the directors: the Redfield Campus. Director Gerald Smith explained in 2009 that most foundation grants are simply a matter of giving the money away to a deserving organization. But with the Redfield Campus, the foundation remains actively involved to this day in helping the project set directions and achieve its mission. The Redfield Campus is a collaborative venture of the University of Nevada, Reno and Truckee Meadows Community College. Western Nevada Community College of nearby Carson City was initially involved but soon dropped out of the collaboration.

The project actively began in 1995 when the Nell J. Redfield Foundation donated sixty acres of land, with a value at the time of $9.2 million, for the

campus. It is located on Wedge Parkway, at the intersection of Mount Rose Highway and U.S. 395, in the burgeoning south side of the city. Plans called for an eventual six to eight buildings, accommodating ten thousand students, over a twenty-five year build-out period. The collaborative venture's vision statement outlines the hopes and dreams of its founders:

> *The Redfield Campus will offer new instructional programs, complement existing ones, and enhance educational partnerships in northwestern Nevada. In doing so it will emphasize new and innovative programs that are currently unavailable or underdeveloped and programs—old and new—at multiple sites, programs that emphasize providing students what they need for their career development. An additional component of the campus will be outreach intended to help further the economic development of northwestern Nevada. Additionally, the campus will offer a venue for expanded community and cultural opportunities and events in northwestern Nevada.*

In 2005, the Redfield Campus came alive with the opening of the University's fifty-five-thousand-square-foot Nell J. Redfield Building and the Community College's thirty-four-thousand-square-foot High Tech Center. The foundation donated $6 million to assist in funding construction of the Redfield Building.

The Redfield Campus is also home to the innovative Renewable Energy Center, a research, education and outreach resource for geothermal and renewable technologies. Ted Batchman, emeritus dean of the University's College of Engineering is the center's founding director. "The goal is to develop partnerships with industry, government agencies, University educators and researchers to help Nevada achieve its goal of becoming energy independent and a net exporter of green energy," Batchman said in explaining the purpose of the new program.

In early 2011, the *Reno Gazette-Journal* announced that the Nell J. Redfield Foundation had committed $750,000 to establish a National Merit Scholarship Program at the University of Nevada, Reno. The program awards scholarships to the brightest students in the country and is among the most highly coveted academic honors for high school students. Later that same year, it was announced that the foundation had contributed $1 million to the brand-new Terry Lee Wells Nevada Discovery Museum for children.

Much good work has been accomplished in Nell Redfield's name. Her face would probably redden at how often her name now appears in print

The Nell J. Redfield Building anchors the Redfield Campus, a collaborative venture of the University of Nevada, Reno and the Truckee Meadows Community College, in south Reno, on land donated by the Nell J. Redfield Foundation. *Photo by Theresa Danna-Douglas, Nevada Silver & Blue, University of Nevada, Reno.*

in a positive light, as she was never an outgoing person. She would be justly proud of all the positive good her generosity has fostered.

Arguably, the title of this chapter could have been "The Nell J. Redfield Legacy," as it was her half of the community property that has funded her foundation. Unless you believe that LaVere's 1974 will—the one in which he bequeathed most of his assets to charity—was genuine, it's difficult to identify many lasting marks the man made. But there were a few, and they are worth remembering.

LaVere's protection of his vast mountain holdings against development certainly qualifies as one outstanding legacy. A sizable segment of the Humboldt-Toiyabe National Forest, the largest in the United States outside Alaska, may well have ended up as crowded, noise-polluted housing tracts in the hands of other men, its magnificent natural wonders lost forever. And to the nation's large numismatic community, the Redfield Hoard has certainly proven to be a worthwhile legacy by preserving so much of our historic coinage. And finally, in LaVere's favor, it was his remarkable talent for making money that provided his wife, Nell, with the capital she so generously earmarked for charitable purposes.

There was, however, little generosity in LaVere Redfield's final will, even to those he owed. He eschewed leaving anything to his niece Hazel Warner (H.B.R. Bushard), behind whose skirts he hid for years when buying vast tracts of land. Likewise, he ignored other nieces who had treated him kindly and favorably and even relatives to whom he owed money. Nothing, not a cent to any of them. Instead, he left his entire post-tax estate to a niece he barely knew, shunning all those to whom it might be assumed he owed a debt. So in the end, LaVere Redfield leaves Nevadans with one more mystery to ponder.

After all is said and done, after all the words are written and after all the myths and folklore are dispensed with, do we really know LaVere Redfield? One small story, related by his friend and banker, Bill Leonesio, comes perhaps as close to defining the man and his actions as any other.

Not too many years before he passed away, Redfield would drive up to his mountain property every October and November. There he would spend up to a month cutting down Christmas trees, driving them down to Reno and selling them to a wholesaler in the city. He certainty didn't need the money, and since he sold the trees rather than donating them to a worthy cause, he didn't do it to help less fortunate families either. Why then? Redfield was in Leonesio's bank one day when a fellow he knew came up to him and asked him why he spent so much time harvesting and selling Christmas trees, given his wealth. Redfield looked the man straight in the eye and said, "Simple answer. Because I want to." Not as profound a response as one might have hoped for, but maybe that's why all the world's eccentrics do the things they do: just because they want to.

Perhaps, as author John Berendt remarked in the Prologue of our story, such men and women truly are artists, and their masterpieces are their own lives.

Bibliography

ARTICLES, MANUSCRIPTS, NEWSPAPERS, BOOKS, ORAL HISTORIES AND DISSERTATIONS

Adams, Eva B. *Windows of Washington: Nevada Education, the U.S. Senate, the U.S. Mint.* Reno: University of Nevada, Nevada Oral History Program, 1982.

Aldridge, Alan. *Religion in the Contemporary World: A Sociological Introduction.* Malden, MA: Blackwell, 2000.

"Ancestors of Jonathan Browning." Redfield family tree, in private hands, 2007.

"August Hill." *Sierra Magazine*, 1963.

Biltz, Norman Henry. *Memoirs of "Duke of Nevada": Developments of Lake Tahoe, California and Nevada; Reminiscences of Nevada Political and Financial Life.* Reno: University of Nevada Oral History Program, 1969.

———. *Papers, 1933–1973.* Reno: University of Nevada, Mathewson-IGT Knowledge Center, Special Collections Department.

Bowers, Q. David. *American Coin Treasures and Hoards.* Wolfeboro, NH: Bowers and Merena Galleries, 1997.

———. *Silver Dollars & Trade Dollars of the United States: A Complete Encyclopedia.* Vol. 2. Wolfeboro, NH: Bowers and Merena Galleries, 1993.

Clark, Walter Van Tilburg. *The City of Trembling Leaves.* New York: Random House, 1945.

"Classicum" 1916 yearbook. Ogden High School. Ogden, UT.

Coin World magazine, October 26, 1988.

Conforte, Joe, and David Toll. *Breaks, Brains & Balls: The Story of Nevada's Fabulous Mustang Ranch.* Virginia City, NV: Gold Hill Publishing, 2011.

Denton, Sally. *America Massacre: The Tragedy at Mountain Meadows, September 1857.* New York: Vintage Books, 2003.

"Descendants of Jonathan Browning." Family tree of Browning family, in private hands, February 2007.

Douglass, Jack. *Tap Dancing on Ice: The Life and Times of a Nevada Gaming Pioneer.* Reno: University of Nevada Oral History Program, 1996.

Federal Supplement, Volume 17, Cases Argued and Determined in the United States District Courts. "United States of America v. LaVere Redfield, Defendant, cr. no.13324, District of Nevada, 03/31/1962." St. Paul, MN: West Publishing, 1962.

Freeman, Lincoln. "Norman Biltz, Duke of Nevada." *Fortune* (September 1954).

Funding Universe. South Jordan, UT. http://www.fundinguniverse.com.

Georgetta, Clel. Papers. Collection no. 99–42, Series XX, "Diaries and 'Pages of Interest' Index, 1924-1979"; Box 16: XX/27–308, 1972–April 20, 1979. University of Nevada, Reno Mathewson-IGT Knowledge Center, Special Collections Department.

Green, Paul M. "Redfield Morgan Dollar Hoard Increased Collector Supply," http://blog.jtcoins.com/redfield-morgan-dollar-hoard-increased-collector-supply.html.

Goodman, Mike. *How to Win: Dice, Roulette, Poker, Blackjack (21), Horse Racing, Betting Systems, Money Management. International Gambling.* 2nd ed. Los Angeles, CA: Holloway House, 1983.

Hale, Preston Q. *From Coyotes to Corporations: Pages from My Live in the West.* Ann Arbor, MI: Sheridan Books, 2003.

Harmon, Mella Rothwell. "Divorce and Economic Opportunity in Reno, Nevada during the Great Depression." Master's thesis, University of Nevada, Reno, 1998. University of Nevada, Reno Mathewson-IGT Knowledge Center, Microfilm Thesis 4086.

Harrah, William F. *My Recollections of the Hotel-Casino Industry and as an Auto Collecting Enthusiast.* Reno: University of Nevada Oral History Program, 1980(?).

Henderson Home News, Henderson, NV.

"How to Win $6,500: Two Student Theoreticians Invent System for Beating Roulette Wheel." *Life,* December 8, 1947.

Hulse, James W. *The Silver State: Nevada's Heritage Reinterpreted.* 2nd ed. Reno: University of Nevada Press, 1998.

Jorgenson, Danny J. "Cutlerite Membership 1853." http://freepages.genealogy. rootsweb.ancestry.com/~hannahslife/cutlerite_membership.htm.

King, R.T., ed. *Every Light Was On: Bill Harrah and His Clubs Remembered.* Dwayne Kling, interviewer. Reno: University of Nevada Oral History Program, 1999.

Kling, Dwayne. *The Rise of the Biggest Little City: An Encyclopedic History of Reno Gaming, 1931–1981.* Reno: University of Nevada Press, Gambling Studies Series, 2000.

Koval, Ana, and Patricia Lawrence-Dietz. "National Register of Historic Places Nomination for the Hill/Redfield Mansion." Carson City, NV: State Historic Preservation Office, 1984.

Laxalt, Robert. "Down to His Last Million," *American Weekly* magazine supplement, April, 13, 1952.

———. *Papers, 1936–1996.* University of Nevada, Reno Mathewson-IGT Knowledge Center, Special Collections, #85-09, box 8.

Lewis, Oscar. *Sagebrush Casinos: The Story of Legal Gambling in Nevada.* Garden City, NY: Doubleday & Co., 1953.

Los Angeles Examiner, April 6, 1952.

Los Angeles Times, November 6, 1931.

McDonnell, Sharon. "When Setting Becomes Character." *Writer* (June 2010).

Melton, Rollan. *Sonny's Story: A Journalist's Memoir.* Reno: University of Nevada Oral History Program, 1999.

Miller, Max. *Reno.* New York: Dodd, Mead, 1941.

Moe, Albert Woods. *Nevada's Golden Age of Gambling.* Reno: Nevada Collectables, 1996.

The Nation, July 24, 1958. http://www.thenation.com.

Nelson, Warren. *Always Bet on the Butcher: Warren Nelson and Casino Gaming, 1930s–1980s. Reno:* University of Nevada Oral History Program, 1994.

———. *Gaming from the Good Old Days to Computers.* Reno: University of Nevada Oral History Program, 1978.

Nevada, A Guide to the Silver State. Writers' Program of the Work Projects Administration, "America Guide Series." Portland, OR: Binfords & Mort, 1940.

Nevada, The Last Frontier. Reno: Reno Chamber of Commerce, Nevada Information Division, 1935. University of Nevada, Reno Mathewson-IGT Knowledge Center, Special Collections Department.

Nevada Silver & Blue alumnae magazine. Reno NV: University of Nevada, Reno.

Nevada State Journal, Reno, NV.

Numismatic News, Iola, WI, September 9, 2009.

Ogden City, Utah, Cemetery Records. http:www.ims.ogdencity.com/cemetery/default.asp.

Ogden Sesquicentennial Committee. *Ogden, Utah: The First 150 Years*. Ogden: Sesquicentennial Committee, 2002.

Orsi, Richard J. *Sunset Limited: The Southern Pacific Railroad and the Development of the American West, 1850–1930*. Berkeley: University of California Press, 2005.

Polk's Reno-Sparks (Washoe County, Nevada) City Directory. Monterey Park, CA: R.L. Polk Co., 1923, 1931, 1933, 1935, 1937, 1948, 1958.

Raymond, C. Elizabeth. *George Wingfield, Owner and Operator of Nevada*. "Wilbur S. Shepperson Series in History and Humanities." Reno: University of Nevada Press, 1992.

Redfield, Francis Mylon. *Reminiscences of Francis Mylon Redfield: Pioneer of Oregon and Idaho*. Pocatello, ID: privately printed, 1949.

"Renewable Energy Center Opens at Redfield Campus," *Nevada Silver & Blue*, Winter 2009.

Reno Evening Gazette.

Reno Gazette-Journal.

Roberts, Richard C., and Richard W. Sadler. *A History of Weber County*. Salt Lake City: UT: State Historical Society, 1997.

Rocha, Guy. "Myth 143: The Great Depression in Nevada." Nevada State Library & Archives, Carson City, NV. http://nevadaculture.org.

Sack, Ivan. *Forester Lost in the Woods, Sailor Lost on Rocks and Shoals: My Careers with the Forest Service and the U. S. Navy*. Reno: University of Nevada Oral History Program, 1978.

San Francisco News, March 5, 1952.

Saturday Evening Post, Indianapolis, IN, September 20, 1952.

Sawyer, Raymond I. *Reno, Where the Gamblers Go!* Reno: Sawston Publishing, 1976.

Sion, Mike. "Thrift Personified," *R-Life* (July 2006).

Smernoff, Noah. *A Life in Medicine*. Reno: University of Nevada Oral History Program, 1990.

Southern Pacific Railroad Company Records, 1892–1958. University of Nevada, Reno Mathewson-IGT Knowledge Center, Special Collections Department, NC910-933.

Swobe, Coe. "What I've Learned." *Nevada Silver & Blue* (Fall 2007). http://www.nevadasilverandblue/online/fall2007/readmore/swobe.html (accessed June 9, 2010).

Terry, Alice. *Recollections of a Pioneer: Childhood in Northern Nevada, Work at the University of Nevada, Observations of the University Administration 1922–1964 WICHE, and Reno Civic Affairs*. Reno: University of Nevada Oral History Program, 1976.

Tygiel, Jules. *The Great Los Angeles Swindle: Oil, Stocks and Scandal during the Roaring Twenties.* New York: Oxford University Press, 1994.

University of Nevada, Reno website: "Redfield Campus." http:// www. redfieldcampus.unr.edu/about/.

U.S. census, 1900, 1910. hppt://www.ancestry.com.

Walton-Buchanan, Holly. *Historic Houses and Buildings of Reno, Nevada.* Reno: Black Rock Press, University of Nevada, 2007.

Washoe County, NV Assessor's Office. "Appraisal Records."

Washoe County, NV Recorders Office. "Grantee Deeds."

———. "Official Records."

Williams, Paul. "LaVere Redfield Remembered." From a lecture before the Nevada Historical Society, June 2007, Reno, NV.

World War I Draft Registration Record. "LaVere Redfield." http://www. ancestry.com.

Personal Interviews and Correspondence

Beck, Christine. E-mails to the author, February 11 and 12, 2010.

Brooks, Barbara. Personal interview with the author, March 3, 2010.

Cleaver, Sheri (Dunkee). Personal interview with the author, March 3, 2010.

Clifford, Chuck. Personal interview with the author, February 15, 2010.

Conforte, Joe. Personal interview with the author, May 26, 2010.

Drendel, John S. Personal interview with the author, January 5, 2010.

Durkee, Vern. Personal interview with the author, March 10, 2010.

Flint, George. Personal interview with the author, March 31, 2010.

Goe, Rusty. Personal interview with the author, September 8, 2010.

Hoffman, Jilda Warner. Personal interview with the author, June 16, 2010.

Hug, Proctor. Personal interview with the author, August 3, 2010.

Leonesio, Bill. Personal interview with the author, March 2, 2010.

Metzker, John, Personal interview with the author, March 9, 2010.

Pauly, Dr. Ira, Personal interview and correspondence with the author, July 2010.

Peckham, Don. Personal interview with the author, February 15, 2010.

Quinn, Dave. Personal interview with the author, June 22, 2010.

Raggio, William "Bill." Personal interview with the author, May 6, 2010.

Sale, Jean. Personal interview with the author, February 15, 2010.

Smith, Gerald. Personal interview with the author, August 2, 2010.

Swobe, Chester Coe. Personal interview with the author, September 2, 2010.

Williams, Paul. Personal interview with the author, July 26, 2010.

About the Author

Jack Harpster grew up in Memphis, Tennessee, and graduated in 1959 from the University of Wisconsin School of Journalism with a major in advertising. His eyes were originally set on being a Madison Avenue ad man, but following a multiyear apprenticeship in a small Southern California newspaper, Jack became enamored of the newspaper industry. He spent the next forty-three years on the advertising and marketing management side of the newspaper business and retired in 2002 as the executive director of advertising for the *Las Vegas Review-Journal* and *Las Vegas Sun* and director of new media for the Stephens Media Group.

Shortly after retirement, Jack began writing as a hobby. His first book, *John Ogden, the Pilgrim (1609–1682): A Man of More Than Ordinary Mark*, was a biography of his great⁰-grandfather, an important but little-known early colonial settler. The book was published by Fairleigh Dickenson University Press in 2006. Since then, Harpster has had six other books published, all in the personal or institutional biography genre. He is also the author of more than two dozen journal and magazine articles about history and biography.

Jack and his wife, Cathy, live in Reno, Nevada, where he is involved in numerous local history and historical preservation organizations. He can be reached through his website, www.JackHarpster.com.